Bourke · Studio
White

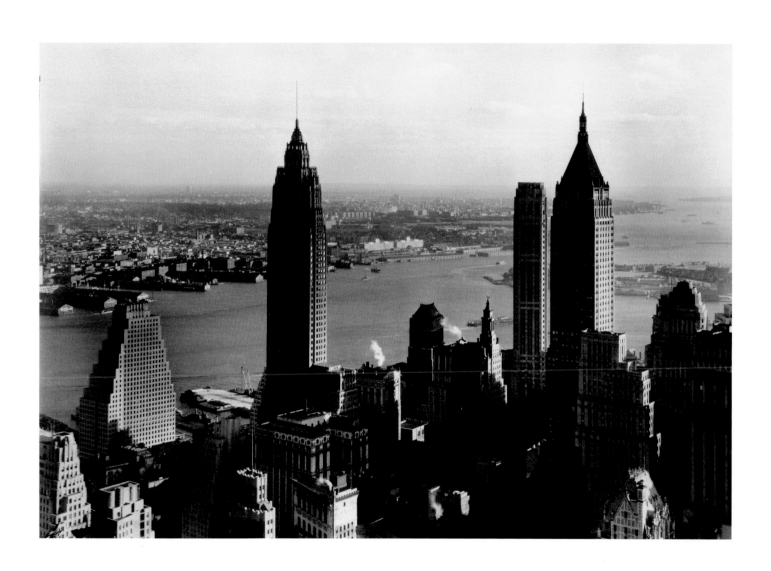

Margaret Bourke-White

THE PHOTOGRAPHY OF DESIGN 1927–1936

STEPHEN BENNETT PHILLIPS

THE PHILLIPS COLLECTION

in association with

Published on the occasion of the exhibition, *Margaret Bourke-White: The Photography of Design, 1927–1936*, organized by The Phillips Collection, Washington, D.C.

This exhibition and book are supported by the Phillips Contemporaries, a group of young supporters of the museum who sponsor educational programs, art acquisitions, and special exhibitions.

February 15–May 11, 2003
The Phillips Collection, Washington, D.C.

After closing at The Phillips Collection, the exhibition will travel to venues throughout the United States, including the following museums:

October 25, 2003–January 4, 2004
John and Mable Ringling Museum of Art, Sarasota, FL

February 14–May 2, 2004
Mint Museum of Art, Charlotte, NC

November 13, 2004 –January 9, 2005
Fort Wayne Museum of Art, Fort Wayne, IN

January 22–March 27, 2005
Portland Museum of Art, Portland, ME

Many of the photographs by Margaret Bourke-White in this book are included in the exhibition.

First published in the United States of America in 2003 by
Rizzoli International Publications, Inc.
300 Park Avenue South
New York, NY 10010

Text copyright © 2002 The Phillips Collection, Washington, D.C.
"Romancing the Machine" © 2002 Stephen Bennett Phillips

2003 2004 2005 2006 / 10 9 8 7 6 5 4 3 2 1

Phillips, Stephen Bennett, 1962–
 Margaret Bourke-White: the photography of design, 1927–1936/
Stephen Bennett Phillips.
 p. cm.
 "February 15–May 11, 2003, the Phillips Collection"—T.p. verso
Includes bibliographical references and index.
ISBN 0-8478-2505-1
1. Photography, Artistic—Exhibitions. 2. Commercial photography—Exhibitions.
3. Photography, Industrial—Exhibitions. 4. Bourke-White, Margaret, 1904–1971—Exhibitions.
I. Bourke-White, Margaret, 1904–1971. II. Phillips Collection. III. Title.

TR647 .B675 2003
770'.92—dc21 2002031906

ISBN: 0-8478-2505-1

Printed in China

Published in association with

The Phillips Collection
1600 Twenty-first Street, NW
Washington, D.C. 20009-1090
www.phillipscollection.org

For The Phillips Collection
Director of Publications: Johanna Halford-MacLeod
Editor: Tam Curry Bryfogle

[Page 1] *Manhattan Skyline,* 1935
[Page 2] *Niagara Falls Power: Hydro-Generators, (March of the Dynamos),* 1928
[Front cover] Terminal Tower, Cleveland, *View from Grillwork,* 1928
[Back cover] Oscar Graubner, *Chrysler Building: Margaret Bourke-White on Gargoyle,* ca. 1932

Contents

Foreword

JAY GATES, *Director*

Most people correctly associate The Phillips Collection with a painterly interpretation of modernism. Nevertheless, The Phillips Collection has long had an interest in photography and holds a small but significant collection of photographs. Duncan Phillips was open to the creative possibilities of the medium and held exhibitions by photographers such as Alfred Stieglitz, Edward Steichen, and Henri Cartier-Bresson. He accepted more than fifty photographs as gifts to the museum in the course of his career, among them nineteen by Alfred Stieglitz, given by Georgia O'Keeffe in 1949. Over the years the collection has grown, and the exhibition for which this publication was prepared is organized around Margaret Bourke-White's *Steps, Washington, DC* (1935), which my predecessor, Charles S. Moffett, had the foresight to add to the collection in 1996.

Like Duncan Phillips, who broke the mold in thinking about what a museum might be, Bourke-White was a pioneer. Trained in the same modernist compositional techniques as O'Keeffe, Bourke-White used her artistic vision for quite different purposes. She became a commercial photographer. Stieglitz, who knew a bit about the relationship of art and money, would never have hung Bourke-White's prints in his gallery, because they were not "art photography." The photographs that made her famous in the late 1920s and led to her appointment in 1929 as the first photographer for *Fortune* magazine were of Otis Steel in Cleveland, Ohio (bought, coincidentally, in 1942 by Jones and Laughlin Steel, to which Duncan Phillips owed his fortune). Still, Bourke-White had an artist's eye and saw aesthetic possibilities where few others did. Looking at American industry, she saw beauty in its power, processes, and productivity. The first famous woman photojournalist, she documented economic progress and industrialization in the new Soviet Union. Despite the commercial and documentary nature of her commissions, and in spite of the fact that she made a lot of money from them, aesthetic concerns were always paramount to her, because she understood the power of art and design to communicate.

Margaret Bourke-White: The Photography of Design, 1927–1936 would never have been possible without the commitment of funders. We are immensely grateful to the Phillips Contemporaries, a membership group at the museum, whose early and enthusiastic support made the project possible. Putting together the exhibition and its catalogue required the collaboration of many people. For this reason, I would like to thank the entire staff of The Phillips Collection for their effort in bringing this project to its realization. I am especially grateful to Stephen Bennett Phillips, curator, for the dedication, enthusiasm, and hard work that he has displayed in organizing this exhibition, and to Johanna Halford-MacLeod, director of publications, for her steadfast guidance in every phase of the publication of this beautiful book. ■

INDUSTRIAL CABLE, ca. 1930

Preface

STEPHEN BENNETT PHILLIPS, *Curator*

Although a number of exhibitions and publications have been devoted to Margaret Bourke-White's photographs, none has adequately explored her important early images. *Margaret Bourke-White: The Photography of Design, 1927–1936* examines the critical early years of Bourke-White's life and work before she was hired by *Life* magazine. This was a period when she was forming her aesthetic vision and forging new territory in the field of photojournalism.

Many of the images in the exhibition and this book have not been seen by the general public since they were first published in the early to mid-1930s, while others have never been reproduced. When these photographs were reproduced in magazines such as *Fortune*, they looked very different from the way they appear in this book, where they can be seen as aesthetic objects. In fact, what the general public saw when these images were published some seventy years ago was mostly seen through the limitations of commercial printing at the time. Bourke-White's photographs were cropped or printed in reduced formats, and their original subtle tonal variations, among the qualities that won her commissions, were lost. Only the compositional drama of her work was unaffected.

During her early career, the images Bourke-White produced for her corporate clients ranged from purely documentary to almost abstract. Her advertising clients usually preferred the more descriptive photographs for reproduction in magazines, but today we tend to admire more the formal side of her work. Collectors have always appreciated this aspect of Bourke-White's photographs. Roy Stryker, professor of economics at Columbia University (and later head of the photographic program of the Farm Security Administration) bought images by Bourke-White to hang in his office at Columbia. When her pictures arrived at *Fortune*, secretaries and writers would ask for prints to decorate their walls. Companies that gave her corporate commissions also wanted her images of industry for their walls, even if the photographs were of other industries. In 1932 Agnes Meyer, wife of Eugene Meyer, the owner of the *Washington Post*, contacted Bourke-White about acquiring several of her photographs. From the portfolio that Bourke-White brought with her to Washington, Mrs. Meyer selected sixteen, ranging in subject from American workers to Russian industry. Mrs. Meyer framed one for her husband's room, and her daughter, the future Katharine Graham, hung a couple in her bedroom and later took one with her to her dorm room at Vassar College. Museums exhibited her work early on, in solo exhibitions, or hanging next to works by contemporaries such as Edward Steichen, Charles Sheeler, and Edward Weston. During the early 1930s her photographs appeared in exhibitions at places such as the Cleveland Museum of Art, the Detroit Institute of Arts, the Museum of Modern Art in New York, the Philadelphia Museum of Art, and the M. H. de Young Memorial Museum in San Francisco.

The idea for an exhibition of Bourke-White's early work began with my interest in learning more about the context in which The Phillips Collection's beautiful photograph, *Steps, Washington, DC* (p. 160), was created. Putting together the exhibition and this book required the help of a great many people. I am immensely grateful to Jay Gates, director, and Eliza Rathbone, chief curator, at The Phillips Collection for their support, guidance, and commitment to this project. I am also grateful to Bourke-White's nephew, Jonathan "Toby" White, who was supportive of the project from the outset. I must acknowledge the huge debt my research owes to the scholars who preceded me, especially Vicki Goldberg, whose insightful biography of the artist is indispensable.

In locating information and photographs, the staff of many institutions were invaluable. I am especially grateful to Carolyn Davis, Paul Barfoot, and the entire staff of the Special Collections Department at the Arents Library at Syracuse University. I would also like to thank Mary Therese Mulligan and Janice Madhu at George Eastman House; Keith Davis and Pat Fundom at the Hallmark Photographic Collection, Hallmark Cards, Inc.; Mary Margaret Carr and Anita Heggli at the Harn Museum of Art at the University of Florida in Gainesville; and Nancy E. Green and Kasia Maroney at the Herbert F. Johnson Museum of Art at Cornell University. I owe special thanks to Michael Shapiro and the staff of his gallery for generously sharing information and making it possible for me to locate collectors. Other gallery owners were also extremely helpful: I am grateful to Howard Greenberg and Laurence Miller

and their respective staffs for helping me to find photographs by Bourke-White, and to Susan Herzig and Paul Hertzmann for further insight into the artist. I would like to thank Rona Tucillo at TimePix for help with rights.

Throughout all phases of the project, many individuals assisted. For their help in locating information on Bourke-White's assignments and published photographs, I am extremely grateful to Pat Good, Ann Marshall, and Guy Halford-MacLeod, as well as to Marcus Ratliff, who made his copies of *Fortune* magazine available to us. A very special thanks is due to Joyce Harmon and Sandy Schlactmeyer for their unfailing assistance at every juncture, as well as to interns Tyler Emerson and Danielle Cavanna, who helped with many of the final details. I would like also to acknowledge the contributions made to this publication by Martin Senn, who worked so hard to make digital scans to equal Bourke-White's photographs, and by Tam Curry Bryfogle, who worked tirelessly to edit the manuscript, as well as our colleagues at Rizzoli, especially Isabel Venero, Belinda Hellinger, and our designer, Susi Oberhelman. At The Phillips Collection, I would like to thank all my colleagues for helping to bring the exhibition project to fruition. I would especially like to thank those who went above and beyond the call of duty: Mary Hannah Byers, Linda Clous, Thora Colot, Joseph Holbach, Chris Ketcham, Bill Koberg, Alec MacKaye, Karen Schneider, Elizabeth Steele, Rachel Waldron, and Shelly Wischhusen. Above all, I would like to thank Johanna Halford-MacLeod, whose enthusiasm, dedication, and advice were vital to the success of the project. ■

Margaret Bourke-White

ROMANCING THE MACHINE

Margaret Bourke-White (1904–1971) was one of the great chroniclers of the Machine Age. In the late 1920s and early 1930s, the first decade of her career, she photographed implements, processes, and industrial output in ways that captured beauty in a world not usually perceived as beautiful. Hers were not merely documentary photographs. Romanticizing the awesome power of industry and machines through close-ups, dramatic cross-lighting, and unusual perspectives, she presented industrial environments as artful compositions. These tour-de-force images, showing her grasp of modern design and aesthetics, soon caught the eye of corporate executives and magazine publishers and propelled Bourke-White to the forefront of photography and journalism in the twentieth century.

It was in a period of economic expansion and optimism that Bourke-White established herself as a professional photographer, pursuing a high-profile career in advertising and journalism that essentially helped shape the world she was recording.[1] When she enrolled at Columbia University in 1921, women had just received the right to vote in national elections and the United States stood on the threshold of a decade of prosperity. Industrial production doubled between 1919 and 1929 as the nation became the most technologically advanced in the world.[2] The thriving economy supported the construction of countless factories, skyscrapers, bridges, dams, and tunnels over that decade.

Americans operated 7.5 million telephones in 1920, up more than sevenfold since 1900. A mere twelve years after Ford Motor Company began to sell its Model T (1908), there were ten million cars and trucks on the road, and in 1921 a national highway system was federally mandated.[3] The first radio station began service in Pittsburgh in 1920, and five years later 571 stations transmitted signals to almost three million homes and businesses. The dynamism of the Roaring Twenties was matched by the spirit of Bourke-White herself, a quintessentially modern woman. Ambitious, glamorous, brave, and entrepreneurial, she was one of four photojournalists hired when Henry Robinson Luce's *Life* magazine was launched in 1936. She was only thirty-two years old when the magazine exploded out of the starting gate with an initial readership of some five million.[4] But for most of the previous decade she was already a household name, interviewed on the radio and written about in newspapers for her bold pursuit of some of the most important industrial photographs of the age. With the naiveté of youth, the twenty-four-year-old Bourke-White overcame daunting obstacles, both social and technical, to produce her first dramatic images inside the Otis Steel Mill in Cleveland, Ohio, in 1928. Women simply did not go inside steel mills. Her persistence and the dazzling quality of her photographs opened the door to numerous special commissions—from the Ford Motor Company and Chrysler Corporation among others. From the time of its launch in 1930, she traveled widely in the United States on assignments for the fledgling business journal *Fortune*, journeying to Europe

Chrysler Building

GARGOYLE OUTSIDE
MARGARET BOURKE-
WHITE'S STUDIO

1930

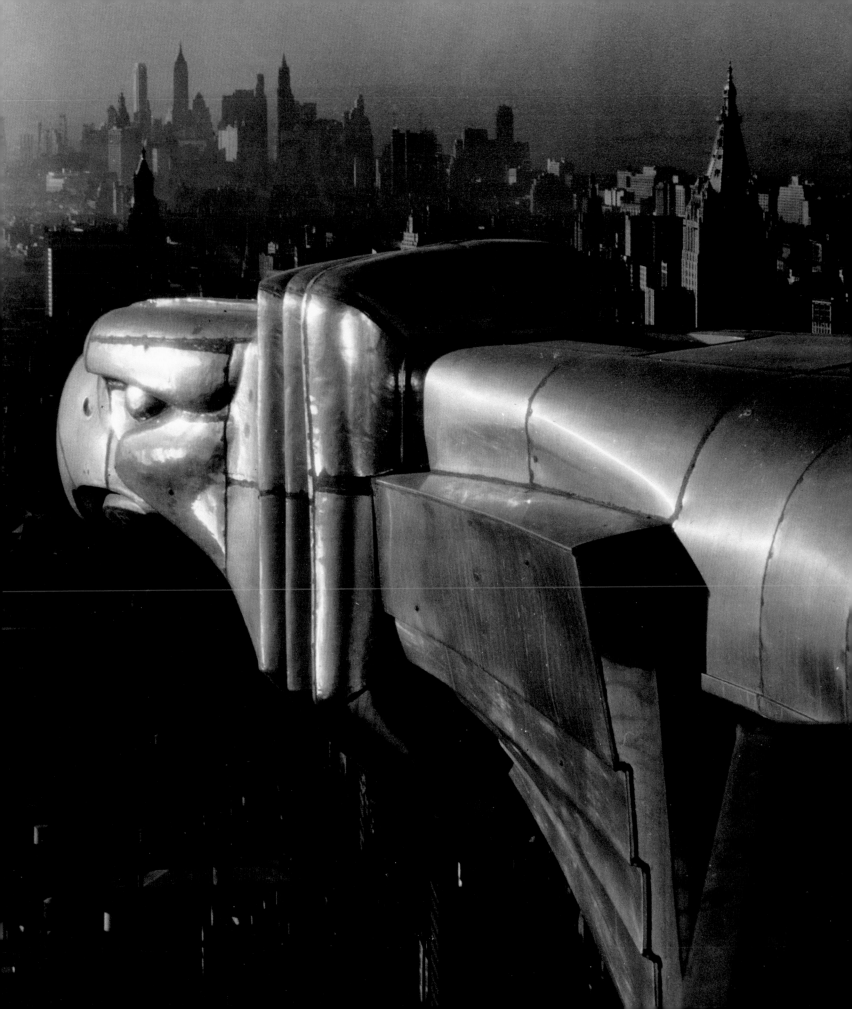

[FIG. 1]

Alfred Stieglitz (1864–1946)

THE HAND OF MAN

1902

and the Soviet Union in 1930, 1931, and 1932 to document the industrial transformation of their societies. Her corporate commissions continued even as her journalistic career took off. These were not always studio assignments. She took her cameras skyward, producing daring aerial shots of airplanes in flight for Eastern Airlines in 1935, only a few years after Charles Lindbergh and Amelia Earhart made history on their solo flights across the Atlantic.

In fact, Bourke-White was always drawn to heights, perhaps as an expression of her personal and professional aspirations. She walked along the tops of fences as a child and requested rooms on the top floors of hotels when she traveled.[5] She took pictures not only from small airplanes but also from catwalks inside steel mills, ledges around the tops of tall buildings, and atop the monumental turbines of a hydroelectric dam. Hired by Chrysler in 1929–1930 to photograph its new skyscraper under construction in Manhattan, she took pictures "800 feet above the street . . . on a tower that swayed 8 feet in the wind, often in sub-freezing temperatures."[6] She then rented a studio on the sixty-first floor of the newly completed Chrysler Building, where she entertained corporate executives, celebrities, and wealthy clients on her studio terrace. At the very beginning of her career, she rented space in the Terminal Tower in Cleveland, briefly the second-tallest building in the world.[7]

Adapting to market conditions as the prosperity and optimism of the 1920s fizzled away, Bourke-White began to develop the skills necessary to make the transition to the general interest and people-focused work that would be required by *Life*. After years spent making art and design from nuts and bolts and other inanimate objects, a human dimension entered her photographs. Her commissions to document the new Soviet Union and the drought in the United States for *Fortune* in 1930 and 1934 opened her eyes to human adversity. Her association with the writer Erskine Caldwell made the further development of her newfound social awareness inevitable.

PRECURSORS AND INFLUENCES

Reading Bourke-White's autobiography, *Portrait of Myself* (1963), one is struck by the absence of all mention of formative artistic influences other than Joseph Pennell's etchings. Yet, Bourke-White grew up surrounded by photographs and was familiar with development processes from an

early age. Her father, Joseph White, was an avid amateur photographer who developed his prints in the family bathtub—with Margaret often at his side—and hung them around the house (she and her siblings served as models for their father's experiments with prisms and viewing lenses).[8] Bourke-White's fascination with the industrial world also dated from her youth and was learned from her father, a prolific inventor and engineer for a printing press manufacturer.[9] Around 1912 he took her inside a foundry, where she saw molten iron being poured. The drama and excitement of this scene stayed in her mind for years.[10]

Bourke-White owed her visual vocabulary as a photographer to Arthur Wesley Dow, whose book *Composition* was first released in 1899. Heavily influenced by principles of Asian aesthetics, Dow valued two-dimensional rhythm and harmony above three-dimensional modeling and imitation of nature in a true work of art.[11] He based his theory on the elements of line, light and dark (or mass), and color. In addition, Dow identified five principles of good composition: opposition, transition, subordination, repetition, and symmetry.[12] These compositional principles can be spotted throughout Bourke-White's early work.

Although Dow's publication did not directly address photography—considered a hobby rather than a fine art at the time—Dow himself was a photographer in the pictorialist manner. Pictorialists wanted artistic status for photography and advocated a painterly approach to it, adjusting the camera lens so that it was slightly out of focus and producing blurred images that resembled impressionist paintings. In 1902 Alfred Stieglitz led a group of pictorialist photographers in a crusade to transform their medium into an accepted

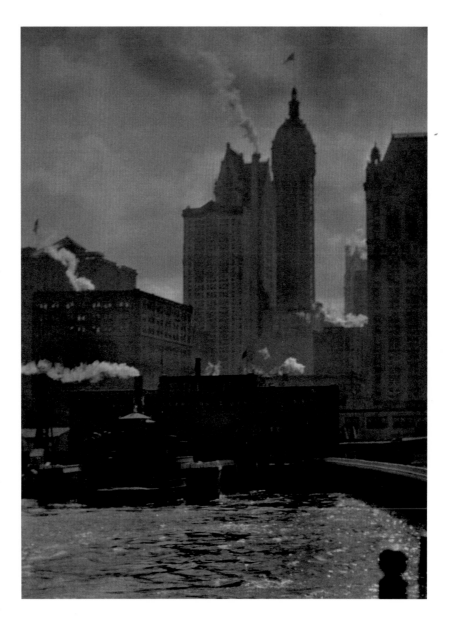

art form. Two of his photographs serve as examples of his fascination with the industrial world and his aspirations for photography. In *The Hand of Man*, 1902 (fig. 1), he caught the smoke and steam from a train pulling out of a rail yard, with an industrial landscape in the background, the soft focus investing the scene with a romance far removed from the soot and grime associated with steam trains. *The City of Ambition*, 1910 (fig. 2), similarly celebrates the modern metropolis, with

[FIG. 2]

Alfred Stieglitz (1864–1946)

THE CITY OF AMBITION

1910

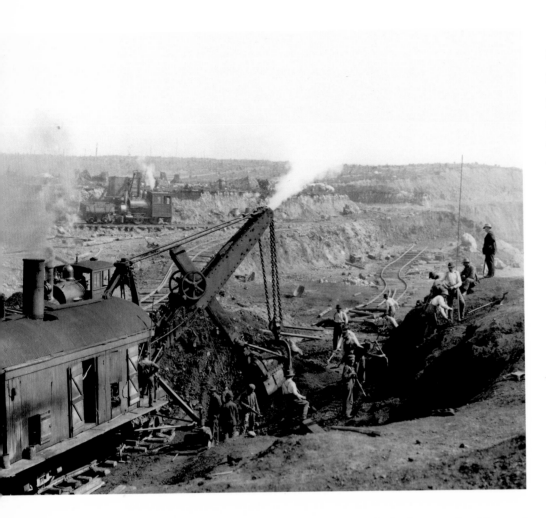

sparkling water in the foreground and layers of progressively taller buildings behind. These images foreshadow some of the pictures that Bourke-White took in Cleveland in the 1920s.

Frances Benjamin Johnston took a more documentary approach than Stieglitz. She photographed coal miners in Pennsylvania and women assembling shoes in a Massachusetts factory.[13] *Men and Machines Scrape the Earth of Its Iron Wealth*, 1903 (fig. 3), depicts laborers working with their equipment to draw iron from the earth, while *The Tugboat Joe Harris*, ca. 1903 (fig. 4), is a quaint, almost childlike image, showing life on the river, with one of the crewmen on deck lazily watching the world go by.

Another pictorialist photographer, Clarence H. White, probably did more than anyone to instill Dow's compositional theories in young photographers of the early twentieth century—and had a direct influence on Bourke-White. From 1907 until his death in 1925, White taught at Columbia University. He took his inspiration from pre-Raphaelite painting and used a soft focus to create romantic and melancholy images. Typical of his work, *The Orchard*, 1902 (fig. 5), reflects the pattern and perspective of American artist James Abbott McNeill Whistler's etchings and their Japanese sources.[14]

As a teacher, White concentrated on the artistic rather than technical aspects of photography. He wanted students to experiment with design and composition and use photography as a means of self-discovery. In addition, he encouraged his classes to consider photography as a profession and to strive to make a living in the field of commercial art.[15] He also believed that women should participate fully in the world of photography, and as a result, his courses attracted many female students, among them Bourke-White. During the spring semester of 1922, she enrolled in his photography course at Columbia, drawn not by a desire to learn the technical side of the medium, but by an interest in the art of design and composition. Her mother bought her a secondhand 3¼ x 4¼ Icas Reflex camera with a cracked lens—a flaw that did not matter at the time, because Bourke-White's early photographs tended toward the pictorialist style favored by White and did not depend on a sharp focus.[16] Bourke-White absorbed a modernist approach to design and abstraction that adhered to Dow's principles

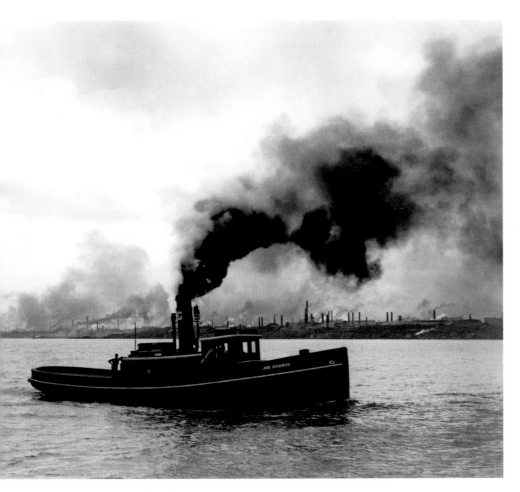

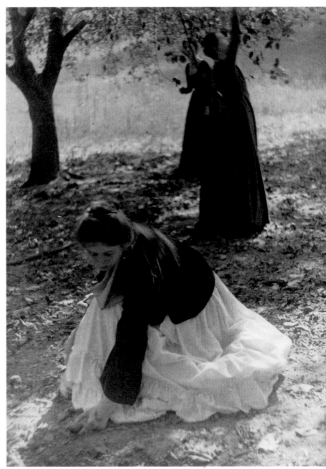

of composition, and she even went to hear a lecture by Dow himself.[17]

Among White's and Dow's students, Karl Struss and Alvin Langdon Coburn, both about twenty years older than Bourke-White and both pictorialists, shared Stieglitz's fascination with the objects of the industrial age.[18] In *Brooklyn Bridge from Ferry Slip, Late Afternoon*, 1912 (fig. 6), Struss highlighted the engineering prowess that went into designing this magnificent structure, positioning his camera under the bridge to reveal its steel armature as an abstract composition of opposing lines and transitional points as well as contrasts of dark and light. In *The House of a Thousand Windows*, 1912 (fig. 7), Coburn

showed the urban world as a cubist composition of angles and planes. He used the repetition of square windows to define an allover pattern that gives the photograph its aesthetic appeal. In *The Tunnel Builders, New York*, 1908 (fig. 8), Coburn captured the silhouette of men and machinery, working in tandem to create one of the wonders of the age. *Chimneys, Pittsburgh*, 1910 (fig. 9), is a bucolic vision of industrial smokestacks enveloped in billowing smoke with workers' cottages nestled below them, their roofs covered in snow.

Another of White's students, Ralph Steiner, Bourke-White's contemporary, became the first of her many mentors and technical advisors in the 1920s and 1930s.[19] Steiner liked photographing

[FIG. 4]

Frances Benjamin Johnston (1864–1952)

THE TUGBOAT JOE HARRIS

ca. 1903

[FIG. 5]

Clarence H. White (1871–1925)

THE ORCHARD

1902

[FIG. 6]

Karl Struss (1886–1981)

BROOKLYN BRIDGE FROM FERRY SLIP, LATE AFTERNOON

1912

[FIG. 7]

Alvin Langdon Coburn (1882–1966)

THE HOUSE OF A THOUSAND WINDOWS

1912

[FIG. 8]

Alvin Langdon Coburn (1882–1966)

THE TUNNEL BUILDERS, NEW YORK

1908

[FIG. 9]

Alvin Langdon Coburn (1882–1966)

CHIMNEYS, PITTSBURGH

1910

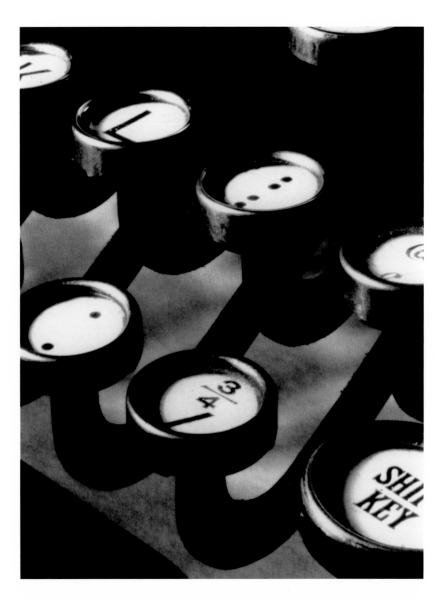

[FIG. 10]

Ralph Steiner (1899–1986)

TYPEWRITER AS DESIGN

1921–1922

[FIG. 11]

Royal Typewriter

KEYS

1934

machines, and the compositional teachings of Dow and White are reflected in his works. His *Typewriter as Design*, 1921–1922 (fig. 10), an extreme close-up, frames the typewriter's array of keys rather than the machine itself. The image is slightly out of focus—betraying the remnants of pictorialism, which Steiner soon abandoned—and the subject is not immediately recognizable, though the "shift" key resolves any question. About ten years later Bourke-White took her own photographs of a typewriter, commissioned

by the Royal Typewriter Company. Her version, *Royal Typewriter: Keys*, 1934 (fig. 11), is more descriptive yet has much in common with Steiner's abstraction. The machine is depicted at an angle and is cut off at the edges, which gives the image just enough compositional tension to make it interesting without obscuring the subject. The dramatic lighting, always key in her work, gives the stainless steel the glamorous sparkle of silver or platinum.

FROM CORNELL TO CLEVELAND

During college Bourke-White found that her photography could generate income. At the University of Michigan in 1924 she and her fiancé, Everett "Chappie" Chapman, a senior engineering student, organized two sales of her photographs, which he had helped her print.[20] The two were married in 1924 but separated soon afterward, and in 1926 she transferred to Cornell University,[21] where she again offered a number of her original photographs for sale. Her fellow students pounced on her scenic views of the campus and, overwhelmed by orders, she had to hire assistants to help fill them. Her images appeared on the cover of the *Alumni News*, and Cornell-trained architects encouraged her to take up architectural photography after college. It was at this point that Bourke-White saw the economic possibilities of a career as a professional photographer. Graduating from Cornell with a degree in biology in 1927, she set out for Cleveland to become a photographer.[22]

Soon after arriving in Cleveland, she met Alfred Hall Bemis, a seasoned photographer who owned a camera store and was willing to give her technical advice.[23] He also introduced her to a

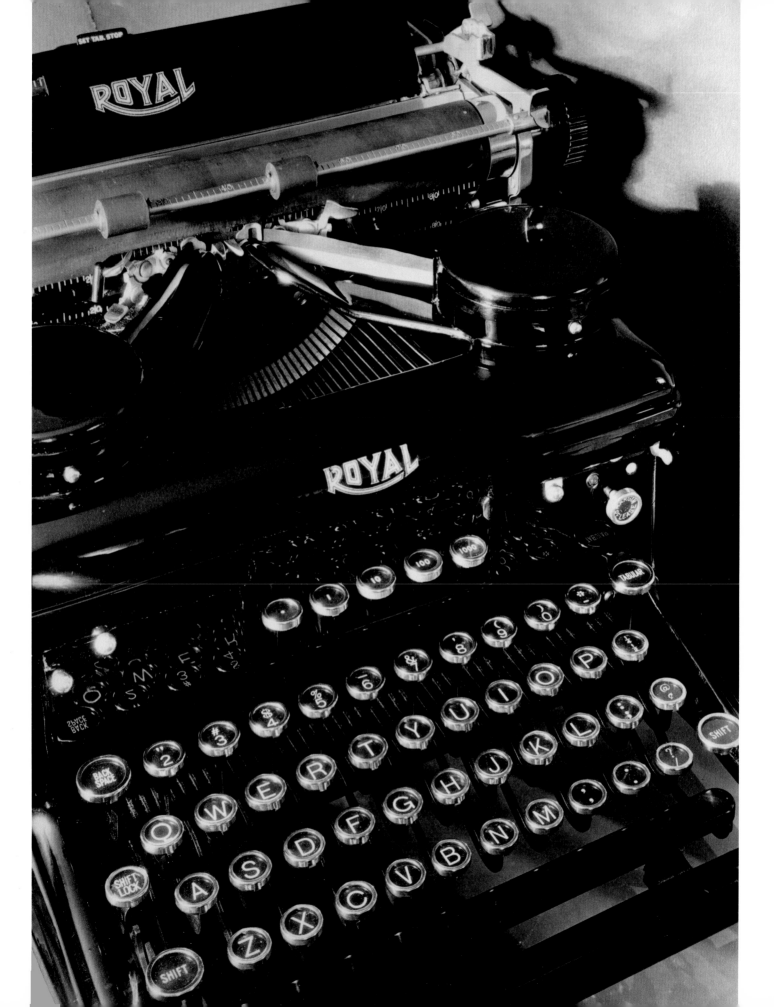

20

[FIG. 12]

W. H. Albers Estate (Alberty Manor)

EXTERIOR OF HOUSE

1929

[FIG. 13]

W. H. Albers Estate (Alberty Manor)

GARDENS

1929

[FIG. 14]

Prentis Estate

MILADY PEROMYSCUS
DRAGS HER TAIL

ca. 1928

photofinisher, Earl Leiter, who helped her refine her darkroom technique. Like most men, both were charmed by her. She needed their help—and that of men in general—to succeed in business. She was attractive and flirtatious, which she used to great advantage throughout her career. As a marketing ploy, she now created a hyphenated surname, adding her mother's family name, "Bourke," to her own. This important-sounding invention was the official introduction of Margaret Bourke-White, photographer.[24] It also marked an important stage in her forging of a distinctive identity. Bourke-White was an ingenious and talented marketer and self-promoter. She built her career not only on her talent as a photographer

but also on her understanding of what her images could do for corporate identity. At the same time she recognized the necessity of selling herself to business executives and influential people as well as to the larger public. She was extremely fortunate to be at the right place at the right time. Her move to Cleveland coincided with a building and industrial boom there.

Bourke-White joined a long line of women who took up the camera to gain financial independence. Almost since its invention in 1839, women had gravitated to photography, both as a hobby and as a profession. In the second half of the nineteenth century most of these women worked in portrait studios. A professional woman

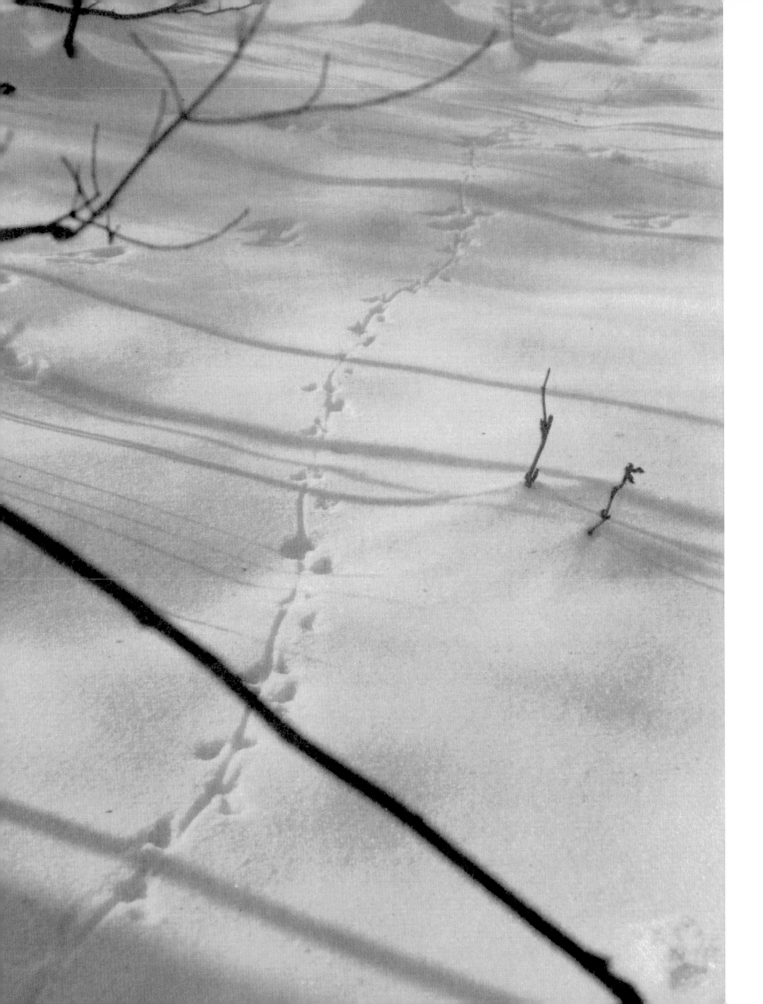

[FIG. 15]

Terminal Tower, Cleveland

SKYLINE

1927

By 1920 more than seven thousand women worked as professional photographers, representing over twenty percent of the industry. Jessie Tarbox Beals and Consuelo Kanaga started out taking newspaper photographs, while Berenice Abbott, Imogen Cunningham, Dorothea Lange, Clara Sipprell, and Doris Ulmann began their careers as portrait photographers.[25]

Portraiture did not interest Bourke-White, but architectural photography did. Interior and exterior shots were seen as natural subjects for women because of their perceived domestic interests.[26] Bourke-White had no particular domestic interests but recognized architectural photography as a way of earning significant sums. She set out to sell portfolios of photographs of the grand estates in Cleveland to the wealthy businessmen who had built them. Within a few years Bourke-White's assessment of the vanity of her well-to-do clients was shown to be correct. Her earnings from these architectural commissions and other work in Cleveland were substantial.[27] Many of her Cleveland architectural photographs are competent but routine. Others display her considerable skill in composition and design. In photographs of the W. H. Albers estate, such as *W. H. Albers Estate (Alberty Manor): Exterior of House* and *Gardens*, both 1929 (figs. 12–13), she employed a soft focus to capture the beauty of the property and reflections in the water. One of her most original garden photographs was taken at the Prentis estate: *Milady Peromyscus Drags Her Tail*, ca. 1928 (fig. 14), emphasizes pure design, with a pattern in the snow defined by reflected light and the shadows of branches cutting across the picture. Several small magazines in Cleveland published her garden shots, and soon national magazines followed

photographer often got her start by assisting in her husband's studio and taking over the business after he died. By the turn of the century, while less fortunate women worked on the assembly line producing the new photographic papers and films, others took photographs for the expanding magazine and book industries, boosted by the advent of new printing technologies. Gertrude Käsebier and Frances Benjamin Johnston, well-known photographers with successful studios, advocated for women's involvement in the field.

suit. The April 1928 issue of *House & Garden* was first, using four of Bourke-White's photographs with the article "In a Garden in Cleveland."[28]

In Cleveland Bourke-White found her true passion: industrial photography. Cleveland, in the late 1920s, was an ideal place to pursue this interest. Upon arrival there, she began to take her camera into the Flats, the gritty industrial district south of Lake Erie, along the Cuyahoga River. Bourke-White saw the simple design and functional structure of the factories and warehouses as fertile ground for photographic exploration. Each time she returned to take pictures in the Flats, she would discover new angles in the industrial landscape of buildings, bridges, and steel mills. This sector of the city held her interest for several years and provided material for some of her best early photographs.[29]

TRIUMPH IN THE STEEL MILLS

Bourke-White's earliest photographs of Cleveland look as if they were taken in 1900 rather than in 1927. Still reflecting the pictorialist tradition, *Terminal Tower, Cleveland: Skyline*, 1927 (fig. 15), shows the city on a foggy day, and the soft focus adds to the romantic feel of the scene. This photographic style persisted in *Otis Steel: Riverside Works from a Distance*, 1928 (fig. 16). Bourke-White's friend Ralph Steiner convinced her to adopt a sharper focus in late 1927 or early 1928, warning her that she would ultimately lose commissions if she did not respond to shifts in taste. He had a valuable perspective on this trend, as a member of the artists' committee and one of the artists included in the *Machine-Age Exposition* in New York City in May 1927.[30] Bourke-White's style did not change overnight, but she gradually

sharpened her focus, and to good effect, in her industrial photographs.

One of Bourke-White's recurrent Cleveland subjects was a skyscraper then under construction. Terminal Tower, built by the wealthy and powerful Van Sweringen brothers above a new railway station and transportation hub for the region, was an important addition to a long-standing Daniel Burnham City Beautiful project.[31] By the end of 1927 Bourke-White had become the official photographer for the project, thereby gaining

[FIG. 16]

Otis Steel

RIVERSIDE WORKS
FROM A DISTANCE

1928

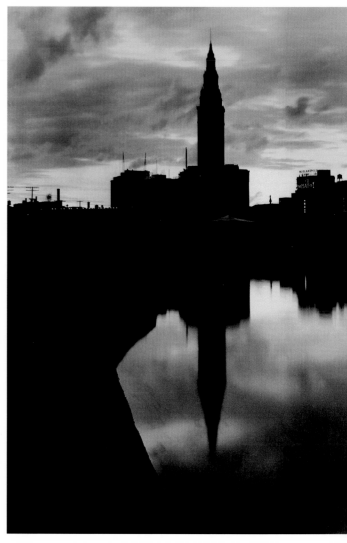

24

[FIG. 17]

Terminal Tower, Cleveland

PUBLIC ENTRANCE

1928

[FIG. 18]

Terminal Tower, Cleveland

TWILIGHT VIEW

1928

[FIG. 19]

Terminal Tower, Cleveland

VIEW FROM STREET

1928

unlimited access to the site as well as an inside track on securing a studio at this fashionable address. Some of her pictures of the tower are purely documentary, but others are masterpieces of modernist design. *Terminal Tower, Cleveland: Public Entrance*, 1928 (fig. 17), would have been ideal for the cover of a promotional brochure, with its straightforward view of the structure. *Terminal Tower, Cleveland: Twilight View*, 1928 (fig. 18), by contrast, shows the tower starkly silhouetted against the sky and reflected in the water below, while the intense black tones convey a romantic

sensibility. *Terminal Tower, Cleveland: View from Street*, 1928 (fig. 19), brackets the sunlit tower with the edges of darkly shadowed buildings, an artful device that imbues the image with dramatic power. *Terminal Tower, Cleveland: View from Grillwork*, 1928 (fig. 20), makes as much of the grillwork in the foreground as of the tower in the background. Bourke-White made several photographs looking through metalwork, and it is interesting that Clarence H. White had set his students the photographic assignment of finding an aesthetic composition in the grillwork of a gate. *Terminal*

Tower, Cleveland: View from Arches, 1928 (fig. 21), pushes the modernist approach even further, with the "cathedral-like arches" of concrete piers in the foreground framing the faint tip of the Terminal Tower in the distance.[32] The strong shadows of the arches almost assume a substance of their own, creating an essentially abstract composition.

The steel mills were another favorite subject. Photographing their exteriors, Bourke-White longed to get inside, but as a woman she was denied access. Through a contact she had made in her architectural photography business, she was able to secure an introduction to the president of Otis Steel. Of her meeting with him she wrote: "I remember standing there by his massive carved desk, trying to tell him of my belief that there is power and vitality in industry that makes it magnificent for photography, that it reflects the age in which we live, that the steel mills are the very heart of industry with the most drama, the most beauty—and that was why I wanted to capture the spirit of steel making in photographs." Her charm and enthusiasm prevailed. He granted her unrestricted access to the plant while he was in Europe for several months.[33]

Traveling to Otis Steel nearly every night during the winter of 1927–1928, she discovered the difficult nature of her subject. Bemis and Leiter accompanied her to the mill and back to the darkroom to help develop the photographs. The first prints were almost black. Bemis brought in new equipment from his store for her to use— floodlights and flash pans to illuminate the interior and a faster lens to record the action—but even with these she could not achieve any contrast beyond pale shades of gray. Night after night, useless negatives filled her trash can. Just as

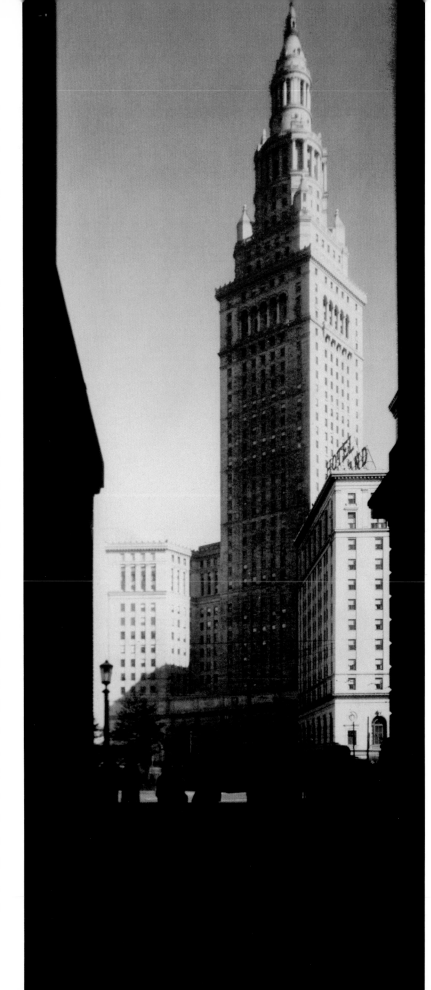

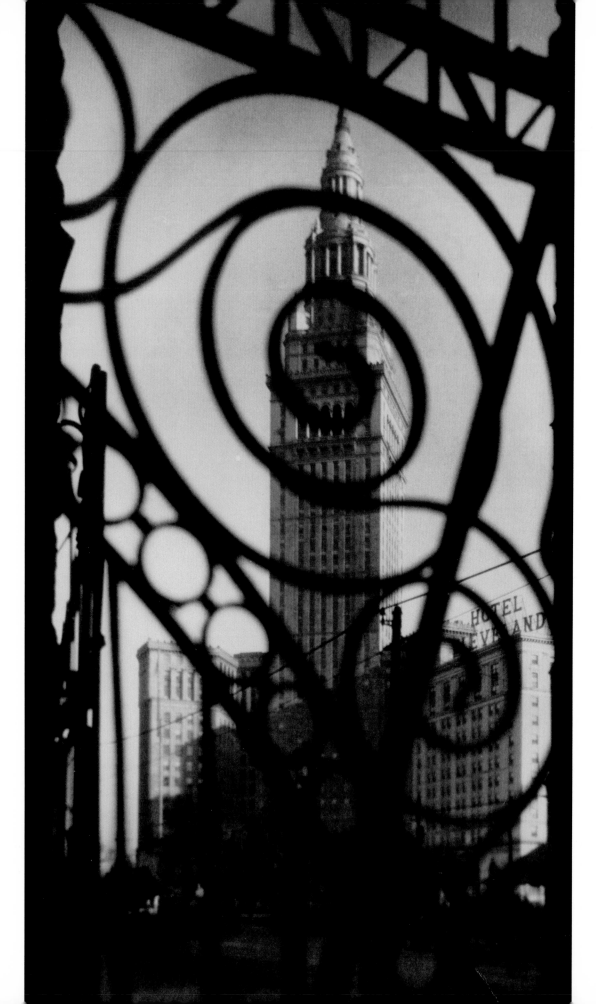

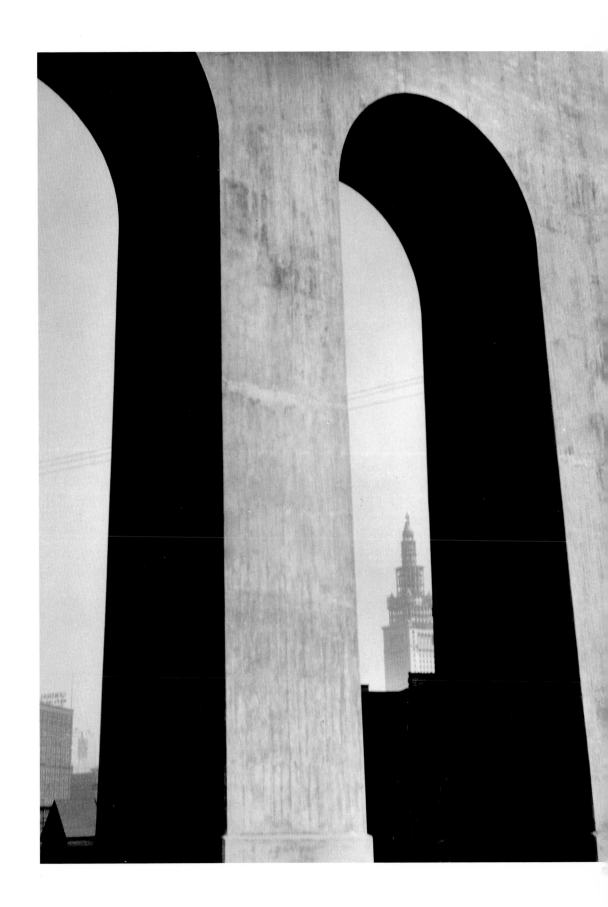

[FIG. 20]

Terminal Tower, Cleveland

VIEW FROM GRILLWORK

1928

[FIG. 21]

Terminal Tower, Cleveland

VIEW FROM ARCHES

1928

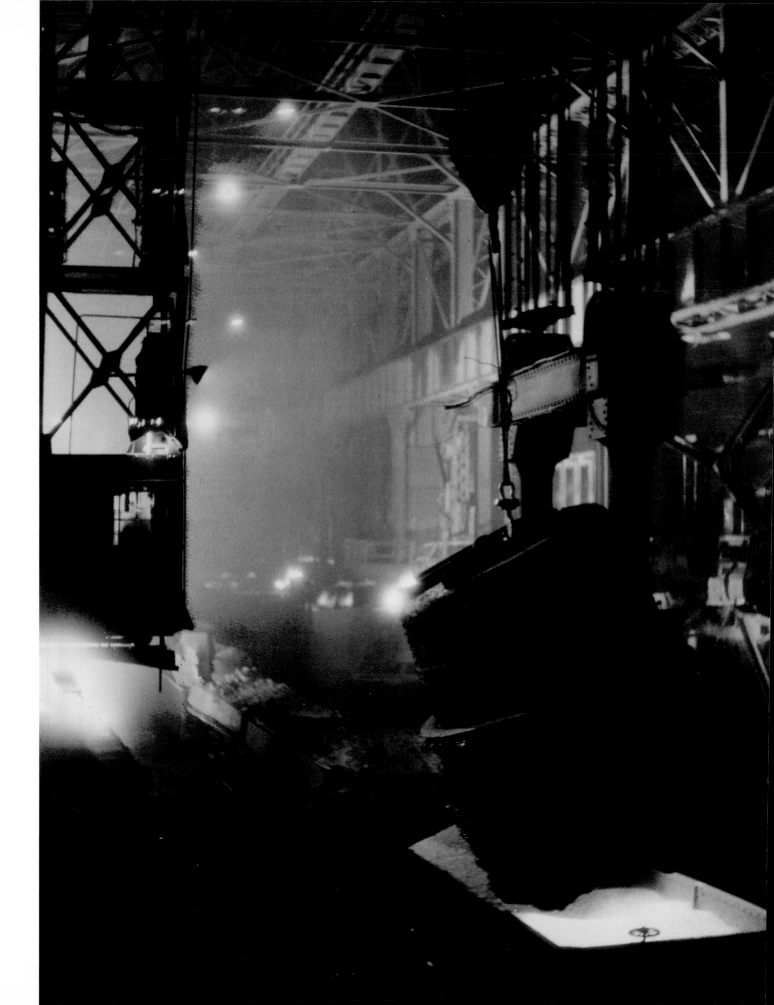

she and Bemis were becoming thoroughly discouraged, two traveling salesmen appeared. One brought magnesium flares that lit up the inside of the steel mill, and the other had a new type of photographic paper with high silver content that captured a wide range of tones from light to dark. After about five months of work Bourke-White finally attained success. *Otis Steel: Dumping Slag from Ladle* and *Otis Steel: 200 Tons, Ladle*, both 1928 (figs. 22–23), show the steel-making machinery with just enough detail for the silhouettes to read as shapes bathed in light. The president of Otis Steel was delighted and gladly paid one hundred dollars apiece for eight photographs. He also commissioned her to take eight more, to include in a company publication to be called *The Otis Steel Company—Pioneer* (1929). The photograph *Otis Steel: 200 Tons, Ladle*, won first prize in an exhibition at the Cleveland Museum of Art in May 1928.[34]

With such images glorifying the Machine Age, Bourke-White now commanded respect in the field of industrial photography. She was not alone in the field, however. Many photographers were drawn to the sources and products of America's growing wealth in the 1910s and 1920s. Paul Strand, a protégé of Stieglitz's, took a famous shot of Wall Street in 1915. Fascinated by the mechanisms of his Akeley motion picture camera, he took close-ups in the early 1920s of the camera as well as tools like drills and lathes.[35] *Lathe #1, New York*, 1923 (fig. 24), taken in extreme close-up, abstracts the machine to a set of interlocking shapes. Compared with Bourke-White's *National City Bank: Lock Mechanism*, 1931, or her *Wurlitzer: Wires Inside Organ*, 1931 (figs. 25–26), Strand's images of lathes and his movie camera focus

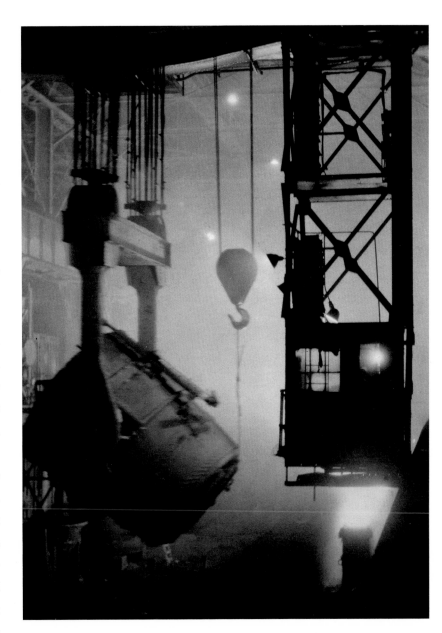

less on the rhythm of forms and patterns and seem linear, static, and solid. Ironically, Bourke-White's effects derive in part from the cinematic quality of her lighting.

Another industrial photographer, Lewis Hine, had concerns that were quite different from Bourke-White's. Whereas she looked to industry for graphic power, Hine's interest was industry's human impact. Early in the twentieth century he

[FIG. 22]

Otis Steel

DUMPING SLAG
FROM LADLE

1928

[FIG. 23]

Otis Steel

200 TONS, LADLE

1928

took photographs in factories—to document poor working conditions and the exploitation of child labor—in hopes of spurring government intervention.[36] In *Spinner and Foreman in a Georgia Cotton Mill*, 1908 (fig. 27), with its endless spools of thread and the obvious disparity between the man and his young charge, Hine highlighted the monotony of mass production and the social injustices brought about by industrialization. His *Powerhouse Mechanic*, 1925 (fig. 28), captures the beautiful design of the machine but places a worker in the center of the composition in a way Bourke-White rarely did. Her *Chrysler: Gears*, 1929 (fig. 29),

shows the awesome size of the gear, with a workman barely included at one side to provide a sense of scale. This man looks puny and insignificant next to Hine's powerfully muscled worker, the equal or even the master of the machine. Hine went on to photograph the construction of the Empire State Building in the early 1930s. The laborers in his *Maneuvering the Girder*, 1931 (fig. 30), small against the great steel skeleton and the skyline of Manhattan, are partners with their materials. *Preparing to Hoist a Girder*, 1931 (fig. 31), is a paean to the virility of both worker and machine and the beauty of the industrial fabrication.

Charles Sheeler shared Bourke-White's passionate and enduring interest in industrial subjects. As early as 1920 he teamed up with Strand to make the film *Manhatta*. Its abstract shapes, dramatic angles, and multiple exposures created a disorienting and disturbing view of New York City. Sheeler made photographs from fifteen of the film's stills, which he used as the basis for paintings and drawings. Throughout the early 1920s he continued to find inspiration in the urban landscape, but by the last half of the decade he turned his attention increasingly to industrial scenes. In 1927 Ford Motor Company hired Sheeler to photograph its River Rouge plant in Michigan, then the largest and most technologically advanced factory in the world. Sheeler focused on the factory itself, rather than on the workers, and Ford chose thirty-two photographs for promotional purposes and published them in many periodicals in the United States as well as in Europe, the Soviet Union, and Japan. Although Bourke-White may not have been aware of her other precursors, it seems likely that she saw Sheeler's photographs when they were reproduced

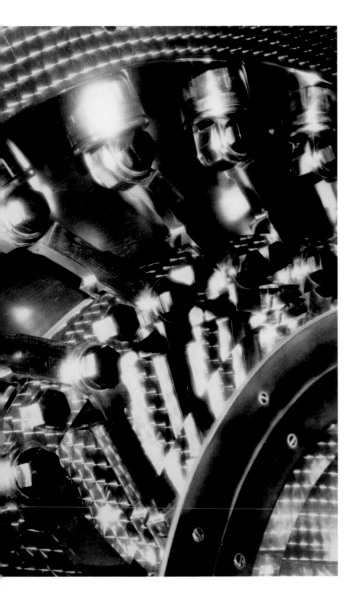

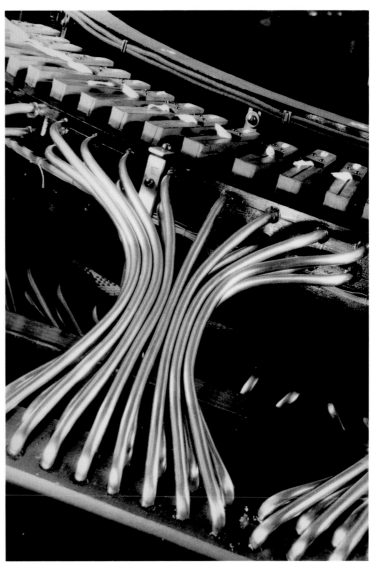

in *Vanity Fair* in 1928.[37] Two decades later she inscribed one of her books to him: "It is a pleasure to sign this book for Charles Sheeler, whose work has taught me so much."[38]

A comparison of what Sheeler and Bourke-White made of their factory subjects is revealing. The Rouge plant was new when Sheeler photographed *Ford Plant: Open Hearth, Ladle Hooks*, 1927 (fig. 32). In his cool, precise, daylit images, he portrays a series of pristine spaces, carefully designed and articulated for the industrial tasks

to be performed there. Sheeler's factory is a model for the future. Bourke-White's vision of Otis Steel is romantic in a nineteenth-century way. Hot and smoke-filled, it is a theater for industrial processes resembling a Wagnerian stage set. In fact, photographing *Otis Steel: Dumping Slag from Ladle* and *Otis Steel: 200 Tons, Ladle*, Bourke-White lacked the technical means to make a nocturnal photograph as clean as Sheeler's daytime shots. But her taste at the time was for the smoke and vapors of the late nineteenth century, and these very

[FIG. 25]

National City Bank

LOCK MECHANISM

1931

[FIG. 26]

Wurlitzer

WIRES INSIDE ORGAN

1931

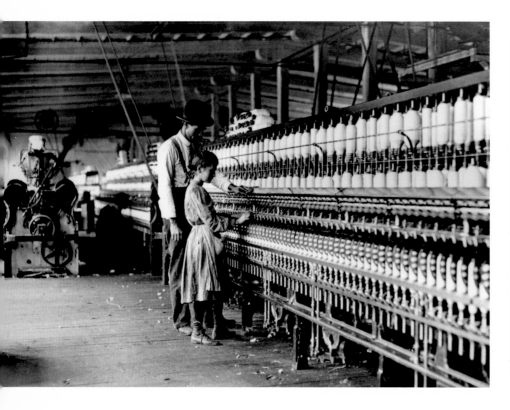

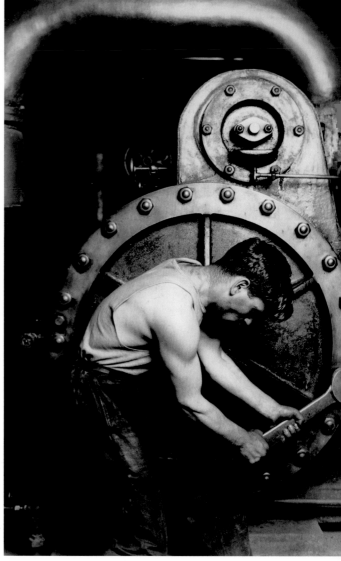

[FIG. 27]

Lewis W. Hine (1874–1940)

SPINNER AND FOREMAN IN A GEORGIA COTTON MILL

1908

[FIG. 28]

Lewis W. Hine (1874–1940)

POWERHOUSE MECHANIC

1925

[FIG. 29]

Chrysler

GEARS

1929

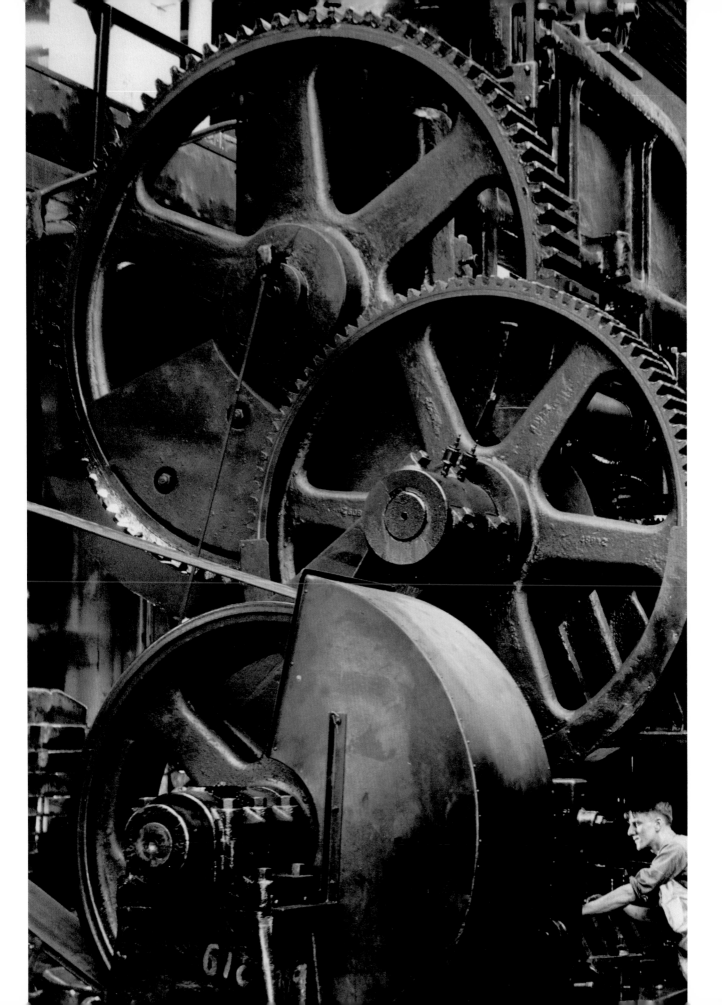

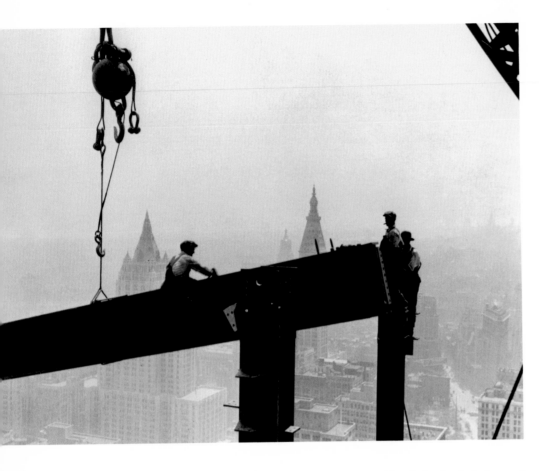

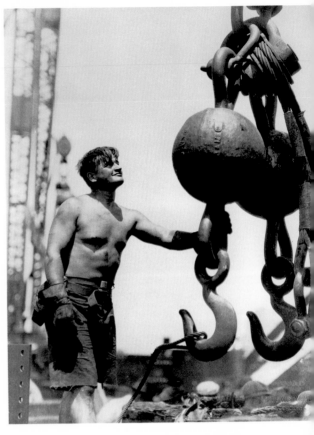

elements disguised her lack of technical control in a situation involving extreme contrasts of light and dark. She was also captivated by the subject itself, the process of making steel.

Working by day, Sheeler made immaculate prints of an ideal future. Two decades older than Bourke-White, he was far more experienced and artistically sophisticated. His interest lay not in the subject itself but in the design—whether of the subject or of the photograph. Sheeler's *Ford Plant: Criss-Crossed Conveyers*, 1927 (fig. 33), is a masterpiece of two-dimensional design and at the same time it is a faithful document of Ford's plant. In 1930 the Art Directors Club of New York City, promoting excellence in advertising and commercial photography, awarded Bourke-White a medal for one of her own photographs of Ford's River Rouge plant, and by the time she photographed *Boulder Dam: Construction* in 1935 (fig. 34), she had caught up with Sheeler in her weighting of the image, in favor of design over her personal response to the subject.[39]

By the spring of 1928 Bourke-White's images, like Sheeler's, were appearing in newspapers and magazines across the United States. People took notice. In October 1928 Roy Stryker, then a professor in the economics department at Columbia University, contacted her for permission to use some of her industrial photographs published by *Trade Winds*, a magazine of the Union Trust, in a textbook he was writing: "They are without doubt the finest set of industrial pictures I have ever seen and . . . wish to commend you upon your ability to capture the artistic in the factory."[40]

Early Corporate Commissions and the Advent of *Fortune*

From 1928 until 1936 Bourke-White supported herself through corporate and magazine assignments as well as advertising.[41] Edward Steichen, as chief photographer for the Condé Nast publishing empire, was a dominant force in this world from 1923. He enjoyed near celebrity status and commanded high prices for his photographs, which grew increasingly modernist—with sharp focus and stark contrasts of black and white, achieved through strong artificial lighting.[42] Bourke-White surely knew Steichen's work— after all, she loved fashion. His images may have influenced the drama of her own photographs, but her work for corporations did not allow her much artistic license. She often had to follow a

script specifying the desired shots, and as she later said: "If your subject is soup, it must out-soup any you ever dreamed of, with fragrant fumes rising straight from the film gelatin. If you photograph a rubber tire, it must look more like rubber than rubber itself. This became my specialty." Such work did not excite her, but she actively solicited the business, because it was an important source of income. Her magazine work was less lucrative but allowed for more abstraction, more compositional freedom, and more atmosphere.[43] Bourke-White tried to convince her corporate advertising clients of the power of modern design and elegant composition in presenting mundane industrial subjects in a positive light, but unlike Stieglitz, with his commitment to art for art's sake, Bourke-White accepted the

[FIG. 32]

Charles Sheeler (1883–1965)

Ford Plant

OPEN HEARTH,
LADLE HOOKS

1927

[FIG. 33]

Charles Sheeler (1883–1965)

Ford Plant

CRISS-CROSSED
CONVEYORS

1927

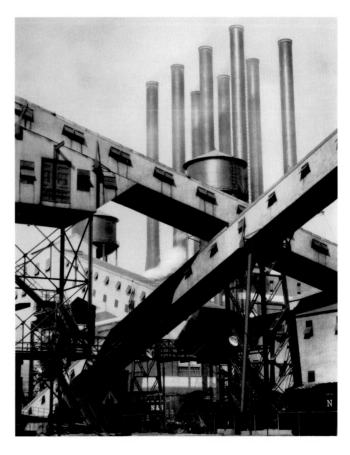

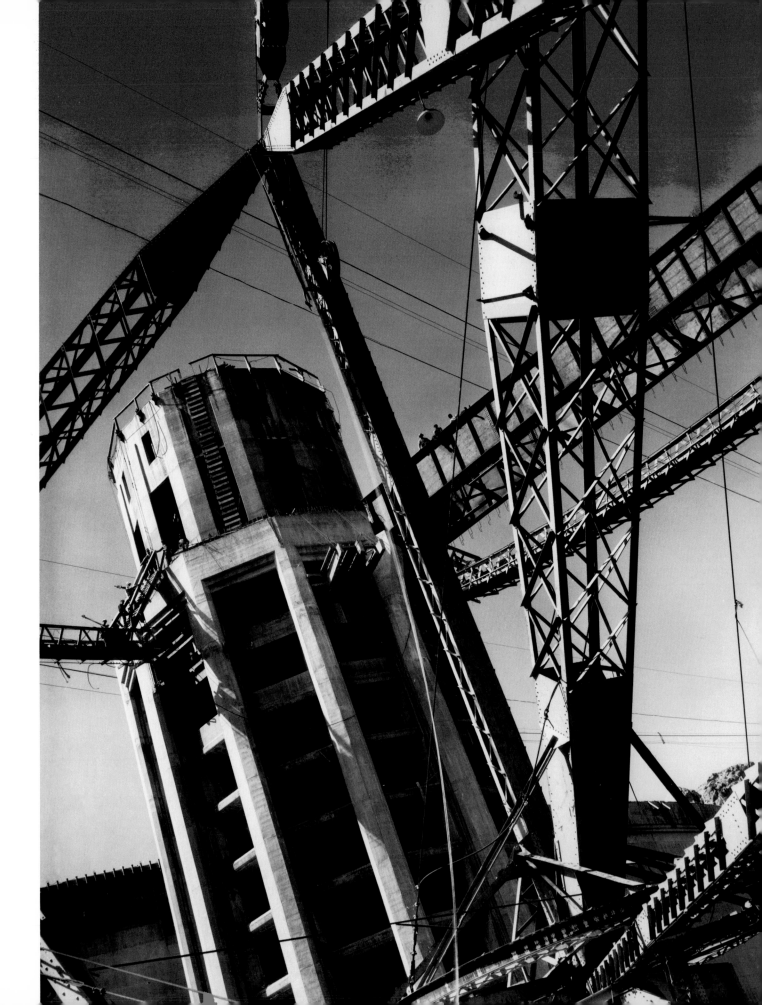

primacy of her clients' demands and made it a priority to meet them.

Unconstrained, however, she created forceful images. She understood the drama of the diagonal and the curve. She framed many of her photographs so that similarly shaped forms appeared repeatedly on a diagonal across the field of view and seemed to continue into infinite space beyond. Although she often shot her subject from a distance, she also, and more potently, brought the camera up close and filled the picture plane. She might single out individual objects, machine parts, architectural elements, or people. Yet she treated people no differently than inanimate objects at this stage in her career. In the cinematic *Ford Motor: Open Hearth Mill*, 1929 (fig. 35), for Ford Motor Company, the silhouetted worker appears as a humble worshiper at the shrine of the massive machinery. In *Oliver Chilled Plow: Plow Blades*, 1930 (fig. 36), a close-up of the shiny steel surfaces verges on complete abstraction. In *Cleveland Trust: Stairs*, ca. 1929 (fig. 37), an interior view of the Cleveland Trust Company building, Bourke-White used intense crosslighting to define a composition of opposing lines and transition points, in a reprise of Clarence H. White's compositional grillwork exercise. Inside the Lincoln Electric Company factory in 1929 Bourke-White photographed *Lincoln Electric: Sparks* (fig. 38), with random arcs of light threaded against a dark background, devoid of context or a sense of scale. Several years later, in *International Harvester: Welding Parts*, 1933 (fig. 39), for International Harvester, a factory worker, backlit by a dramatic explosion of sparks, provides scale and narrative content for a story clearly centered on the machine.[44] After the triumph of the Otis

Steel photographs, Bourke-White was highly sought after by other steel companies. *Republic Steel: Pouring Steel*, 1929 (fig. 40), conveys the intense heat of the molten steel in an image of great abstraction.

Making a name for herself with these corporate commissions, Bourke-White came to the attention of Luce, publisher of *Time* magazine. In a twist of fate, her move to Cleveland may have accelerated this fruitful contact. Coincidentally, Cleveland's former mayor, Newton D. Baker, became a charter subscriber to *Time* in 1922 and gave the magazine important endorsement.[45] Luce's publishing venture was headquartered there from the summer of 1925 to the summer of 1927.[46] By the summer of 1927, when Bourke-White arrived in Cleveland, Luce had developed significant business relationships there and had frequent interactions with the city's chamber of commerce. There can be no doubt that Luce, who was not himself a visual person, was exposed to Bourke-White's work through his Cleveland connections and probably by seeing *The Clevelander*, a chamber of commerce publication, and *Trade Winds*.[47]

Luce's plan was to use photography to document all aspects of business and industry, an idea that had never been tried before. In some ways Bourke-White's career is unimaginable without her symbiotic relationship with Luce's media empire. Her swashbuckling style, her ingenious and relentless self-promotion in an age that admired self-made men and their fortunes, her reverence for industry itself, and her photographic homages to capitalism and technology made her the perfect lens for Luce's vision. Additionally, Luce's magazines—*Time, Life*, and to some extent

[FIG. 34]

Boulder Dam

CONSTRUCTION

1935

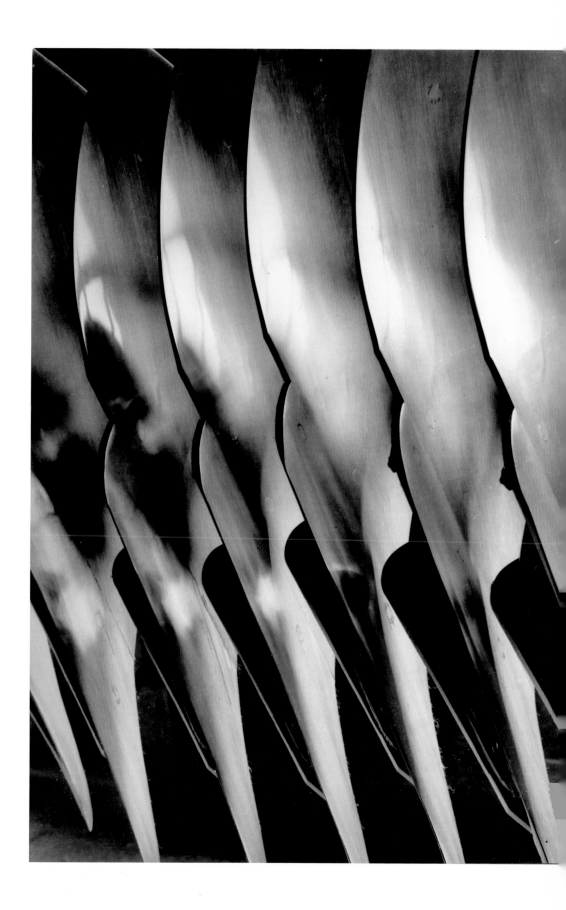

[FIG. 35]

Ford Motor

OPEN HEARTH MILL

1929

[FIG. 36]

Oliver Chilled Plow

PLOW BLADES

1930

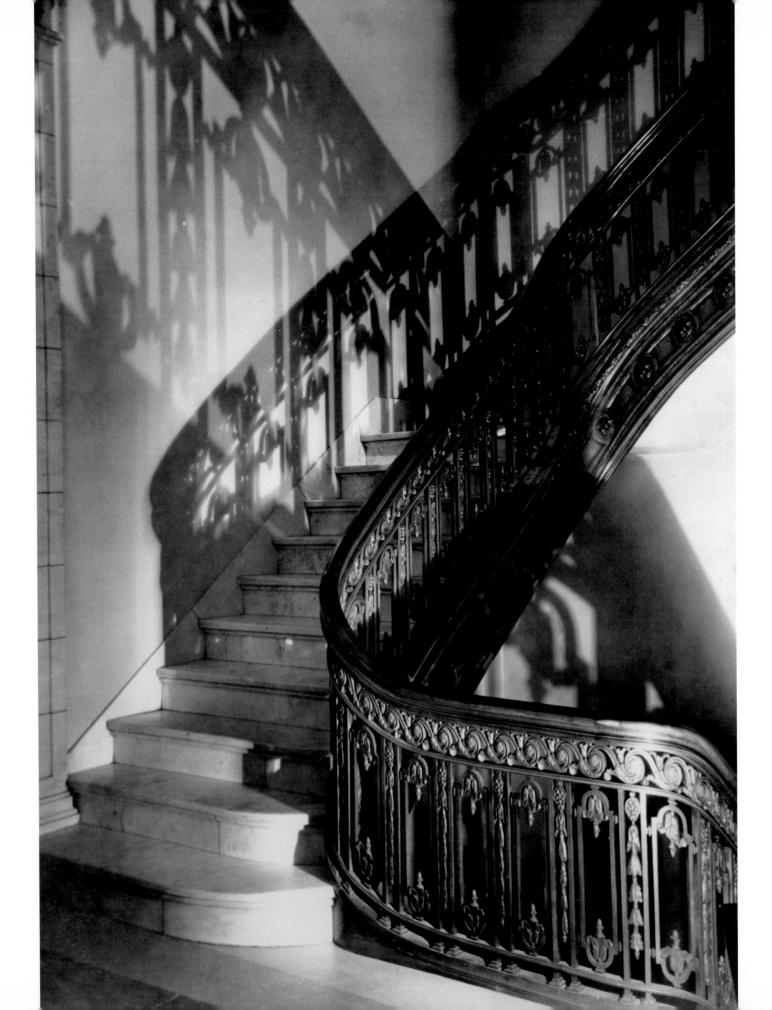

Fortune—ultimately spawned personality journalism, and Bourke-White was nothing if not a personality. She worked hard at it, knowing she needed to cultivate a look and a persona, as did Georgia O'Keeffe, a contemporary in the Dow and Stieglitz artistic lineage. Part of this understanding was innate, and part of it stemmed from difficulties that confronted any ambitious woman in a public sphere at that time. When Luce invited her to join the staff of his new *Fortune* magazine in 1929, he told her she would be the "star photographer."[48] He was offering her national and even international exposure for her work. A month before the stock market crashed, a prototype layout of the publication heavily promoted her role. In fact, she was the only photographer credited, with captions such as "The Photographer: Margaret Bourke-White of *Fortune*'s staff, now touring the U.S." Luce went forward with preparations for the first issue of his magazine in spite of Wall Street's troubles; he reasoned, rightly, that people would be interested in business more than ever. *Fortune* had a small circulation, but it survived the Depression.[49]

By the time Bourke-White came to Luce's attention, she had already had considerable contact with precisely the people who would read and be featured in *Fortune*. It was a luxury publication with beautiful production values, including expensive paper, color advertisements and features, and hand stitching. It covered businesses, industries, tycoons, as well as modern design, architecture, and art. It cost one dollar per issue, many times the price of a newspaper, and had thirty thousand subscribers. There was nothing like it at the time. *Fortune*'s readers were rich, they were business leaders, and more than half of them were in the Social Register.[50] That there

were no complimentary copies puts the price of the magazine in perspective. Bourke-White herself received only a courtesy discount of fifty percent.[51]

Once her contract was signed, Bourke-White began working part-time to generate a portfolio of photographic material for future issues. She was making $25,000 a year from corporate commissions at this time, which explained why she chose to work only part-time for Luce.[52] For her earliest assignments she traveled to Lynn, Massachusetts, to document shoemaking; Corning, New York, to shoot glassmaking; and New London, Connecticut, to explore fisheries. She soon learned that the key to successful magazine work was to record "the unseen half" of a story.[53] Previously, she had sought to make interesting and beautiful pictures. Now she was conscious of the part each image could play in a photographic narrative. She took a variety of shots for each assignment.

Without any critical feedback, Bourke-White continued to work on faith and her ample self-confidence through the fall of 1929. With numerous stories in production, Luce still had not found the right one for his inaugural issue. He wanted to highlight an industry that was basic to the American economy, and one that readers would not readily see as appealing. After much debate, he decided to feature the Chicago stockyard— more specifically, hog processing at the Swift meatpacking plant. Bourke-White undertook the assignment with imagination and a strong stomach. In *Swift: Hogs Hanging*, 1929 (fig. 41), she used a benign repetition of form to present the rather gruesome subject of dead animals hung from their hind legs. In *Swift: Mountains of Pig Dust*, 1929 (fig. 42), she captured the exquisite topography of great mounds of ground-up body parts stored

[FIG. 37]

Cleveland Trust

STAIRS

ca. 1929

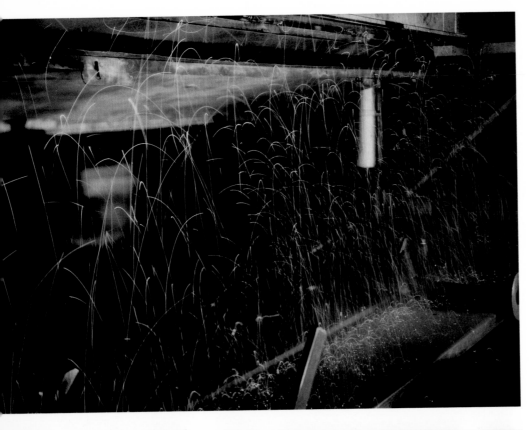

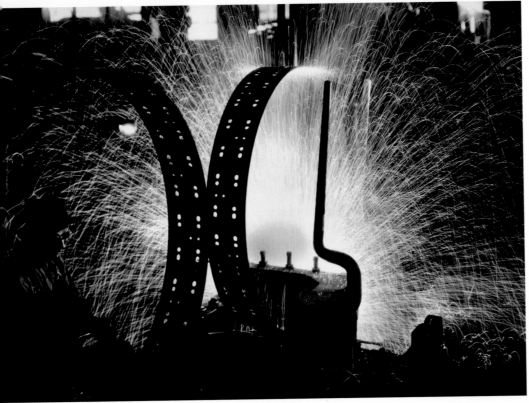

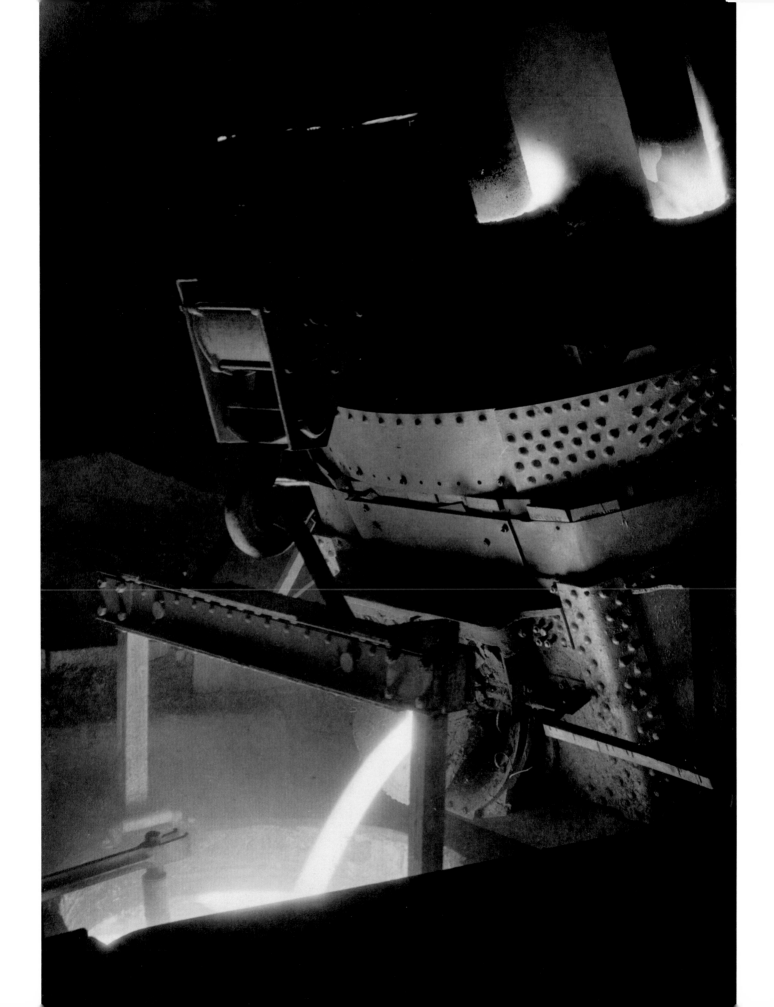

44

Departing from *Time*'s policy of not identifying
journalists, Luce credited Bourke-White (and only
her) in his new magazine, because she was an asset,
a marketable commodity who would draw sub-
scribers. Thus *Fortune* traded on her celebrity and
ultimately spread her reputation around the globe.[55]

Among her early assignments at *Fortune*,
some photographs reveal her tried-and-true
approach to industry, such as *Great Lakes: Coal
Rig*, 1929 (fig. 43), with its dramatic silhouette of
machinery against the evening sky. The caption
Bourke-White gave this moody photograph when
she used it as an illustration in her autobiography
likened the coal rig to a dinosaur rising on the
shore of Lake Superior.[56] The picture also serves
as a reminder that her major interests, other than
photography, lay in natural history, particularly
insects and reptiles. It shows her almost cinematic
knack for expressing the simultaneously gigantic
and romantic aspects of industry.

Other projects inspired more inventive
solutions. At the Elgin Watch factory she was
"enchanted by the exquisite shapes of minute
watch parts."[57] In a composition of allover pat-
terning, her *Elgin: Watch Parts*, 1929 (fig. 44),
shows hundreds of circular objects strewn across
the picture plane in a random way, with intense
lighting that catches the shiny surfaces at different
angles to display a wide range of tonal variation.
An example of Bourke-White's use of Dow's com-
positional theory of pattern, the mass of small
manufacturing components seems to stretch on
forever in the absence of spatial context. The eye
wanders restlessly over the composition, which has
no top or bottom and no center, and which seems
to be an excerpt from something very much larger.

[FIG. 41]
Swift
HOGS HANGING
1929

in a large warehouse before being mixed into
livestock feed. This image gives no hint of the
stench, which so permeated the cloth camera
cover and light cords that the equipment had to
be left behind.[54] Instead, she revealed an unlikely
beauty in this unglamorous industry. It was
exactly what Luce had in mind, and he used these
photographs for the lead story in his first issue
of *Fortune*, which appeared in February 1930 and

This was, indeed, the point of Bourke-White's industrial photographs. In *Singer Sewing Machine: Wood*, 1929, and *Phelps Dodge Copper: Pipes*, 1932 (figs. 45–46), again she isolated parts to stand for the larger whole, creating two classically modern images that focus on design elements rather than on a definite image of the objects themselves.

Bourke-White lived in Cleveland until 1930 and commuted to her assignments for *Fortune* and other clients. But after documenting the construction of the Chrysler Building for the Chrysler Corporation in 1929–1930,[58] she transferred her base of operations to New York City. Securing a studio in the Chrysler Building proved a challenge for the attractive, twenty-six-year-old woman: the building manager assumed she would soon get married, give up her business, and leave with the rent unpaid. Backed by *Fortune*, however, she signed a lease on 7 October 1930 for room 6109, which cost $387.92 per month plus electricity. This was expensive, but it gave her one of the most desirable addresses in the city.[59] And on her considerable earnings at the time, the rent should have been within her means. She hired her good friend John Vassos to create a stylish interior that was simple but elegant, with extensive curves and built-ins, a subdued palette, and wood and aluminum accents. Light fixtures were made of frosted glass and brushed aluminum, and much of the furniture was covered in tan or pale green artificial leather.[60] When the studio was finished in early 1931, it epitomized industrial chic, as seen in *Stairs to Terrace*, in *View of Desk*, and in *Main Sitting Area*, all 1931 (figs. 47–49). Along with her fame, her upscale new address gave her entrée into high society. Although her lease denied her access to the terraces, she used them extensively

to entertain friends and clients and to house an unusual menagerie of reptiles.[61]

In New York she hired darkroom technicians to print her photographs to her exacting standards. She relied increasingly on the technical expertise of employees like Oscar Graubner to realize her vision, providing the tonal subtleties that make her photographs so extraordinary. In fact, she began to run the Bourke-White Studio

[FIG. 42]

Swift

MOUNTAINS OF PIG DUST

1929

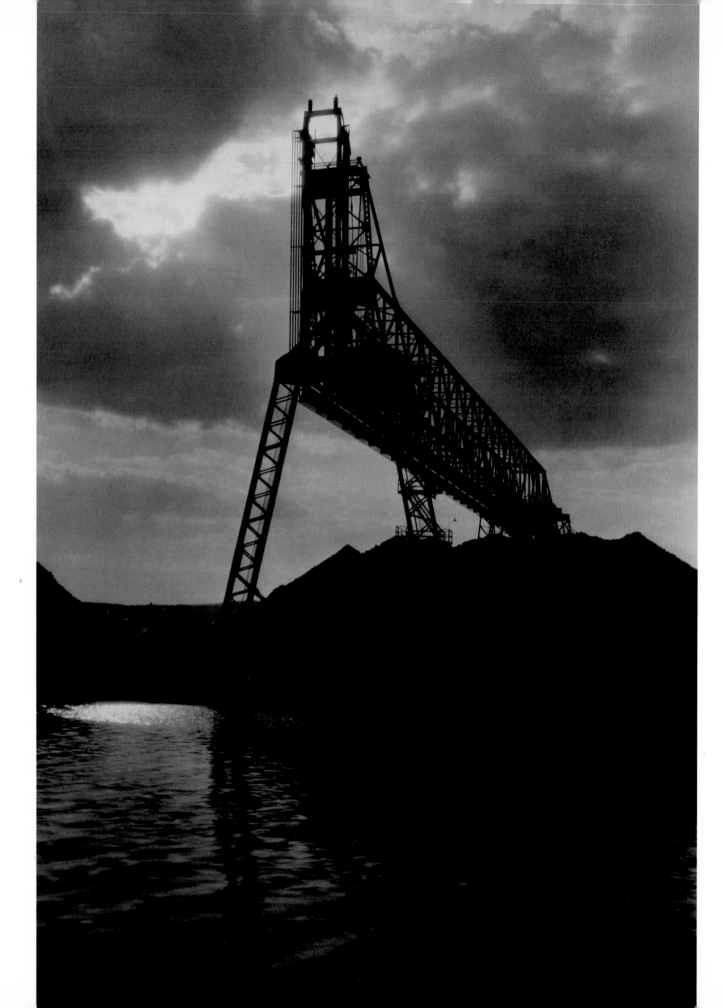

[FIG. 43]

Great Lakes

COAL RIG

1929

[FIG. 44]

Elgin

WATCH PARTS

1929

[FIG. 45]

Singer Sewing Machine

WOOD

1929

[FIG. 46]

Phelps Dodge Copper

PIPES

1932

like a small corporation, with her focus devoted to creating opportunities and generating business while she delegated the drudgery to a staff of assistants. She would put off paying a bill rather than fire an employee, thinking that to lose staff members would diminish her power and the importance of her studio. From the outset of her career, Bourke-White displayed considerable business acumen. She saw and seized opportunities and markets, and she understood the importance of image to the success of her endeavors. Her ability to generate an impressive income was not in doubt, but she was less secure in her capacity to manage money and was often in debt because of a lack of fiscal discipline.[62]

VIEWS FROM THE USSR

In the summer of 1930 Bourke-White embarked on an assignment that would change her life. *Fortune* sent her to Germany on the SS *Bremen*, the fastest ship on the transatlantic route. This was her first trip to Europe, and the magazine's editors wanted her to turn her camera on German industry.[63] She approached her subjects there the same way she did in the United States, emphasizing design and composition. *AEG: Man Working on Generator*, 1930 (fig. 50), taken at AEG (Allgemeine Elektrizitäts-Gesellschaft, Germany's famous equivalent to General Electric), is divided diagonally into two zones, with a workman in the upper left and a fan-shaped section of a generator filling

[FIG. 47]

Chrysler Building:
Margaret Bourke-White's Studio

STAIRS TO TERRACE

1931

[FIG. 48]

Chrysler Building:
Margaret Bourke-White's Studio

VIEW OF DESK

1931

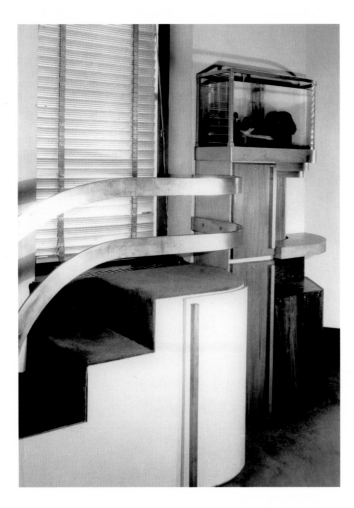

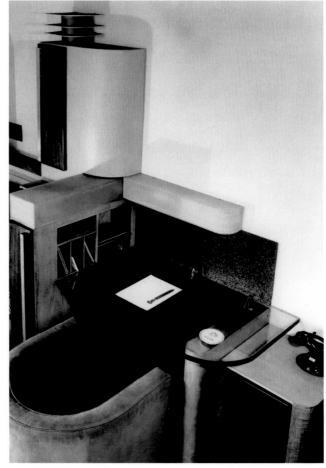

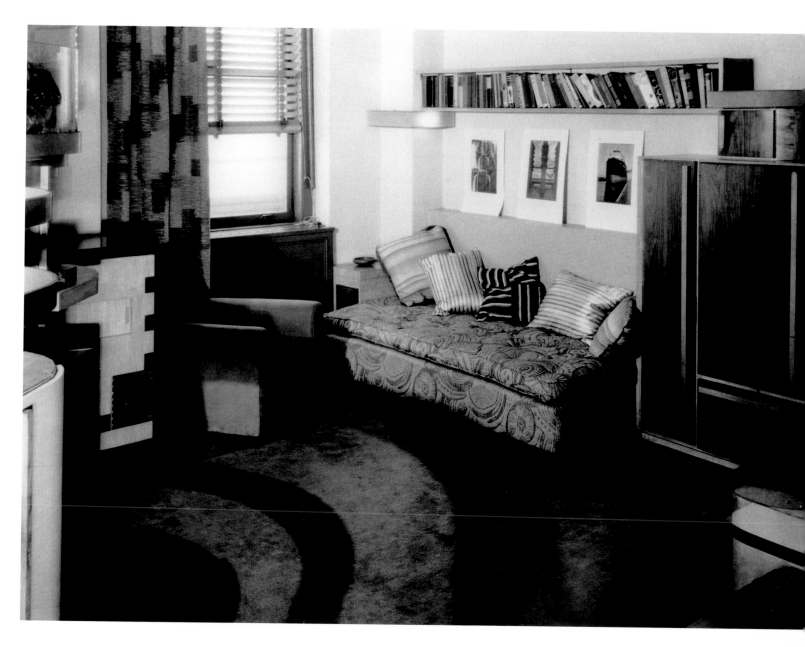

[FIG. 49]

Chrysler Building:
Margaret Bourke-White's Studio

MAIN SITTING AREA

1931

the lower two-thirds with an arc of almost pure pattern. *AEG: Men Working on Generator*, 1930 (fig. 51), is even more contrived, with the camera pointed through the circular opening in a generator to frame three men at work on the other side.

But Bourke-White cherished greater ambitions for this trip to Europe. The USSR had built more than fifteen hundred factories since 1928 under a rapid industrialization plan. Many Amer-

ican engineers served as advisors on these projects and traveled freely throughout the Soviet Union, but no foreign journalist had been allowed to document the country's progress.[64] This was just the challenge to inspire Bourke-White: "With my enthusiasm for the machine as an object of beauty, I felt the story of a nation trying to industrialize almost overnight was just cut out for me." In a bid to get a visa to the USSR, she called in many

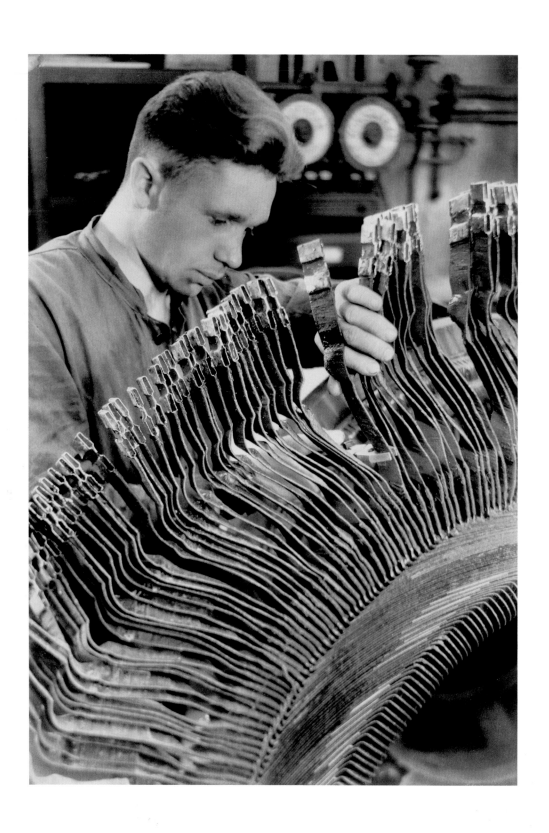

[FIG. 50]

AEG

MAN WORKING
ON GENERATOR

1930

[FIG. 51]

AEG

MEN WORKING
ON GENERATOR

1930

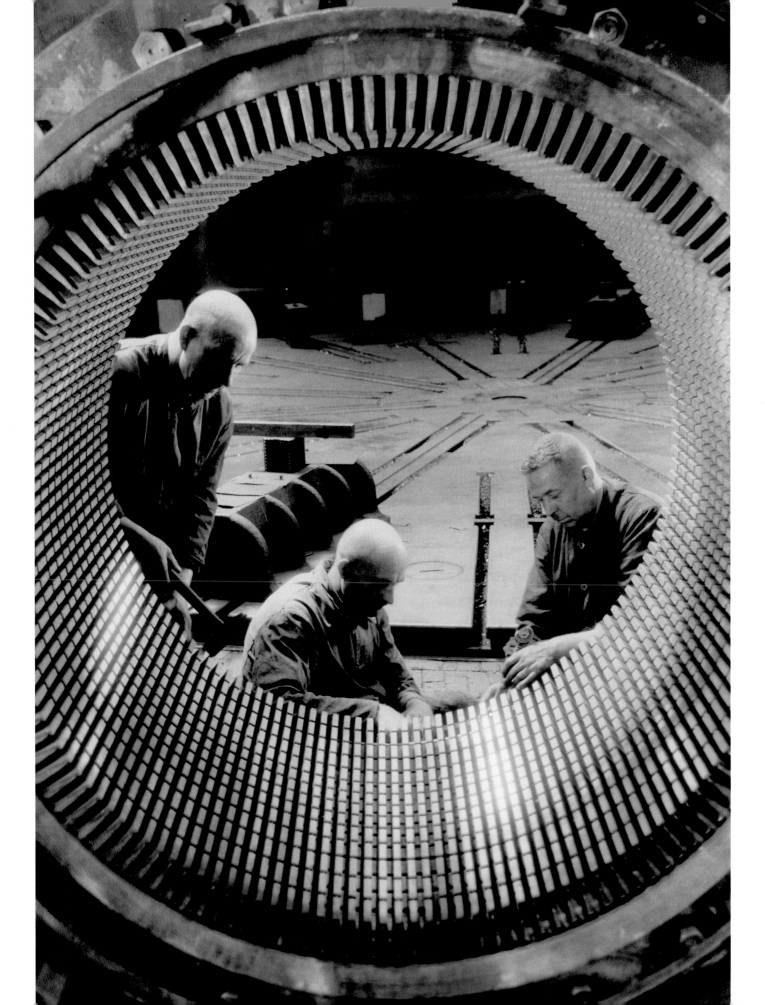

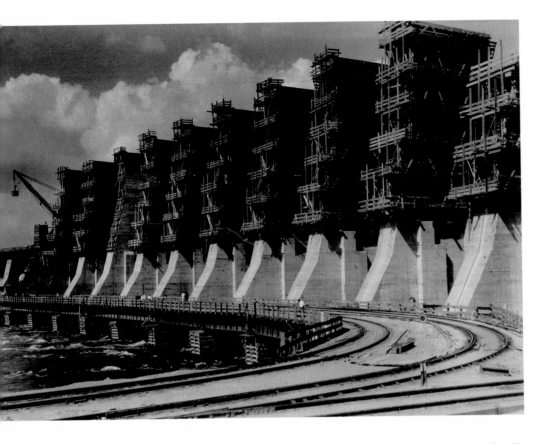

the building of the world's largest dam, which was being overseen by an American.[67] In *USSR: Dneprostroi, Dam Construction*, 1930 (fig. 52), Bourke-White's skillful design captures the brute nature of the gigantic project. The curving railroad tracks lead the eye into the image, where the wood scaffolding establishes a pattern of parallel and perpendicular lines that only ends far in the distance with the oblique, upraised arm of an enormous crane. *USSR: Moscow, Ballet School, Dancers*, 1931 (fig. 53), shows in design shorthand how the industrialization of the Soviet Union was incorporated into all aspects of life. Here, ballet students practice a machine dance, their arms locked as they move in unison.[68]

For the newly industrialized USSR, with its agricultural roots, the tractor was the ultimate machine. Bourke-White saw a certain naiveté and "machine worship" in the Soviet workers she met—farmers who had only recently been relocated to factories: "The tractor was the object of special reverence, but still the tractor operators ran them up and down the fields like racing cars until they broke."[69] One might say, in light of history, that there was a certain naiveté in Bourke-White's take on the Soviet Union, too. *USSR: State Farms, Tractor and Workers in Field*, 1930 (fig. 54), a romantic image with an expansive sky filling more than three-quarters of the picture, could be a Soviet propaganda photograph. Near the center of a low horizon line looms the imposing silhouette of a tractor, while off to one side stand the static figures of a man and woman. *USSR: Verblud, An American Disc-Harrow*, 1930 (fig. 55), makes an interesting counterpoint to Bourke-White's contemporary signature close-up of *Oliver Chilled Plow: Plow Blades*, 1930 (fig. 36, p. 39) in

[FIG. 52]

USSR: Dneprostroi

DAM CONSTRUCTION

1930

[FIG. 53]

USSR: Moscow

BALLET SCHOOL, DANCERS

1931

favors and waited weeks with no answer. Finally on her last day in Germany, she received word that her trip was approved.[65]

Arriving in the USSR, with permission to take photographs only around Moscow, she petitioned the Commissariats of Heavy Industry and Railroads for permission to tour the country and photograph the industrial areas. Eventually her patience and persistence paid off, and she was able to journey across the USSR, accompanied by an interpreter. She won the respect of her Soviet hosts, who believed that artists—especially photographers—had the power "to stir the imagination of the people with the grandeur of the industrial program."[66] The Soviet photographs covered a number of aspects of work and life in the Soviet Union, from construction to ballet. On her visit to Dneprostroi she photographed

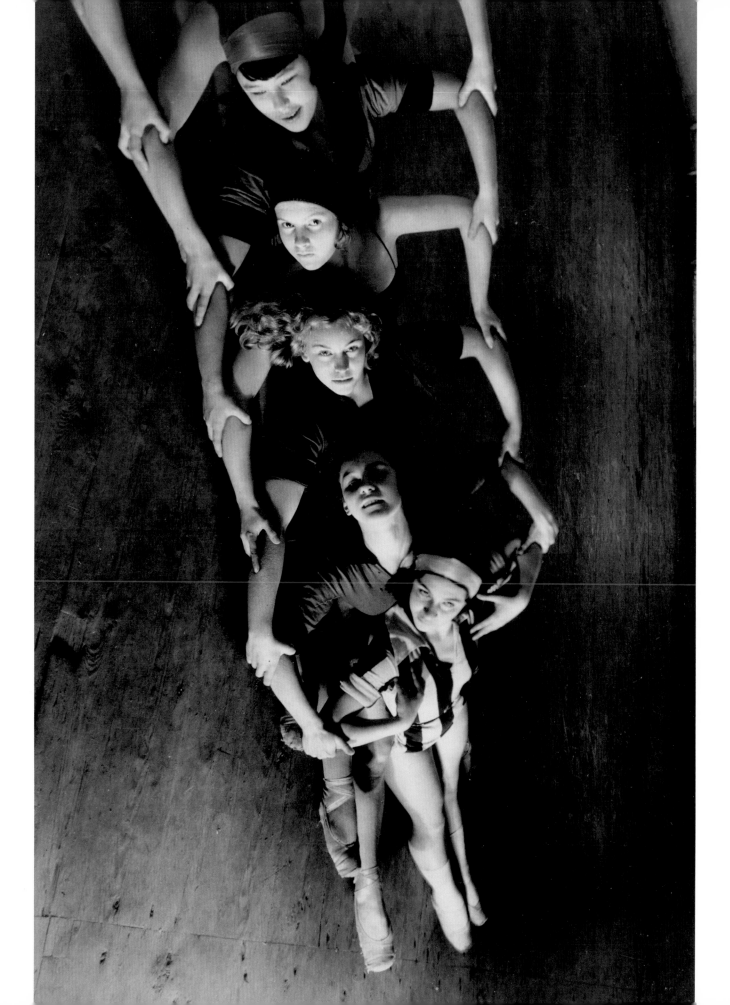

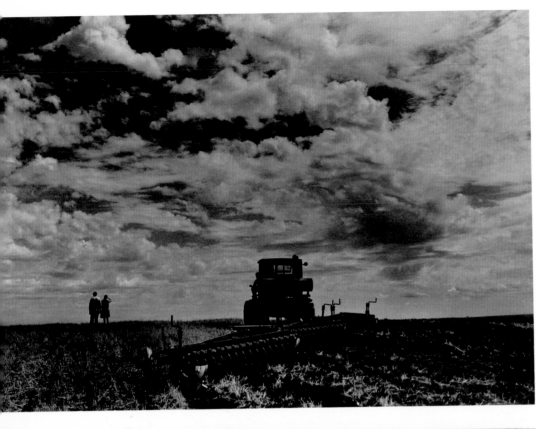

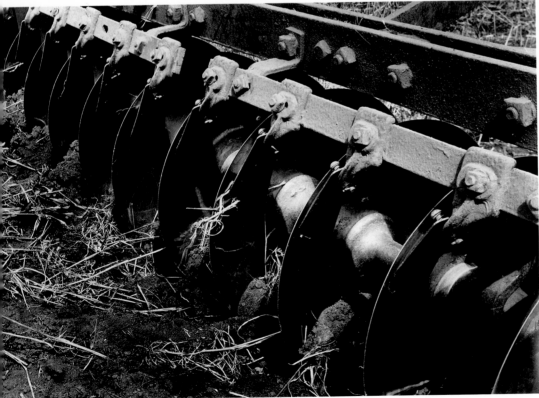

[FIG. 54]

USSR: State Farms

TRACTOR AND WORKERS IN FIELD

1930

[FIG. 55]

USSR: Verblud

AN AMERICAN DISC-HARROW

1930

[FIG. 56]

USSR: Stalingrad

END OF THE TRACTOR LINE

1930

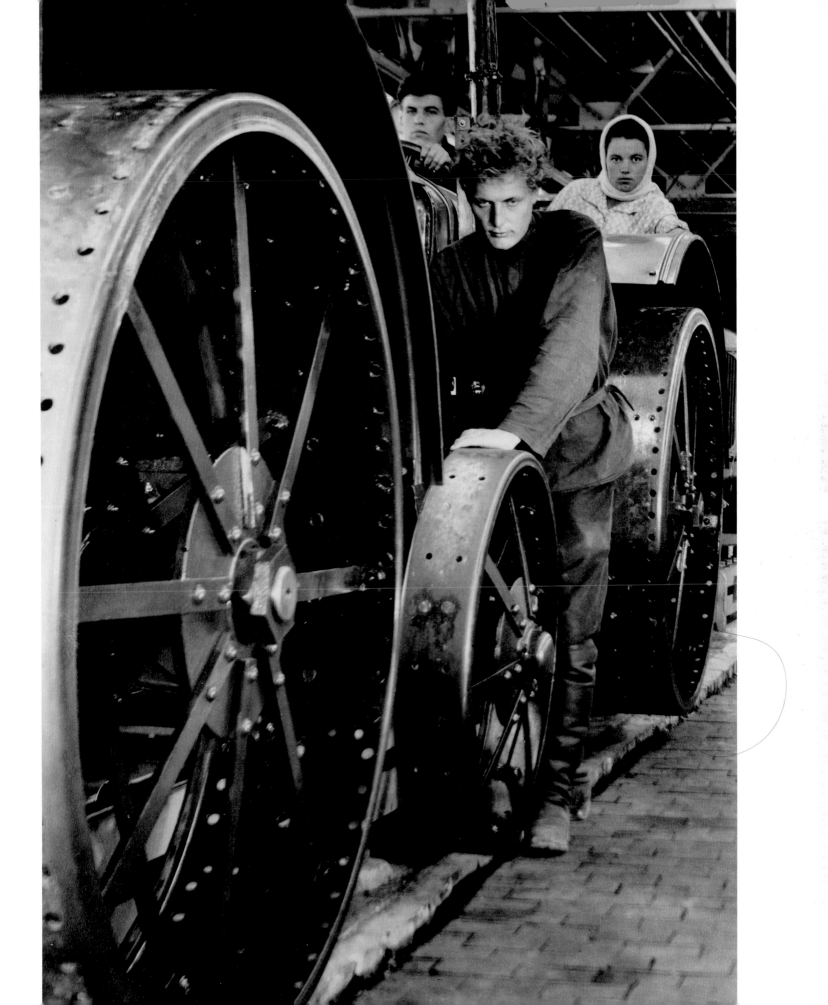

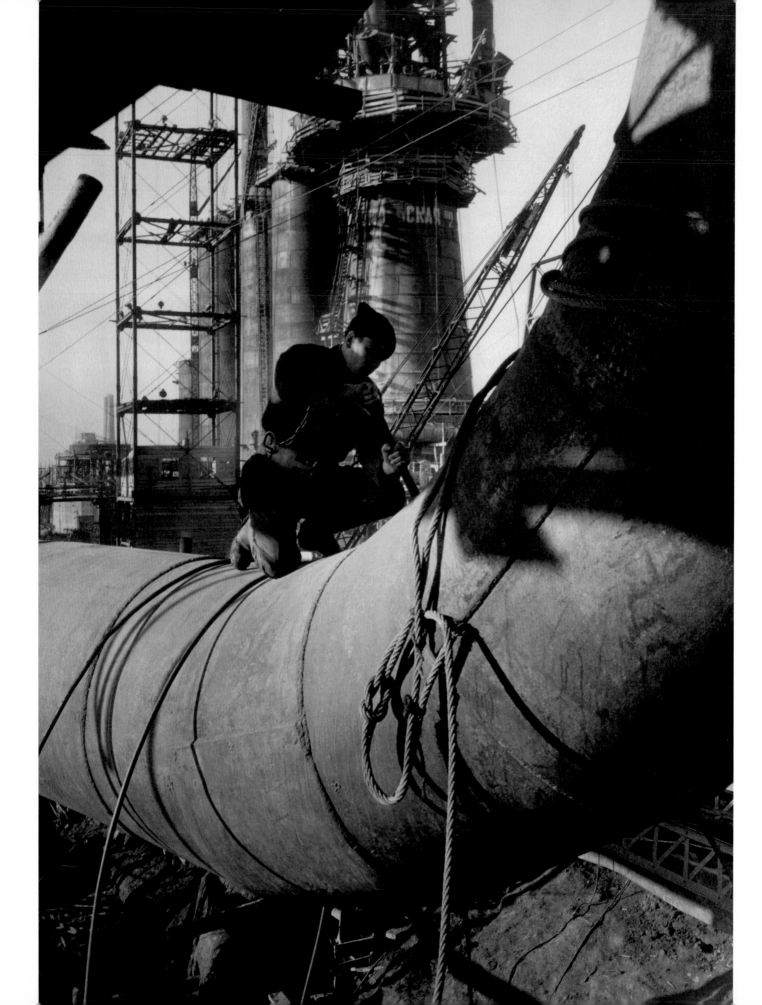

which she highlighted design and composition more than subject matter. Her Soviet image differs significantly in its incorporation of context and, thus, in its emphasis. In fact, the photographs from the USSR are overwhelmingly narrative and should be seen as an important stage in Bourke-White's development as a photojournalist.

With its rhythmic design, *USSR: Stalingrad, End of the Tractor Line*, 1930 (fig. 56), is one of the most famous images from this trip. Like many of her contemporaries, Bourke-White saw the new Soviet Union through an optimistic lens. This photograph can be seen as promoting the notion of proletarian heroism: three beautiful workers carefully positioned with the one in the foreground pointlessly straining in an artistic, unproductive pose amid the gleaming wheels. The picture could have been taken from the socialist realist art of the day. Today the image strikes the observer as poignantly emblematic of the subordination of human beings to the Soviet state, in much the same way as Bourke-White's American workers seem to be servants of the assembly line.

As the Depression grew in severity, many Americans looked to the USSR with fascination and hope for the future. When Bourke-White returned to the United States, she was considered something of an expert on the Soviet Union. *Fortune* published some of her images in its February 1931 issue, and she published a book, *Eyes on Russia*, illustrated with her photographs, the same year. These experiences and publications made her even more of a celebrity, and she started to give lectures across the country as well as radio interviews and product endorsements.[70]

Bourke-White's warm reception in the United States prompted the Soviet government to invite

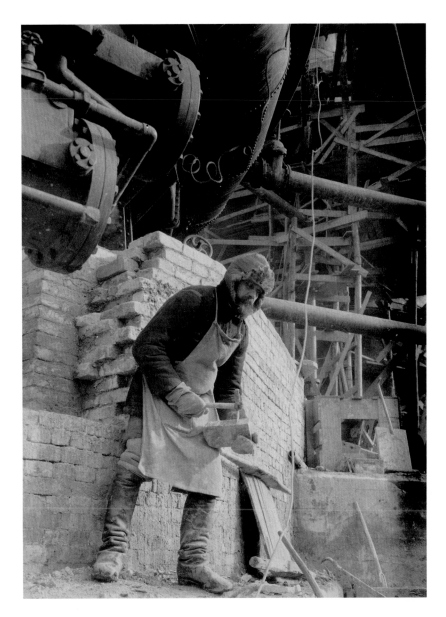

her back in 1931. The photographs from her second trip are more focused on human subjects.[71] *USSR: Magnitogorsk, Blast Furnace Construction Worker*, 1931 (fig. 57), resembles her earlier photographs, with its emphasis on design. The workman here is subordinate to the large pipe that gives the image its dramatic impact. But in *USSR: Magnitogorsk, Worker Laying Bricks*, 1931 (fig. 58), the man is not simply a compositional element. His figure is shown in full, not cut off

[FIG. 57]

USSR: Magnitogorsk

BLAST FURNACE
CONSTRUCTION WORKER

1931

[FIG. 58]

USSR: Magnitogorsk

WORKER LAYING BRICKS

1931

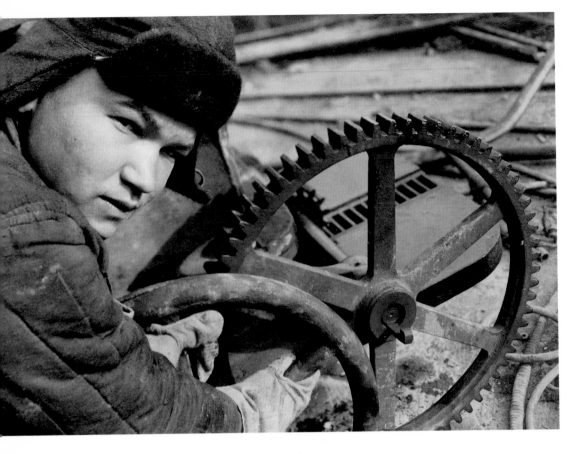

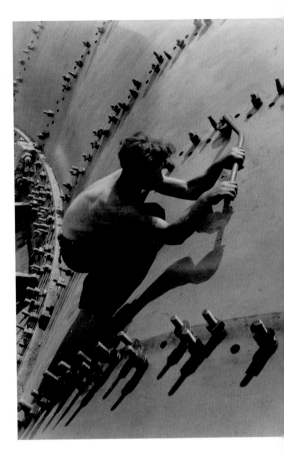

[FIG. 59]

USSR: Magnitogorsk

BOY AT GEAR WHEEL

1931

[FIG. 60]

USSR: Dneprostroi

MAN ON TURBINE SHELL

1930

at the edges. He does not appear stiff or posed. Rather, he looks as if his labor has been momentarily interrupted. *USSR: Magnitogorsk, Boy at Gear Wheel*, 1931 (fig. 59), gives an intimate close-up of a boy's face as he turns to look directly at the camera. A year earlier, in *USSR: Dneprostroi, Man on Turbine Shell*, 1930 (fig. 60), she posed the worker in such a way as to seem small and insignificant against the gigantic turbine shell, which seems to stretch on forever.[72]

In 1932 Bourke-White returned to the Soviet Union again, this time with a movie camera. But her skill as a photographer did not translate into moving pictures, and she abandoned the medium: "I composed each scene with lengthy care and took innumerable static views, forgetting that the important work in motion pictures is motion."[73]

On this third trip to the USSR she decided to visit some of the rural areas of the country. In Baku she saw the oil fields and created the stunning image *USSR: Baku, Man with Donkey at Oil Wells*, 1932 (fig. 61), in which a peasant and his beast of burden stand before towering symbols of a new, industrialized world. The figures of the man and his donkey, who have stopped on the path to pose for the photographer, align with the oil wells behind them, while their reflections in the water are almost indistinguishable from those of the background structures. In the same year Luce spent twelve days in the Soviet Union, which he found "a thoroughly disgusting place." He was an important opinion maker, thus his reactions were interesting and influential. The three thousand words he wrote on his impressions

of the Soviet Union were intended as a guide for his editors and as "a slight corrective of the focus" of Bourke-White's "great performance" in her *Fortune* article of the previous year.[74]

AWAKENING

In the 1920s Bourke-White was not very socially and politically aware. What mattered to her were the men in power in the industrial world.[75] One of her early advertising shots gives a telling insight into her attitude toward people as subjects. The Higbee Company, a department store in Cleveland, had commissioned her to photograph a number of products, including items in their children's department. For *Higbee Department Store: Toys*, 1929 (fig. 62), she placed a series of miniature cars and trucks in the background and a confrontation between toy cowboys and Indians in the foreground; in the middle she staged nine dolls, which were arranged stiffly with their arms slightly bent at their sides. Their seemingly casual positions—the toy dogs interspersed among them, the sideward glances from a few of their eyes—all give the photograph a surreal quality, as if the dolls might be real children. Bourke-White portrayed these dolls with more human definition than the workers in many of her early photographs.

[FIG. 61]

USSR: Baku

MAN WITH DONKEY
AT OIL WELLS

1932

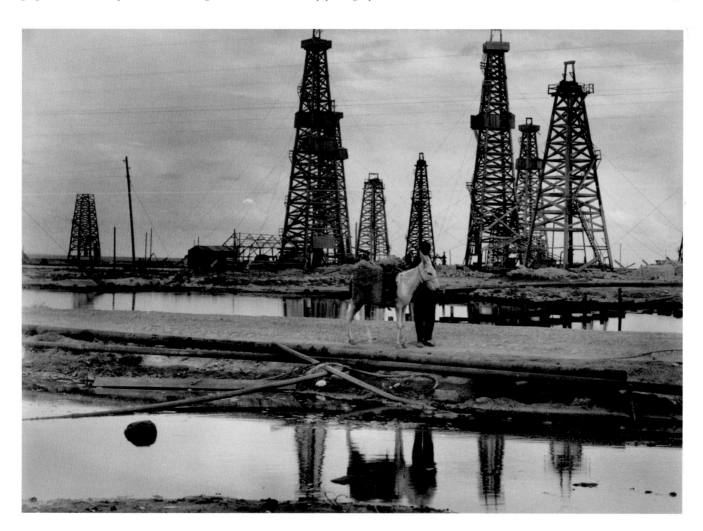

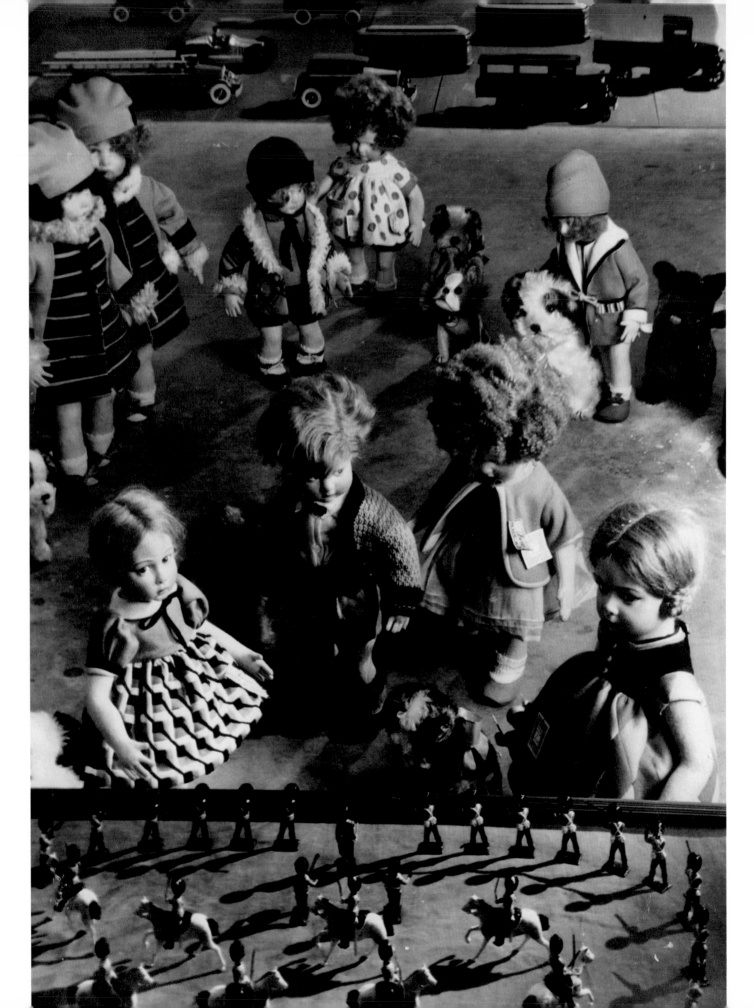

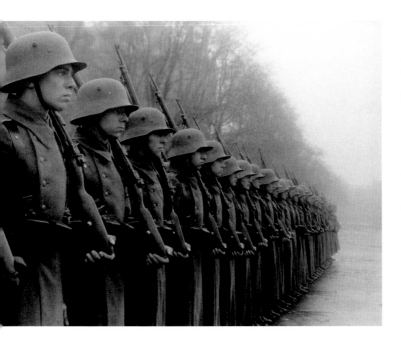

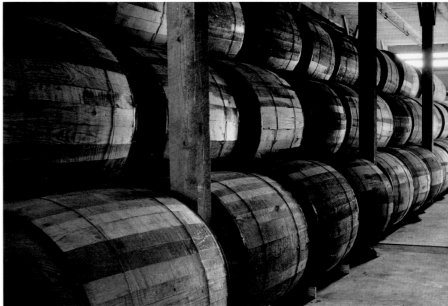

Usually the people in these early images make no eye contact with the camera. Treated as mere objects or design elements, they communicate scant human emotion. Compare *German Army: Soldiers*, 1932, and *Chesterfield Cigarette: Barrels*, early 1930s (figs. 63–64), for instance. One photograph documents the remilitarization of the German army in the early 1930s. But the soldiers standing at attention, guns on their shoulders, look as stiff and still as the wooden barrels in a warehouse. Both are photographed on a marked diagonal and derive the same compositional strength from this device. For *Retsof Salt Mine: Miner Drilling*, 1930 (fig. 65), Bourke-White directed two workmen to stand in line with one another and hold their drills in parallel positions. She aggressively illuminated the underground space and persuaded the workers to stand still for a long exposure, which resulted in a dramatic, detailed image. But the miners are just as artificially posed as the dolls at Higbee's department store. For *Flintkote: Man Adjusting Machine*,

1935 (fig. 66), she placed the worker at an angle to the camera; he bends slightly forward, his arm held at a right angle. It is a handsome pose, but it would not have allowed the man to operate the heavy papermaking machinery. For *Chesterfield Cigarette: Barrel Makers*, early 1930s (fig. 67), she instructed three men to take workmanlike poses, the one at the left in the most awkward and forced position. The photograph, though compositionally quite beautiful, with the barrel interior forming a circular frame around three figures cast in strong light, makes the subjects look like puppets or mannequins.

Occasionally the workers in Bourke-White's early photographs are better integrated with the activities portrayed. In shots of Campbell Soup's workers, such as *Campbell Soup: Peeling Onions* or *Campbell Soup: Cleaning Mushrooms*, both 1935 (figs. 68–69), the women seem unaware of the camera and concentrate on their jobs. The primary appeal of the images still derives not from the human subjects but from the compositional

[FIG. 62]

Higbee Department Store

TOYS 61

1929

[FIG. 63]

German Army

SOLDIERS

1932

[FIG. 64]

Chesterfield Cigarette

BARRELS

early 1930s

ROMANCING THE MACHINE

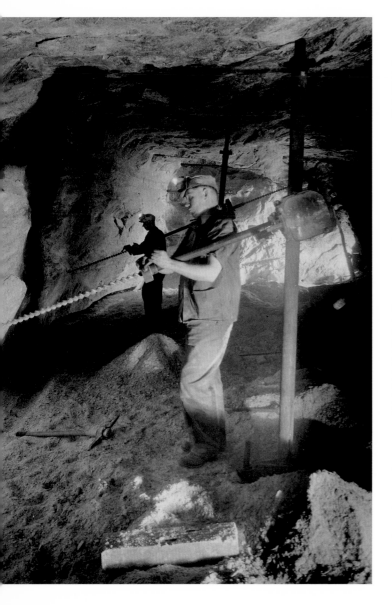

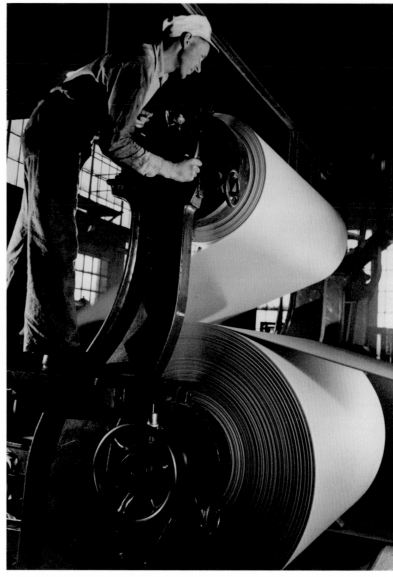

[FIG. 65]

Retsof Salt Mine

MINER DRILLING

1930

[FIG. 66]

Flintkote

MAN ADJUSTING MACHINE

1935

[FIG. 67]

Chesterfield Cigarette

BARREL MAKERS

early 1930s

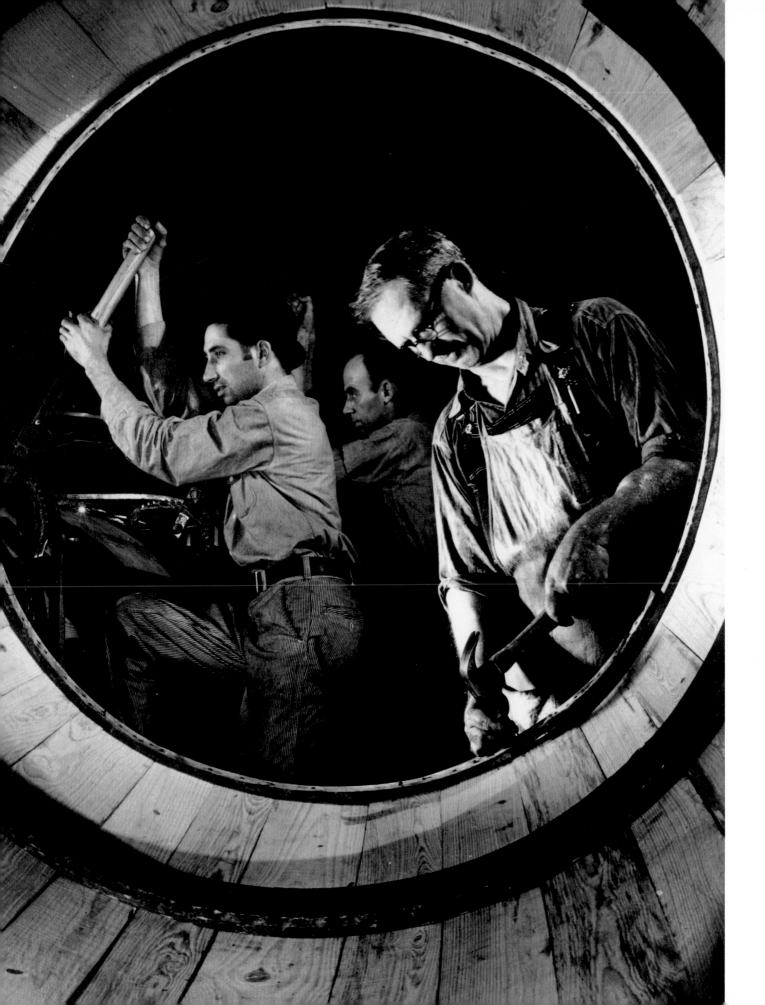

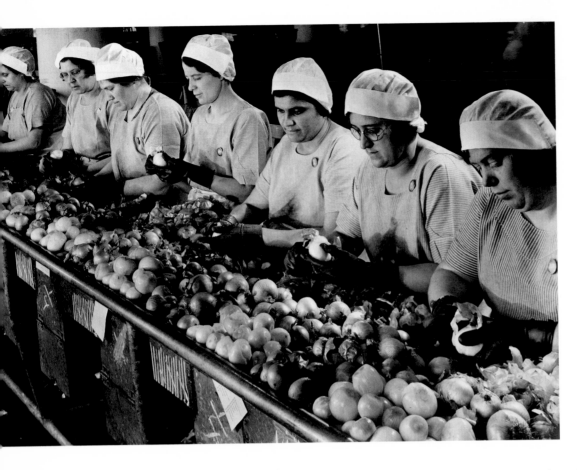

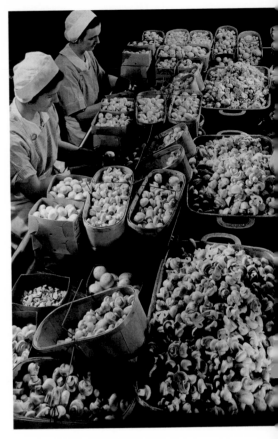

[FIG. 68]

Campbell Soup

PEELING ONIONS

1935

[FIG. 69]

Campbell Soup

CLEANING MUSHROOMS

1935

design—from the insistent diagonal of the work-table in the former, and the endless baskets of mushrooms in the latter—which also conveys the monotony of the women's tasks. For another assignment, commissioned by Armour Meats, Bourke-White shot *Armour: Making Red Hots*, 1934 (fig. 70), with three women looking intently down at a table covered with link sausage. All three photographs add a sympathetically humor-ous element not found in most of Bourke-White's work: the Campbell Soup women are dressed to match their mushrooms and onions in little white caps, and the Armour women go at their tasks with robustly sausagelike arms.

Rarely does a workman look straight at Bourke-White's camera, as in *Lehigh Portland Cement: Man Pushing Bags*, 1930 (fig. 71). But here the frontal view and rectangular composi-tion give great immediacy to the encounter. The strong, cinematic illumination from the lower left emphasizes the modeling of the man's face and upper torso as they emerge from the darkness; it also unifies the image so that creases in the bags look almost like folds in the shirt. The man's position seems unnatural—with his arm bent back at a ninety-degree angle and his upper arm parallel to the bags of cement, more to balance the composition than to push the load. Despite his gaze, half-smile, and jaunty hat, he is a stiff, inanimate hybrid. With his bent arm suggesting a handle, he looks like a toby jug.

Bourke-White gained a deeper sensitivity toward human beings on her trips to the Soviet Union, where many of the people she met lived

at a level of poverty she had not encountered before.[76] In *USSR: Magnitogorsk, Boy with Hammer*, 1931 (fig. 72), she captured a disconcerting seriousness in the face of a youth engaged in heavy work. Issues of child labor rise to the surface in this photograph. She returned to the United States with greater appreciation for the human condition and people's will to survive, and she showed a new empathy for the suffering of the American worker.

By 1934 both *Fortune* and Bourke-White had to make changes in response to the realities of the Depression. Many readers had lost their jobs, and their interest in technology declined. That year fewer than half of the magazine's articles concerned business, as the staff began to assume the role of social historian and investigate problems not adequately addressed by newspapers. Staff members were generally liberal in their political orientation (in contrast to Luce, who tried not to let his political beliefs dictate the magazine's point of view).[77] Bourke-White herself grew increasingly aware of social and political issues, and she experienced mounting financial difficulties of her own. With her supplemental advertising income falling short of expectations, and burdened by the debt from her Russian movie project, she fell so far behind in her rent at the Chrysler Building that she was evicted from her studio and forced to move into more modest quarters.[78]

Skirmishes with *Fortune* over fees can only have heightened Bourke-White's sense of the precariousness of her financial situation. In March 1933 the magazine cut its fee scale from four hundred to three hundred dollars per job. In May 1935 it cut it further. Bourke-White countered by raising hers. When editors at *Fortune* suggested that they

might no longer be able to afford her services, a compromise was reached. Interestingly, the discussion of fees raised the issue of photographic style. *Fortune* itself was changing and wanted more candid photography. It was already using the services of the German pioneer in the field, Dr. Erich Salomon. To maintain her level of activity at the magazine, it would be necessary for Bourke-White to develop a candid technique.[79]

Around this time sketchy reports of a severe drought in the midwestern and southern United States began to appear in the press. *Fortune* was the first national publication to see the importance of the story, assigning Bourke-White to document it in 1934.[80] The editors did not know exactly where to send her but decided she should start in Omaha, Nebraska. Because of the magazine's tight deadline, she had to leave almost immediately. When she arrived in Omaha and found that the drought covered a much wider area than had been realized, she chartered a small airplane to fly her between Texas and the Dakotas. She knew

[FIG. 70]

Armour

MAKING RED HOTS

1934

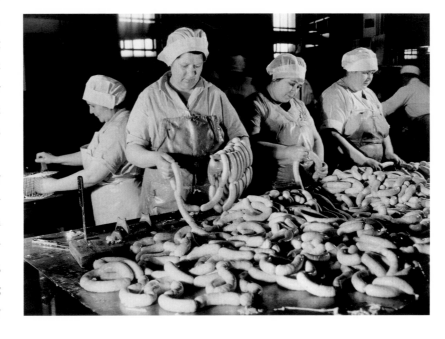

that the story should focus on people,[81] but her inexperience resulted in pictures that emphasize design at the expense of empathy, and some of her photographs come across as stiff and staged, as can be seen in *Drought Area: Farmers* and *Drought Area: Two Men in Front of Store*, both 1934 (figs. 73–74). Others, however, could have been taken by Farm Security Administration photographers. *Drought Area: Farm School* and *Drought Area: The Parched Earth*, both 1934 (figs. 75–76), were images that suggested the aesthetic of photographer Walker Evans. Interestingly, the writer for *Fortune*'s drought story was James Agee, who would later collaborate with Evans on the book, *Let Us Now Praise Famous Men*, about the plight of tenant farmers in Alabama.[82]

Bourke-White's relationship with *Fortune* became strained when the Newspaper Enterprise Association (NEA) scooped the magazine and published her drought pictures first. Luce himself wrote to express his dismay.[83] Bourke-White apologized profusely to the magazine's associate editor, Ralph McAllister Ingersoll, acknowledging that she had given the photographs to NEA but insisting, "I had no knowledge whatsoever that they would feature the drought pictures, that they would use as many of them, or that they would use them apart from the interview. I did not authorize their use in this way."[84] Ingersoll was willing to share the blame for the misunderstanding, but a similar difficulty in early 1935 provoked a much sterner response: "Look here— this latest and most scandalous evidence of somebody's carelessness in your office about releasing pictures you have taken for us for exhibition elsewhere brings to a head a situation which has long been bothering us."[85] A contrite

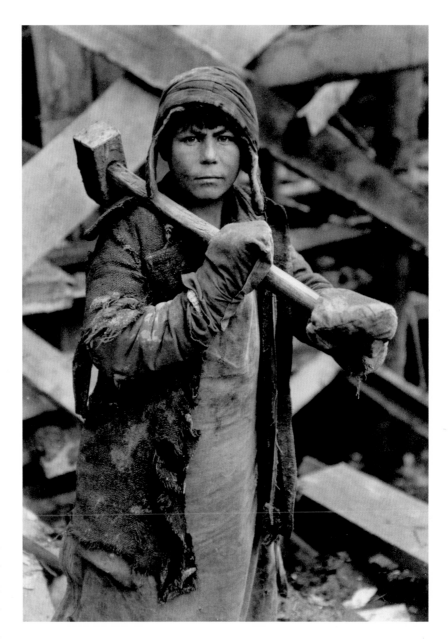

Bourke-White agreed to his demands that her office institute strict procedures to segregate her work for *Fortune* from her other production and refer all requests for permission to publish these photographs to Ingersoll. In typical fashion, she then resorted to various feminine wiles to regain his good graces: "Now that your earnest pupil has learned her lesson, don't you think she might be invited to cocktails?"[86]

[FIG. 71]

Lehigh Portland Cement

MAN PUSHING BAGS

1930

[FIG. 72]

USSR: Magnitogorsk

BOY WITH HAMMER

1931

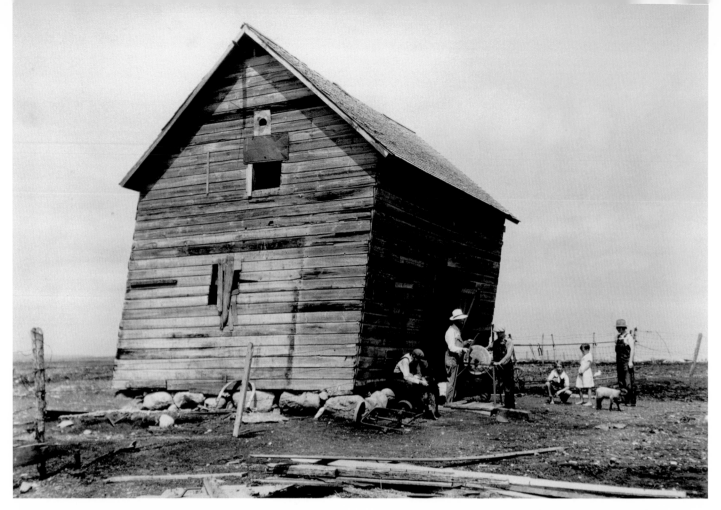

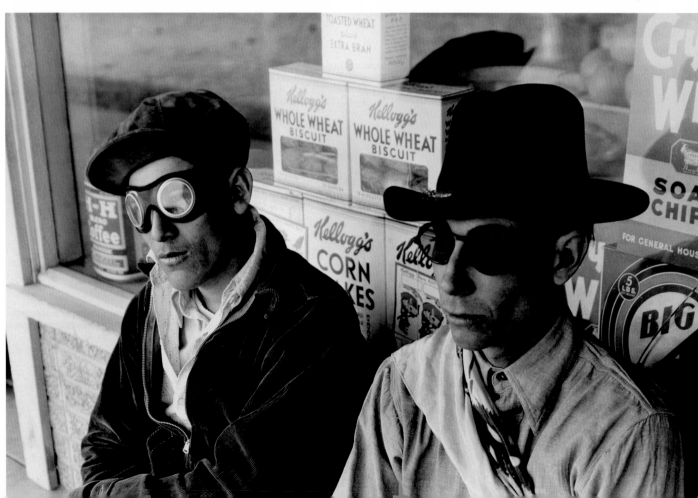

[FIG. 73]

Drought Area

FARMERS

1934

[FIG. 74]

Drought Area

TWO MEN IN FRONT OF STORE

1934

[FIG. 75]

Drought Area

FARM SCHOOL

1934

[FIG. 76]

Drought Area

THE PARCHED EARTH

1934

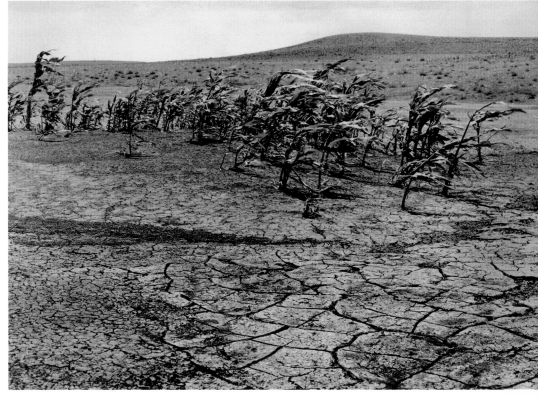

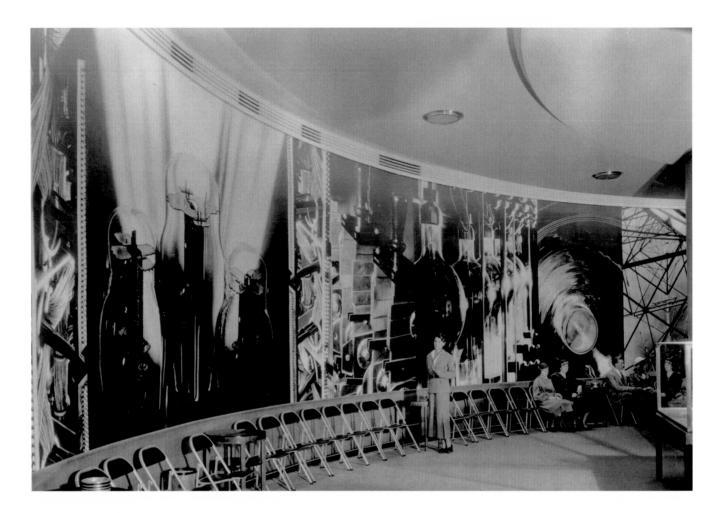

[FIGS. 77–78]

PHOTOMURALS IN
NBC STUDIOS

RCA Building

New York

1934

FROM AIRWAVES TO THE AIRWAYS:
LATER CORPORATE COMMISSIONS

In 1934 Bourke-White, who had already done several corporate murals, received a prestigious commission from RCA to create a monumental photomural focusing on the radio industry for the public rotunda of NBC Studios at Rockefeller Center in New York.[87] Without any requirement to incorporate the human figure, she zoomed in on radio components and produced individual photographs that bordered on abstraction but were instantly readable at the same time. Because of the architectural context, the mural was laid out in two sections, with a total circumference of 160 feet. Each half comprised eleven photographs of various widths but a consistent height of ten feet, eight inches. In the center of each section the largest and least abstract photographs represented the main components of radio—a microphone on one side, embossed with the NBC logo, and radio tubes on the other—while at the ends were images of four different radio transmission antennae. Fittingly for the rotunda, the resulting compilation surged across the walls, emphasizing curves and propelling the eye around the space in a particularly vivid demonstration of Bourke-White's intuitive gifts for design and composition, as seen in *Photomurals in NBC Studios, RCA Building, New York*, 1934 (figs. 77–78).[88] When

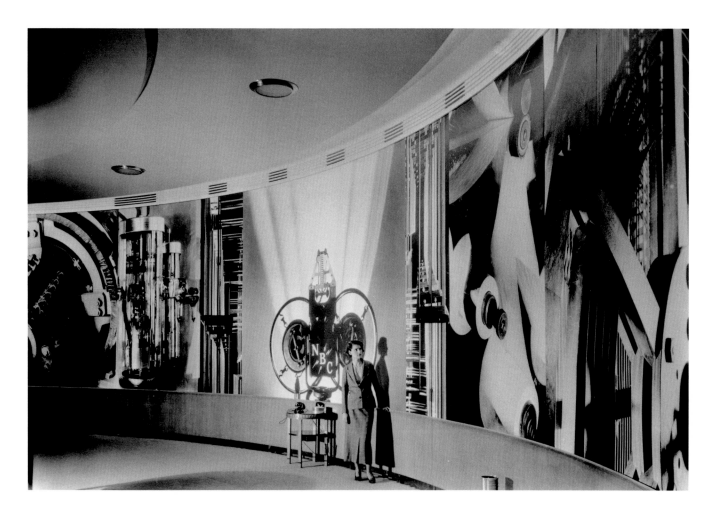

installed, it was the largest photomural in the world, and it remained on display for about twenty years. In the early 1950s it was taken down and probably destroyed.[89]

A regular advertising client in the early to mid-1930s, Goodyear Tire & Rubber Company hired Bourke-White to photograph several large dirigibles. *Goodyear Tire & Rubber: Underside of Dirigible*, 1931 (fig. 79), one of her trademark close-ups, highlighted the abstract design of the photograph rather than the product it was intended to promote. *Goodyear Zeppelin: United States Airship "Akron,"* 1931 (fig. 80), was a more documentary-type shot of a blimp in a hanger. Goodyear gave prints of this image to its dealers as prizes for high

sales, presenting them in frames made of sheet metal and rivets used in dirigible construction.

Bourke-White also took a series of photographs to advertise Goodyear tires. Some of these, such as *Goodyear Tire & Rubber: Traffic*, ca. 1933 (fig. 81), do not seem suited to the purpose. Without the title, it would not be clear whether this bird's-eye view focuses on skyscrapers, urban architecture, or the traffic at an intersection. The elegant layout of the photograph—with the beautiful medallion on the side of a building at the upper left, the repetition of windows establishing a gridlike pattern at the right, and the rectangular windows playing off the boxy shapes of the cars—made it successful in an artistic sense.

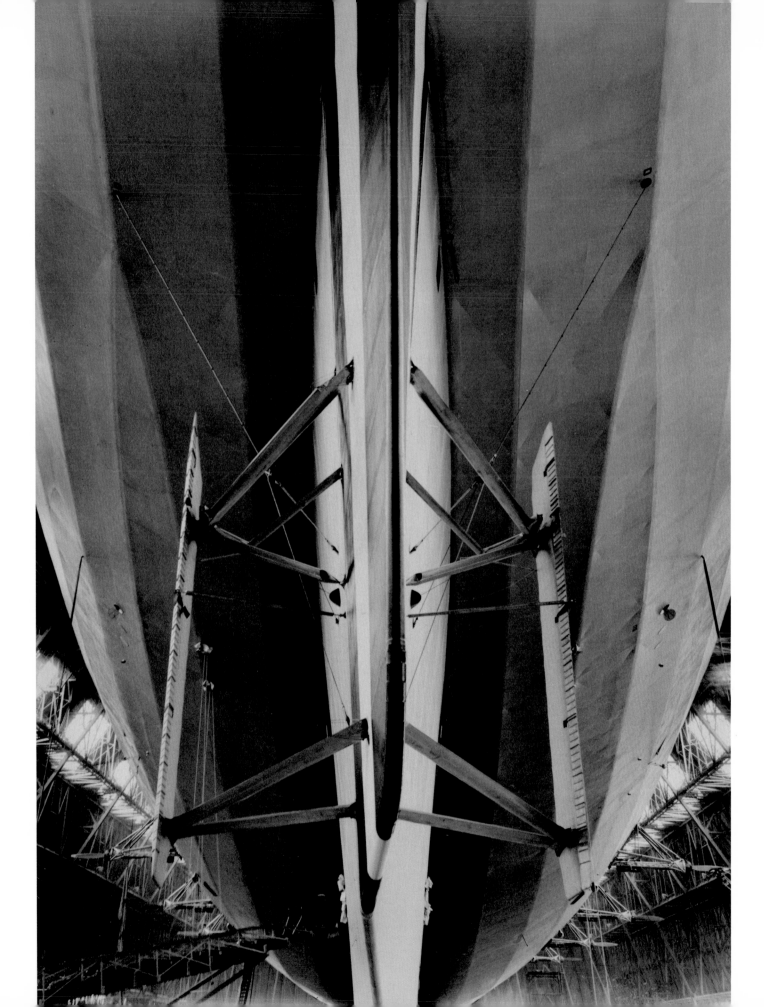

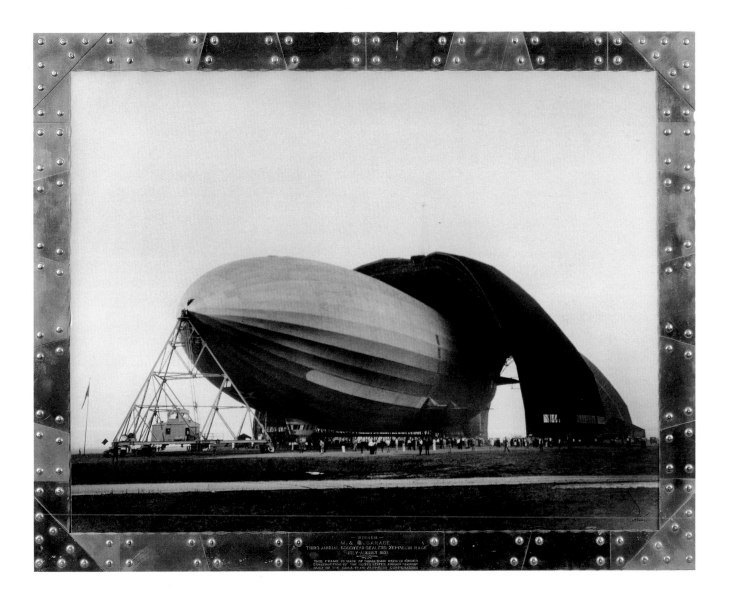

[FIG. 79]

Goodyear Tire & Rubber

UNDERSIDE OF DIRIGIBLE

1931

[FIG. 80]

Goodyear Zeppelin

UNITED STATES AIRSHIP *AKRON*

1931

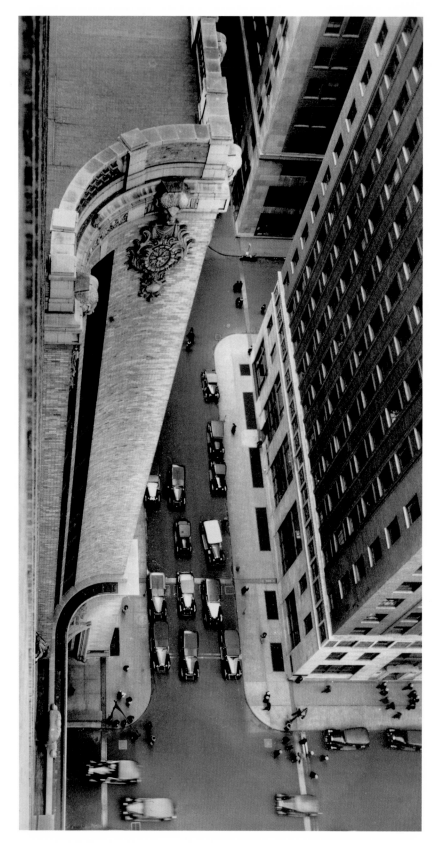

But it is hard today to see how it would have been of commercial use to Goodyear. Other photographs were well scripted and centered on near-miss or near-disaster scenarios that were averted by the Goodyear "Margin of Safety."[90] *Goodyear Tire & Rubber: Safety—Child on Tricycle*, ca. 1933 (fig. 82), shows a mother gesturing dramatically to stop a car before it hits her daughter. *Goodyear Tire & Rubber: Safety—Boys Chasing Ball*, ca. 1933 (fig. 83), depicts two boys running into a street full of cars to retrieve their baseball. Here, the camera's orientation creates a strong diagonal that communicates the point of the photograph very persuasively: thank goodness the car has Goodyear tires.

The William Wrigley Jr. Company commissioned *Wrigley: Dressing Table with Gum* in the mid-1930s (fig. 84), a subtle and effective piece of advertising. Bottles of perfume and jars of makeup on a woman's dressing table share the stage with a string of pearls, various brushes, and a clearly identifiable package of Wrigley's "Double Mint" chewing gum. In the foreground the manicured hands of a well-dressed woman hold another package of gum, while the mirror reflection establishes a sense of depth and allover patterning. This image epitomizes the privilege and prosperity that gave momentum to the consumer age.

Beginning in 1935, TWA, Pan Am, and Eastern Airlines hired Bourke-White to take promotional photographs for them. To undertake the aerial shots, she depended on the technical advice of the photographer sharing her studio, Robert Y. Richie, who had done some aerial work and owned equipment that he taught her to use.[91] But for some of the images, she relied on formulas she had developed earlier. In *TWA: Douglas Plane, Motor*

Assembly, 1934 (fig. 85), she used a favorite device, framing the figure of a mechanic in the round opening of the object on which he worked. Understanding the importance of texture and detail, she made sure to record every rivet. In *TWA: Wing Tip and Propellor Blur*, 1935 (fig. 86), she applied her signature style to a close-up that again emphasized her compositional design over a documentary approach. Likewise, in *TWA: Airplane Wings*, 1934 (fig. 87), she positioned fragments of three airplane wings so as to create a pleasing visual rhythm, then used artificial lighting to bring out the beautiful sheen of the metallic surfaces and pinpoint the thousands of rivets on each wing.

Bourke-White's interactions with Eastern Airlines reveal some of the challenges encountered in these projects. In the summer of 1935 the two parties discussed an extensive assignment that would document the different stages of air travel. After lengthy negotiations, a contract was signed at the end of October that gave her sixty days to complete the work. Eastern Airlines, for its part, agreed

to arrange all the setups, provide air transportation, and pay her fifteen hundred dollars on delivery of final contact prints. The airline's script was exhaustive and gave her little room for creativity. For the aerial shots of a plane flying over the cities that Eastern Airlines served, it was very important to the client that the sites be easily recognizable, such as the Statue of Liberty in New York, the Capitol in Washington, DC, or the lakefront in Chicago. The contract also called for Bourke-White to capture both the Eastern Airlines insignia and the true "metallic, silvery finish" of the airplane, instead of "a dull gray."[92]

Her shots over New York City were her most dramatic and descriptive: "I flew, strapped into a small plane, in close formation with one of the big passenger planes. My pilot flew me over it, under and around it, to get the effect of the big plane looming large in the foreground with the skyscrapers below."[93] In *Eastern Airlines: Plane over Manhattan*, 1935 or 1936 (fig. 88), she caught the airplane at the perfect angle with just the right

[FIG. 81]

Goodyear Tire & Rubber

TRAFFIC

ca. 1933

[FIG. 82]

Goodyear Tire & Rubber

SAFETY—CHILD
ON TRICYCLE

ca. 1933

[FIG. 83]

Goodyear Tire & Rubber

SAFETY—BOYS
CHASING BALL

ca. 1933

[FIG. 84]

Wrigley

DRESSING TABLE WITH GUM

mid-1930s

[FIG. 85]

TWA: Douglas Plane

MOTOR ASSEMBLY

1934

[FIG. 86]

TWA

WING TIP AND
PROPELLOR BLUR

1935

Plane Interior, Passengers, 1935 or 1936 (fig. 90), shows models seated inside an airplane, either reading or looking out the window, with the pilot in the rear of the plane looking directly at the camera. In light of Bourke-White's other commitments, it seems unrealistic to think that a demanding assignment such as this could have been completed in two months. Once February 1936 arrived, Eastern Airlines began to press her to finish the project.[94]

COLLABORATION WITH ERSKINE CALDWELL

In July 1935 Bourke-White discussed her desire to develop "a candid camera technique" with *Fortune*'s art editor. In a follow-up letter she explained, "While it is very important to get a striking picture of a line of smoke stacks or a row of dynamos, it is becoming more and more important to reflect the life that goes on behind these photographs."[95] It took time for her to perfect this approach, and *Fortune* criticized her initial behind-the-scenes shots of an automotive worker's family as "too stiff and posed-looking."[96] In March 1936 a commission from the American Can Company enabled her to experiment with her new subject. Traveling to Brazil to photograph coffee plantations, she produced images to illustrate a brochure, "The Story of Coffee," that was handed out in American schools.[97] On the shoot she took intimate portraits of children such as *American Can: Brazilian Girl,* 1936 (fig. 91), which show a remarkable compassion for her subjects.

To explore her growing interest in human subjects with greater freedom than corporate and magazine assignments allowed, Bourke-White began to look for an independent book project.

shine on its surface and a postcard view of the city below. Other times she resorted to collage. For *Eastern Airlines: Collage with Plane over New York,* 1935 or 1936 (fig. 89), she cut a plane from one photograph and pasted it onto the image of New York City, then photographed the assemblage to create a seamless image that met the client's script. The assignment grew less exciting after the aerial shots were taken. *Eastern Airlines:*

In Erskine Caldwell, author of the highly acclaimed book and Broadway play *Tobacco Road*, she found an ideal collaborator. He wanted to publish a book of text and photographs to counter criticisms that the characters and scenes in his play were unrealistic.[98] During July and August 1936 Caldwell and Bourke-White worked together; he interviewed and she photographed sharecroppers on a tour of the South. Their collaboration resulted in the successful publication of *You Have Seen Their Faces* in 1937.

This project introduced Bourke-White, whose impulse was to direct and manage a composition, to a new way of working. Unlike her, Caldwell did not assert his own agenda. Instead of overwhelming the people he interviewed, he allowed them to open up of their own accord. Bourke-White learned to wait in the background until the appropriate time to move in for close-ups and perhaps an invitation to come inside, where she could take further photographs. Standing off to the side with her remote control, she would sometimes wait an hour or more for her opportunity. This patience finally enabled her to take the candid shots she wanted. She used a large-format camera with extensions for several synchronized flashes, which produced a sculptural effect she could not achieve with a single flashbulb. Caldwell would engage their subjects in conversation while she set up her equipment. When she was particularly anxious to avoid being conspicuous, she used a smaller hand-held camera from among the five she carried on the trip.[99] Bourke-White gained valuable experience from this collaboration with Caldwell and honed her ability to capture people in a more natural and empathetic way.

Wildly successful, *You Have Seen Their Faces* invites comparison with the later publication, *Let Us Now Praise Famous Men*, by James Agee and Walker Evans, first published in 1941. *Fortune* was running articles about the effects of the Depression on individuals and in 1936 commissioned Agee to do a story on a tenant farmer in the South. Agee, who did not want to work with Bourke-White after collaborating with her on the

[FIG. 87]

TWA

AIRPLANE WINGS

1934

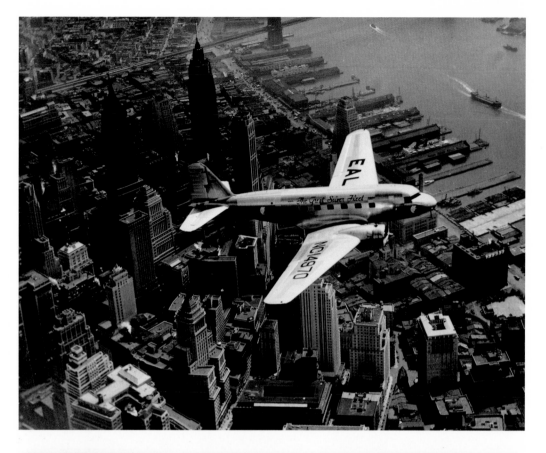

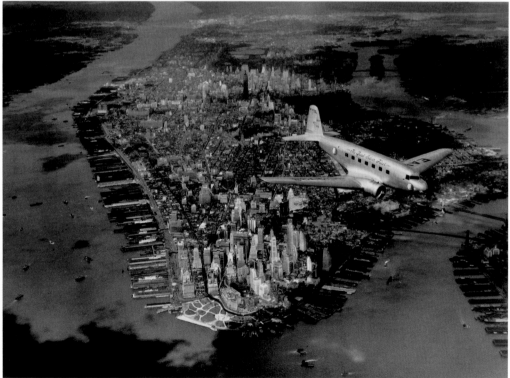

[FIG. 88]

Eastern Airlines

PLANE OVER MANHATTAN

1935 or 1936

[FIG. 89]

Eastern Airlines

COLLAGE WITH PLANE
OVER NEW YORK

1935 or 1936

[FIG. 90]

Eastern Airlines

PLANE INTERIOR,
PASSENGERS

1935 or 1936

[FIG. 91]

American Can

BRAZILIAN GIRL

1936

South are similar to those Evans took in Alabama. The differences, slight to the present-day observer, were sufficient to cause Agee and Evans to loathe Bourke-White, in whose personal and photographic style they detected what would today be called political incorrectness. Bourke-White's *Montgomery, Alabama*, 1936 (fig. 92), would have been framed by Evans straight on, as an example of classic simplicity, deriving its appeal from its connotations of puritan, Shaker-like reductivism.[101] An argument can be made for Evans's sanitized images being no more truthful than Bourke-White's less romantic, object-filled, diagonal compositions. Some of Bourke-White's images may look posed, but the reality she shows in photographs such as *Happy Hollow, Georgia*, 1936 (fig. 93), is the unscrubbed version. Evans, who allowed his subjects to clean up their surroundings and themselves, believed that in doing so he was preserving their dignity and preventing their degradation.[102]

Bourke-White's financial success and perceived frivolity did not endear her to Agee or Evans. At the back of their book they included the transcript of a newspaper article about her, with references to her designer clothes, her expensive leisure pursuits, and her income as one of the most highly paid women in America.[103] A personality puff piece when originally written, its inclusion in the Agee and Evans book can only be construed as cruel and condescending. Bourke-White, we are to understand, was an unenlightened materialist, and this damned her photographs in their eyes. One might add that she was not one of the boys, she did not come from their social class, and she had no intellectual pretensions. In addition, they would have seen advertising photography as an inferior genre.

drought story for *Fortune* in 1934, persuaded Ingersoll to hire Evans, the only photographer, in Agee's opinion, not susceptible to the urge to make politically manipulative photographs. As far as Agee and Evans were concerned, Bourke-White's photography was biased and untruthful.[100] In fact, if one disregards the captions in *You Have Seen Their Faces*, disconcerting to readers today, many of the subjects Bourke-White captured in the

The Launching of *Life*

In March 1936 Bourke-White signed an exclusive contract with NEA and Acme Newspictures, Inc., and named Acme her sole agent in soliciting commissions from advertisers and magazines.[104] In the next few months she was given a wide range of assignments—from taking portraits of President Franklin Delano Roosevelt to covering the track and field races at the Olympic Games. By August, however, she had violated the exclusivity clause of her agreement more than once, and NEA terminated the contract.[105]

Bourke-White may have deliberately sabotaged this relationship, for in September 1936 she signed an exclusive contract with Henry Luce of Time Inc. to take photographs for his new *Life*

magazine, which followed in the footsteps of such successful European illustrated magazines as the French *Vu* and similar German publications. As *Life*'s title implies, Luce wanted to take a human-interest angle. The effervescence of the 1920s had given way to a sense of social fragility, deepened by the Depression and the shadow of war. Bourke-White was eager to combine her skills in photography with a growing social conscience and a newfound interest in how people lived their lives. Any hesitations Luce may have had about hiring her, given her design orientation and her industrial specialty, were swept aside by her work in the South with Erskine Caldwell and the images of Olympic athletes (taken for NEA) that she gave him for prototypes of the new magazine.

[FIG. 92]

MONTGOMERY, ALABAMA

1936

[FIG. 93]

HAPPY HOLLOW, GEORGIA

1936

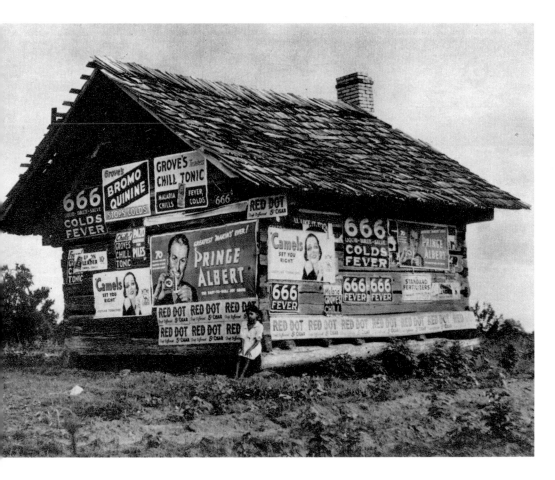

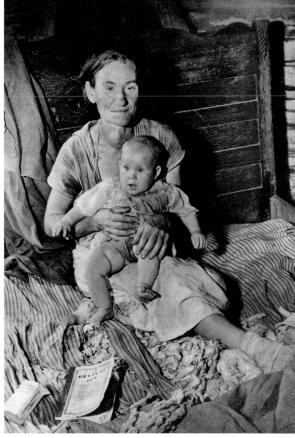

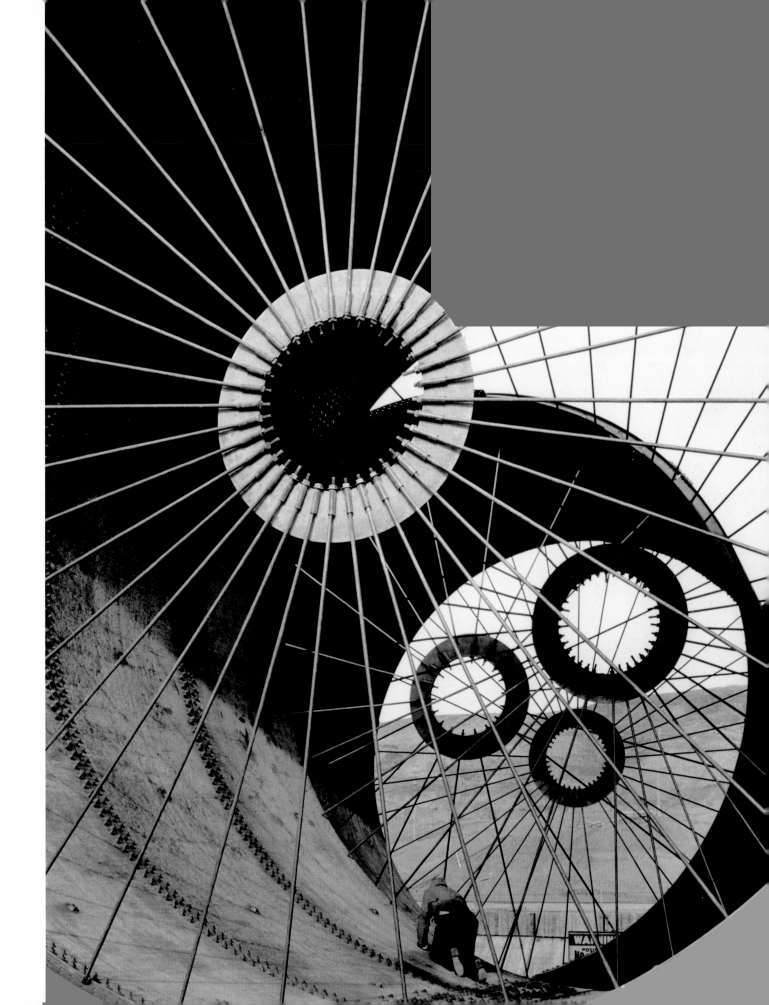

The recent work must have convinced him of her new versatility. When she joined the staff of *Life*, she was one of four photographers, the only woman, and the only one who still used a large-format camera.[106]

For her first assignment, in October 1936, Luce sent her to New Deal, Montana, to photograph the construction of the Fort Peck Dam, a multimillion-dollar project undertaken by the Public Works Administration. Bourke-White began by focusing on the traditional subjects of industry in images such as *New Deal, Montana: Fort Peck Dam, Diversion Tunnel* and *New Deal, Montana: Fort Peck Dam*, both 1936 (figs. 94–95), using compositional devices she had learned from Dow and White more than a decade earlier. By night she explored the town of New Deal, a recently established frontier community inhabited by an assortment of workers, from engineers and construction men to barmaids and quack doctors. She approached her subjects with her new candid style, even if it was still somewhat stiff. In *New Deal, Montana: Bar Room—Couples Dancing* and in *New Deal, Montana: Patrons at Bar*, both 1936 (figs. 96–97), she photographed a number of people enjoying a night on the town. The latter shot included the saloon managers' small child seated on the bar.[107]

With less than two weeks to go before publication, the new magazine still had no cover or lead story. But when Bourke-White's photographs arrived in New York, Luce and his editors knew they had their angle. They used one of her pictures of the dam for the cover and devoted the nine-page lead story, "Franklin Roosevelt's Wild West," to her images of life in the town of New Deal. Luce and the magazine's editors made the

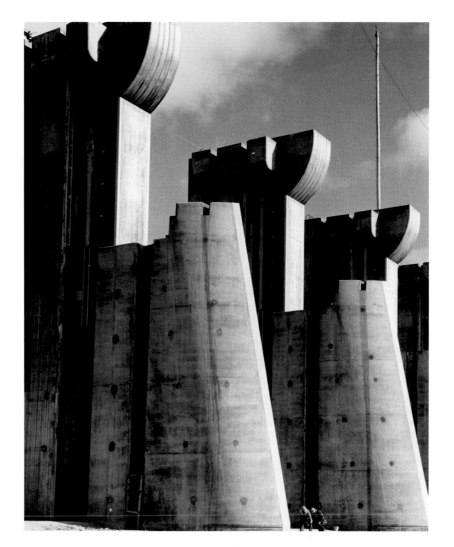

final selection of images for the stories while Bourke-White was still on location, and Archibald MacLeish came in to write captions. Released on 23 November 1936, the inaugural issue of *Life* and its use of Bourke-White's photographs set the tone for the magazine for years to come. When an initial printing of 200,000 copies sold out almost immediately, the presses printed more, until the final count reached 466,000. The image of a four-year-old child at a bar caused instant controversy—which was just what *Life* wanted, because it sold more magazines. It was not possible to print enough copies of the next several

[FIG. 94]

New Deal, Montana

FORT PECK DAM, DIVERSION TUNNEL

1936

[FIG. 95]

New Deal, Montana

FORT PECK DAM

1936

[FIG. 96]

New Deal, Montana

BAR ROOM—COUPLES DANCING

1936

[FIG. 97]

New Deal, Montana

PATRONS AT BAR

1936

issues to meet the demand, and these early editions became collectors' items.[108]

Bourke-White liked working for *Life*. She had great flexibility, and it seemed as though all things were possible. She usually received assignments from the editors, but she was also able to propose her own ideas for publication. She felt that the photographic essay was her special domain, and the editors gave her many suitable stories.[109] Increasingly, her photographs focused on people rather than on industry. Over the next several decades her assignments took her to the Midwest to explore life in American towns; to Louisville to record the devastation caused by the flood of 1937, one of the worst natural disasters in American history; to Moscow to witness the start of Germany's intense nighttime bombing; and to Leipzig after liberation to show the horrors of the Nazi camps. Between these historic assignments, she photographed less serious subjects that were still of interest to readers in articles entitled: "A Long Look at Hollywood," "President Roosevelt Carves up a Turkey," "*Life* Goes to a Paper Festival," and one that was especially close to her heart, "Life Cycle of the Praying Mantis." Bourke-White had arrived at a new phase in her career—and a new stage in photography. She would never again make pictorialist photographs that mimicked paintings, nor would she make overt abstraction her priority. She now embraced photojournalism wholeheartedly, and set about concealing the artfulness and design that underlies effective candid photography. ∎

Photographs

Otis Steel

RIVERSIDE WORKS

1928

Terminal Tower, Cleveland

VIEW FROM BRIDGE

1929

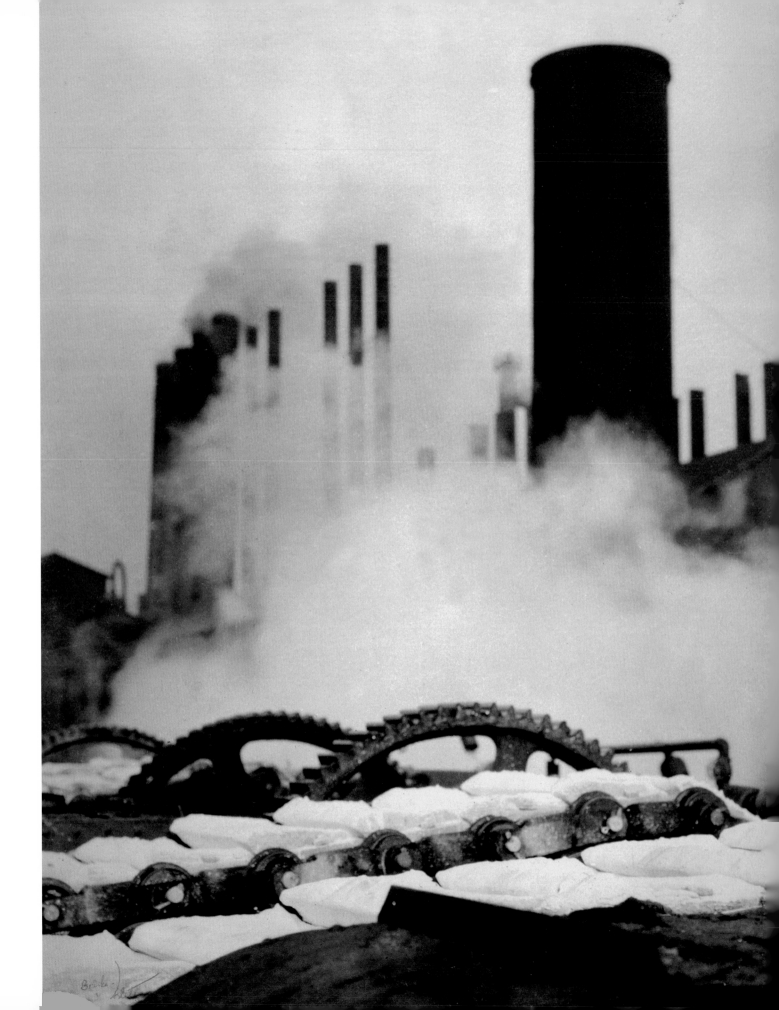

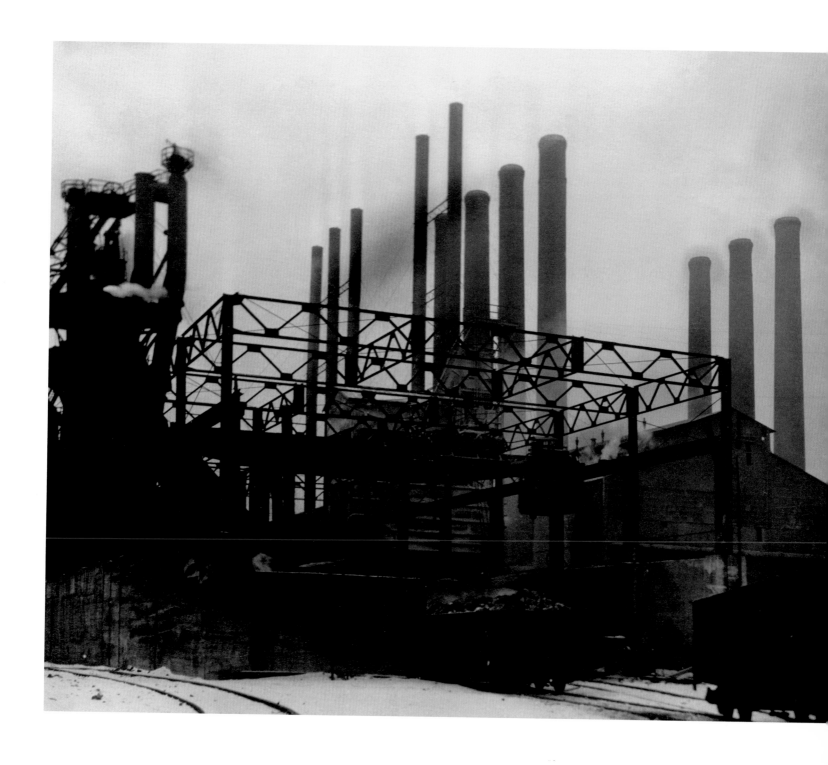

Otis Steel

HOT PIGS

1928

Otis Steel

SMOKE STACKS AND COAL

1928

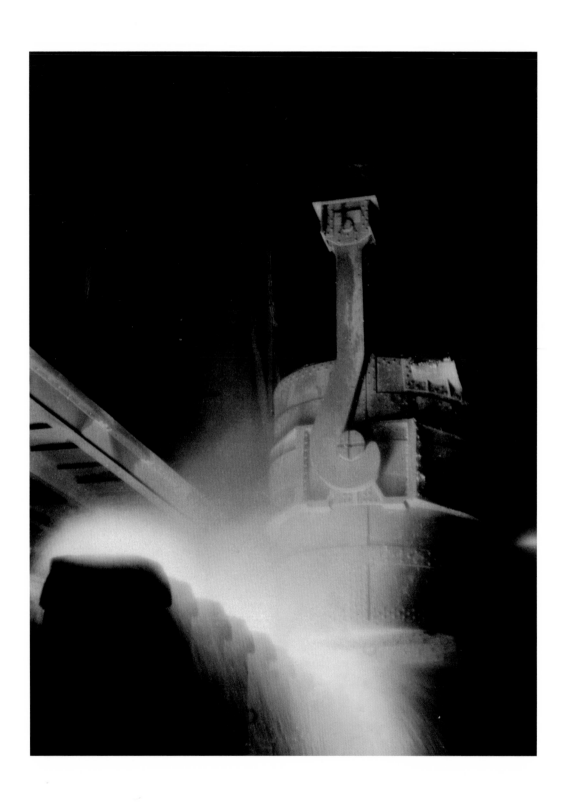

Otis Steel

OPEN HEARTH

1928

Otis Steel

PIG IRON TRAIN

1928

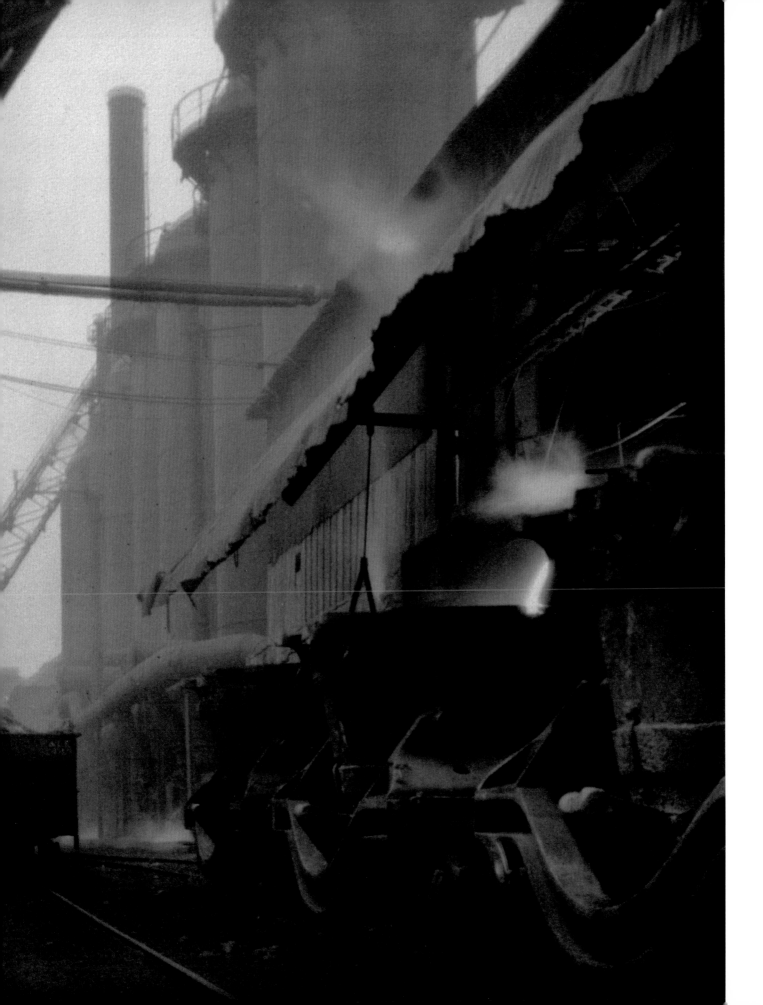

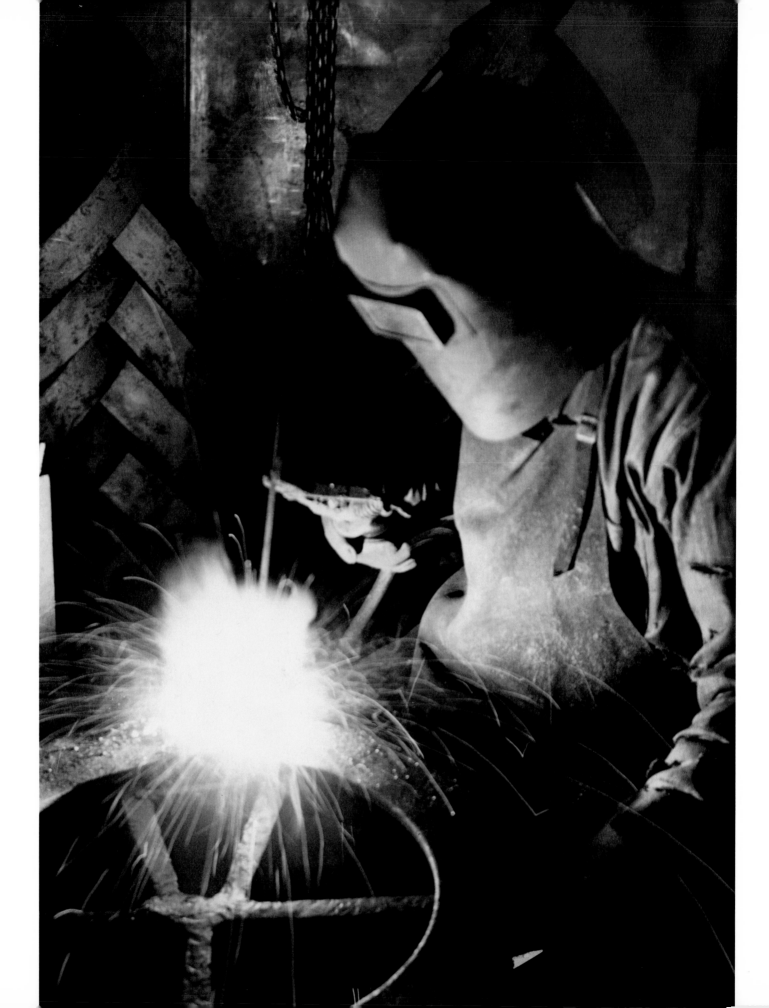

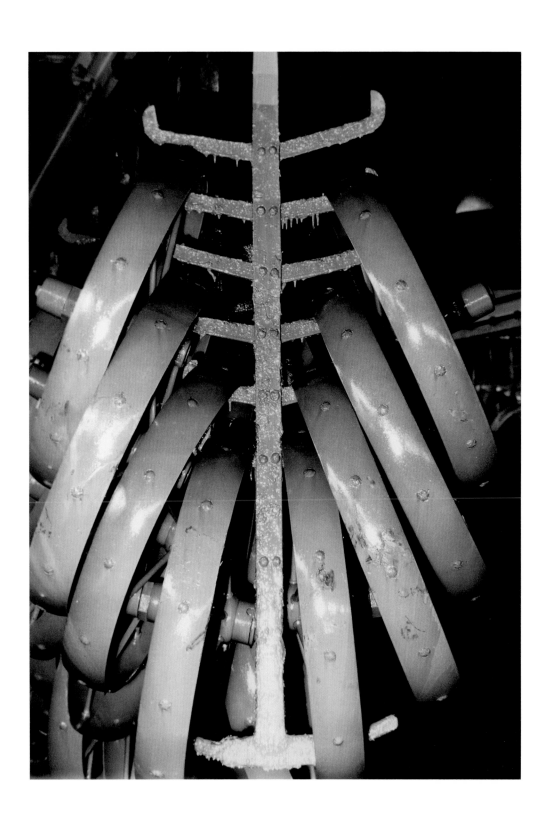

Lincoln Electric

ARC WELDING

1929

Oliver Chilled Plow

WHEELS ON RACK

1930

Lehigh Portland Cement

STORAGE BINS

1930

Lehigh Portland Cement

PIPE

1930

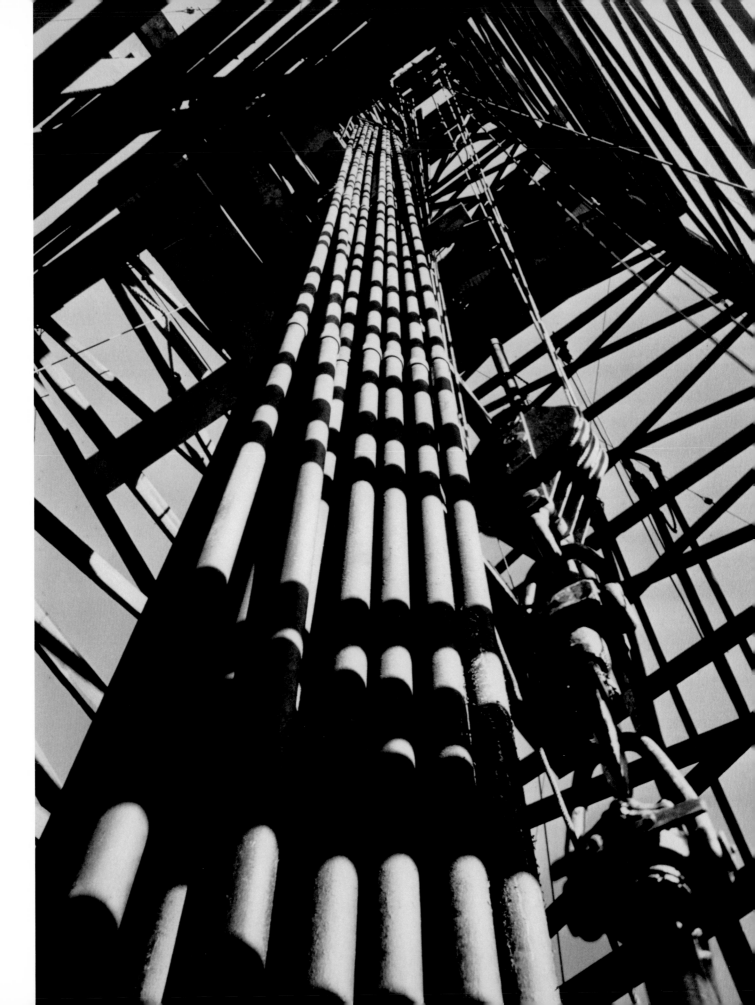

MARGARET BOURKE-WHITE

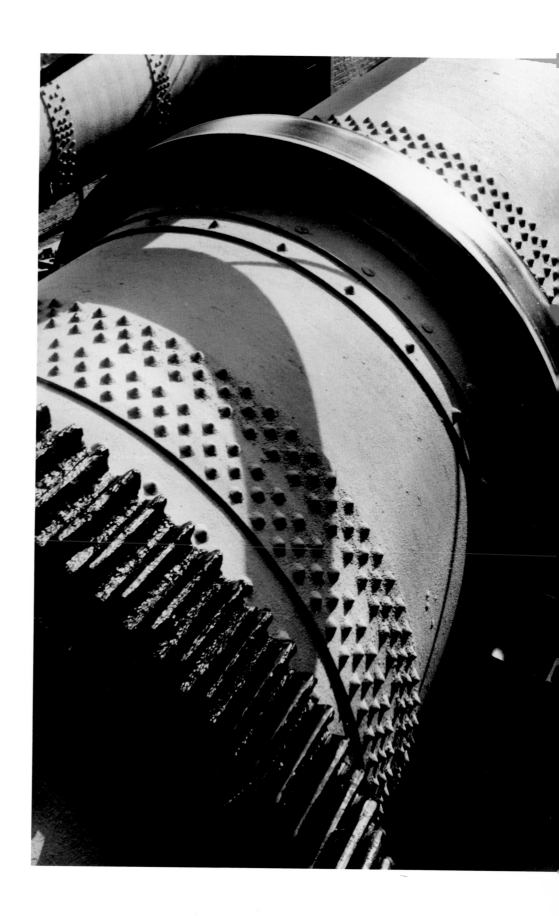

Texas Oil

LOOKING UP INSIDE OIL DERRICK

ca. 1935

Lehigh Portland Cement

PIPE CLOSE-UP

1930

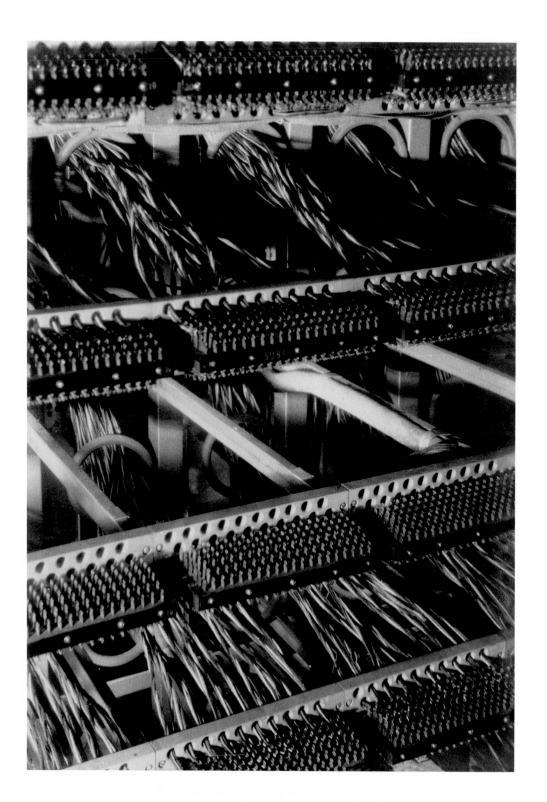

National City Bank

COMPLETED SWITCHES

1931

Union Trust

LOBBY

1930

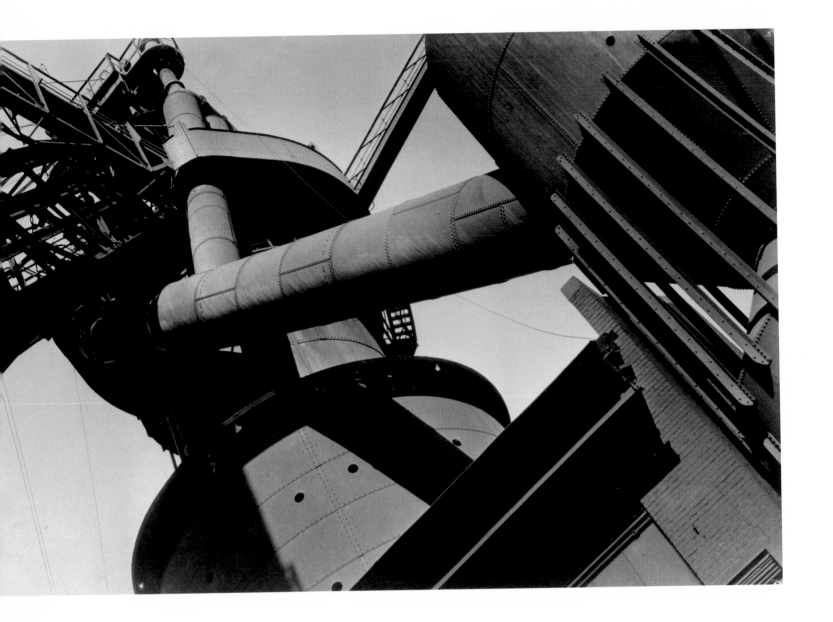

Ford Motor

BLAST FURNACE

1929

Ford Motor

TANK

1929

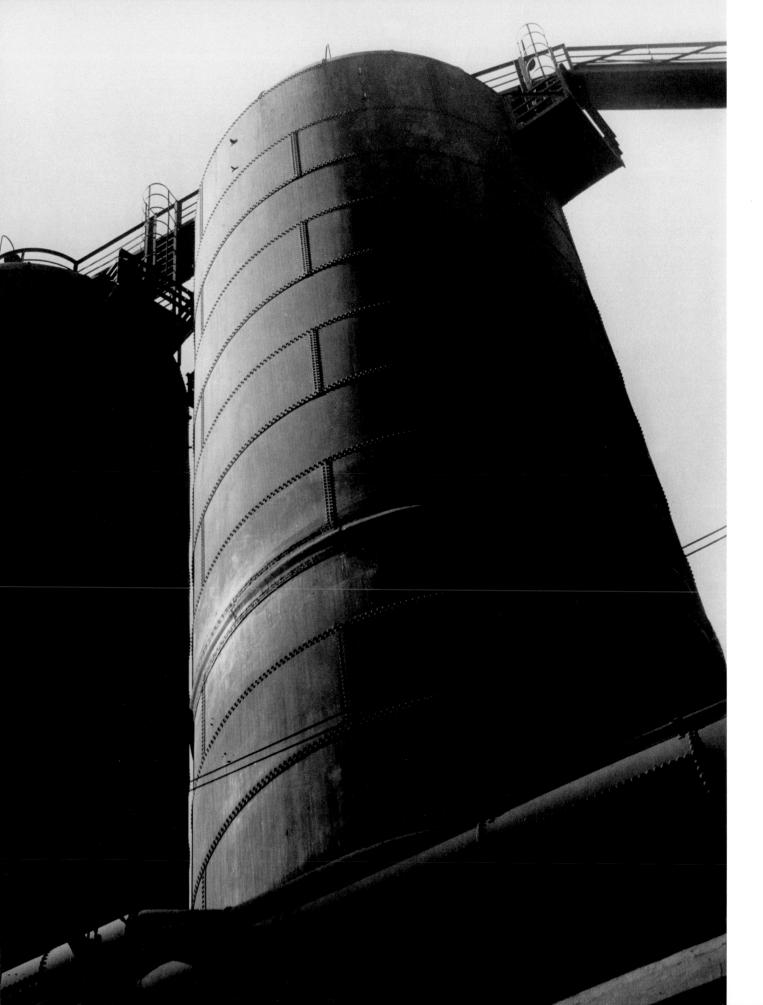

Indiana Limestone

QUARRY FILLED WITH WATER

1931

Indiana Limestone

LIMESTONE BLOCKS

1931

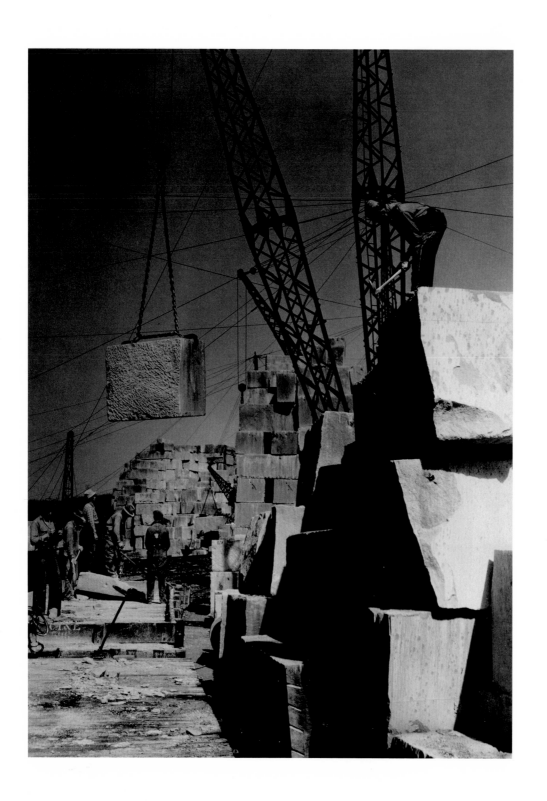

Indiana Limestone

LOADING BLOCKS

1931

Nichols Copper

RAISING COPPER BARS

1932

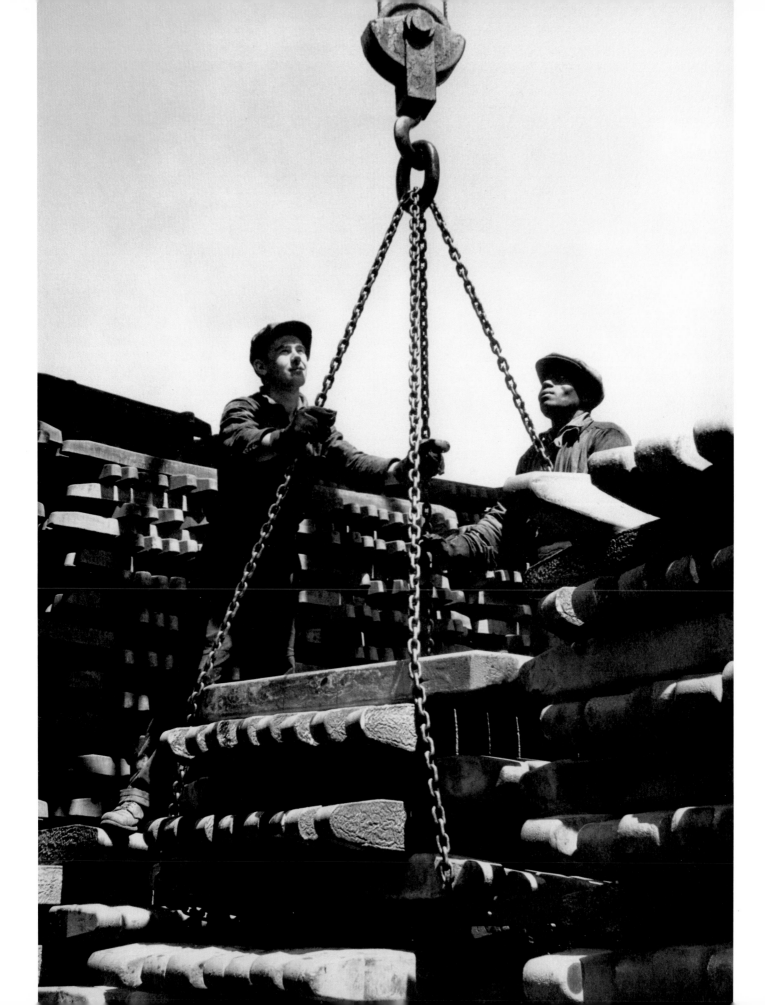

Aluminum Company of America

MAN POLISHING KETTLES

1930

Aluminum Company of America

STEAM JACKETED KETTLES

1930

110

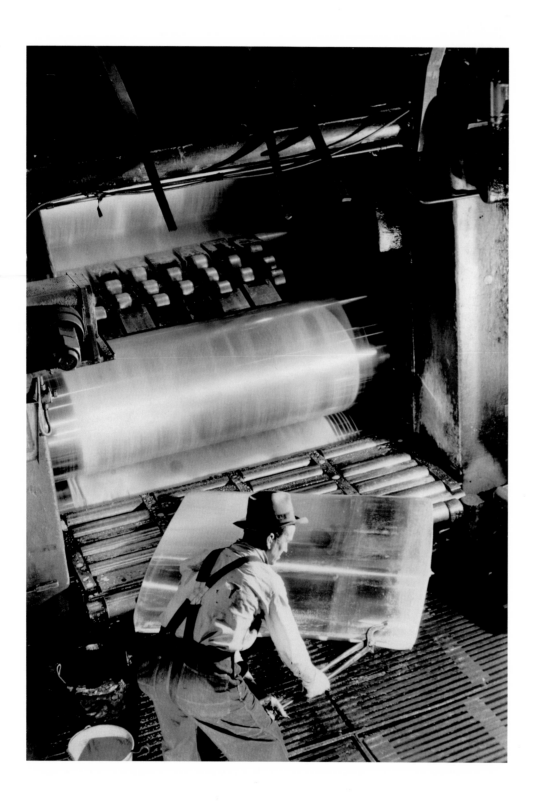

Aluminum Company of America

ROLLING SHEETS

1930

Aluminum Company of America

COIL STRIP

1930

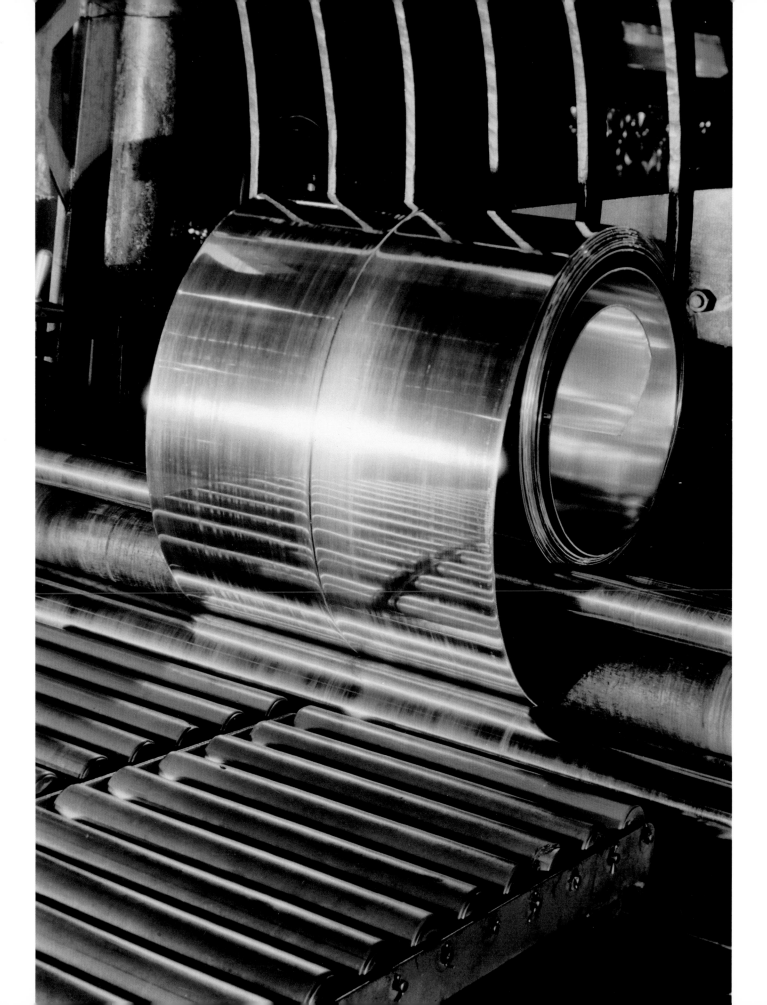

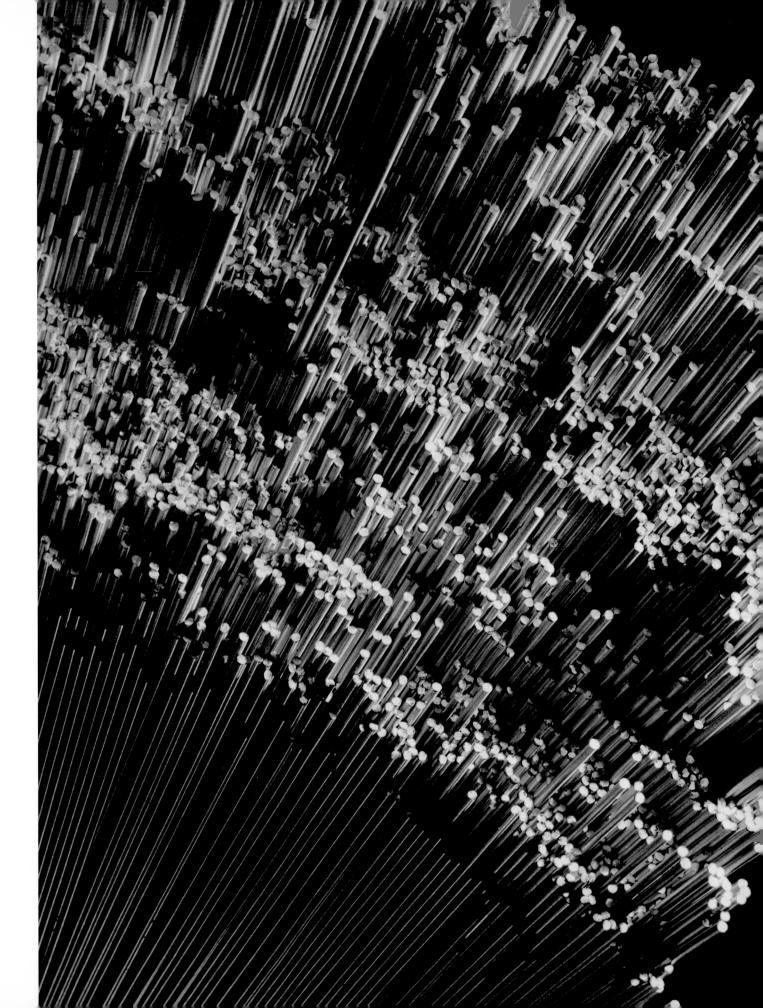

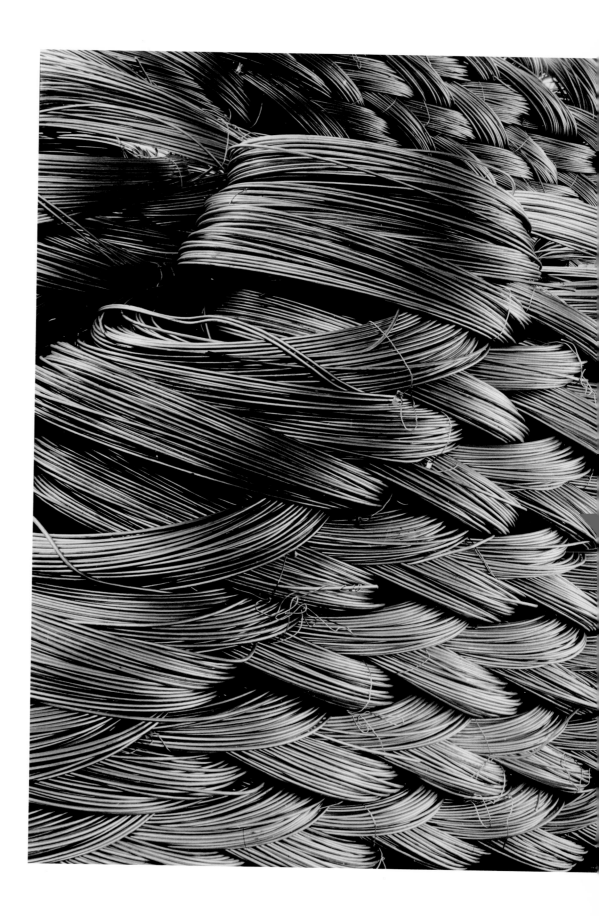

Aluminum Company of America

Aluminum Rods

1930

Aluminum Company of America

Wire

1930

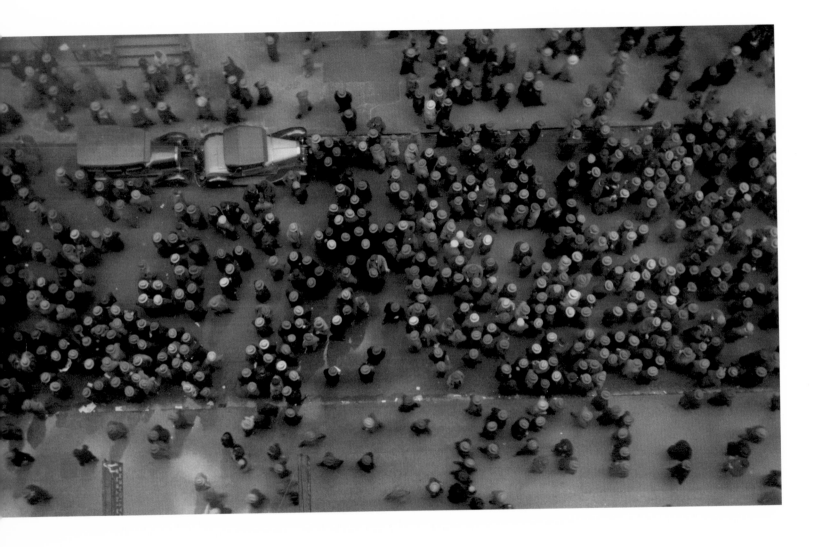

Garment District, Manhattan

S t r e e t S c e n e

1930

Delman Shoes

S h o e s

1933

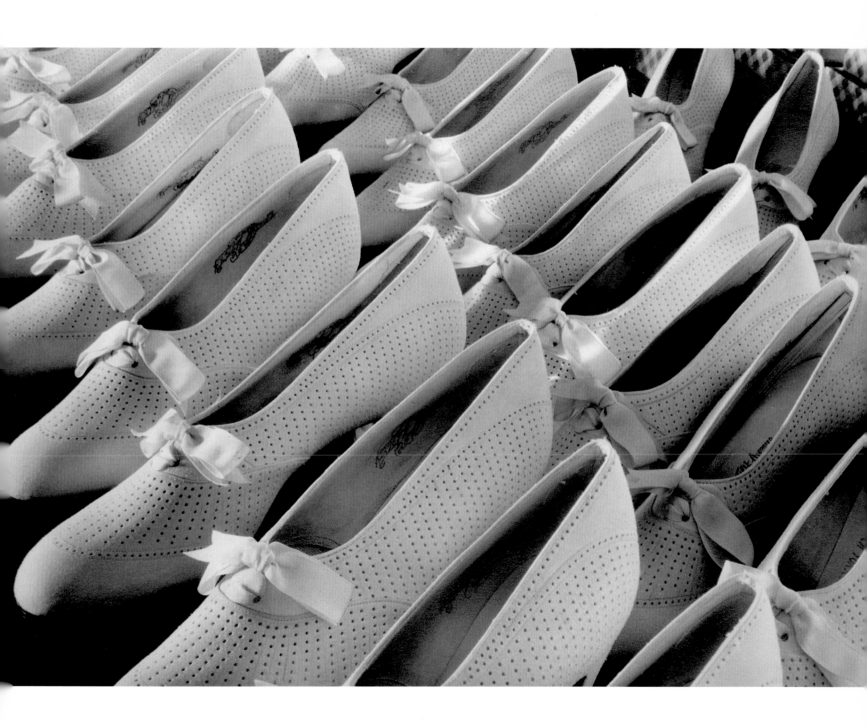

Wurlitzer

PIPES

1931

Russell, Birdsall & Ward

NUTS

1930

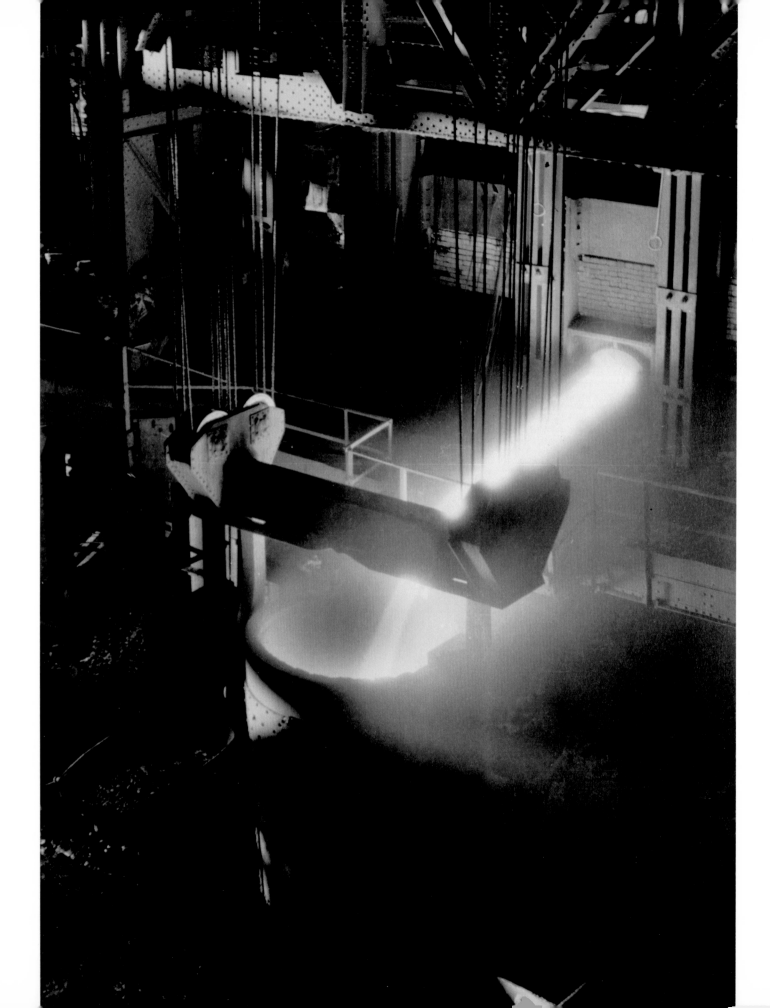

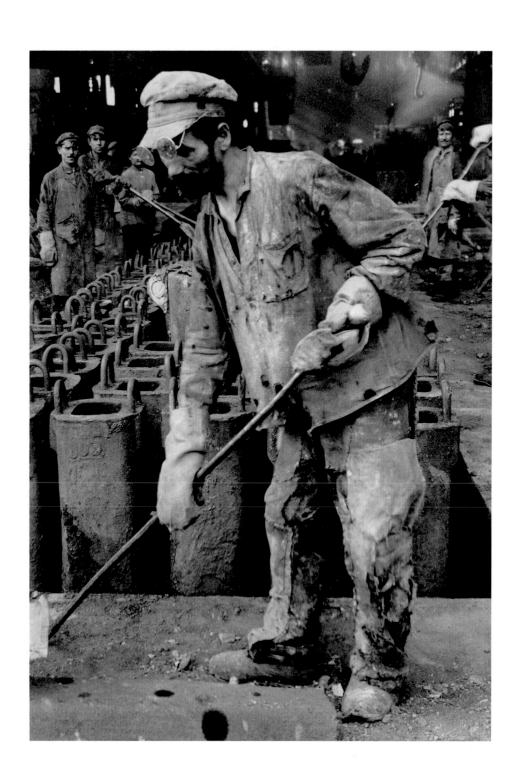

USSR: Stalingrad

Red October Rolling Mills

POURING THE HEAT

1930

USSR: Stalingrad

Red October Rolling Mills

IRON PUDDLER

1930

USSR

Hammer & Sickle Factory

STUDENT WORKERS

1931

USSR

WOMEN BY SHOP WINDOW

1931

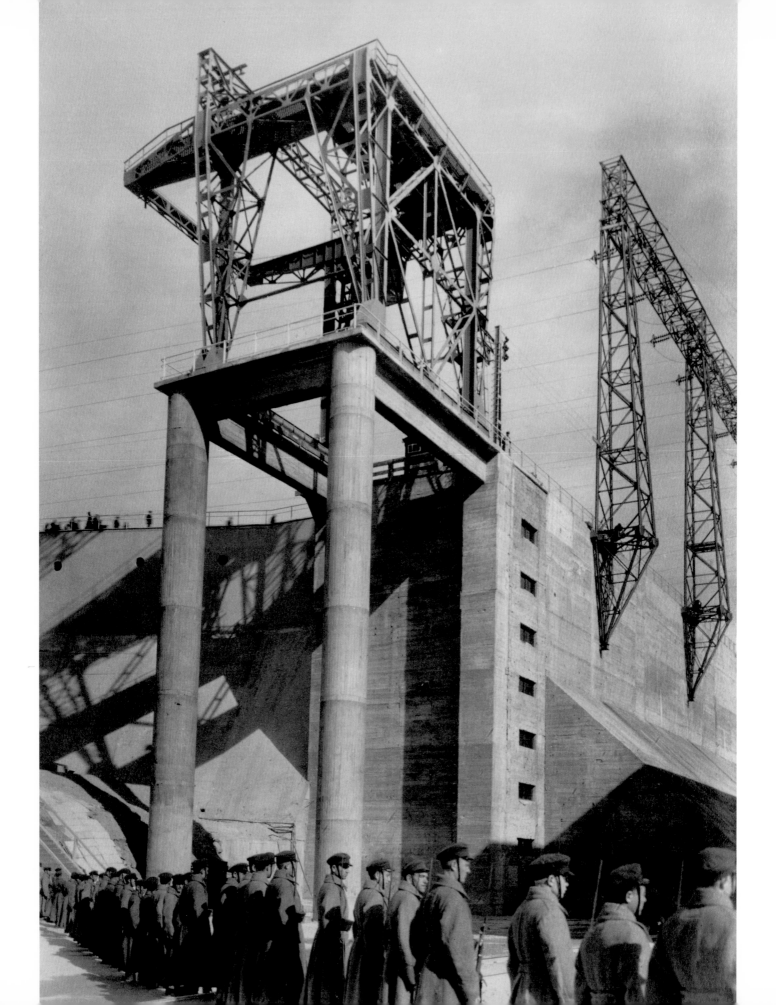

USSR: Dneprostroi

SOLDIERS GUARDING DAM

1930

USSR: Magnitogorsk

STATUE

1931

USSR: Tiflis

CAMELS USED FOR HAULING
ON BAKU OIL FIELDS

1932

124

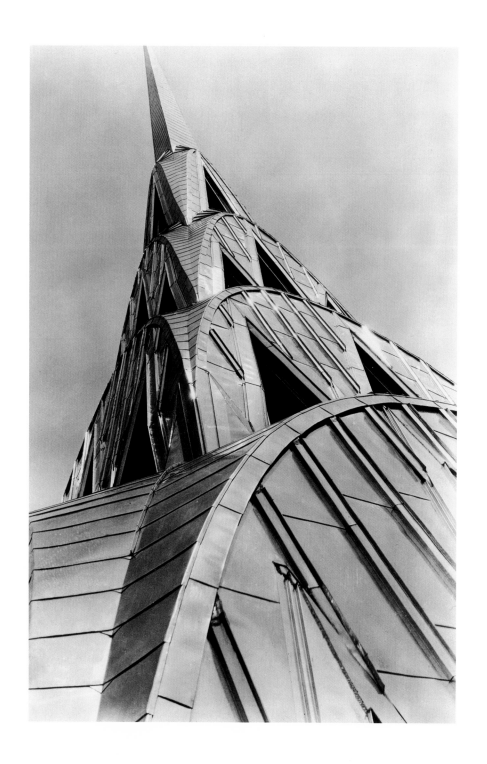

Chrysler Building

TOWER

1931

GEORGE WASHINGTON BRIDGE

1933

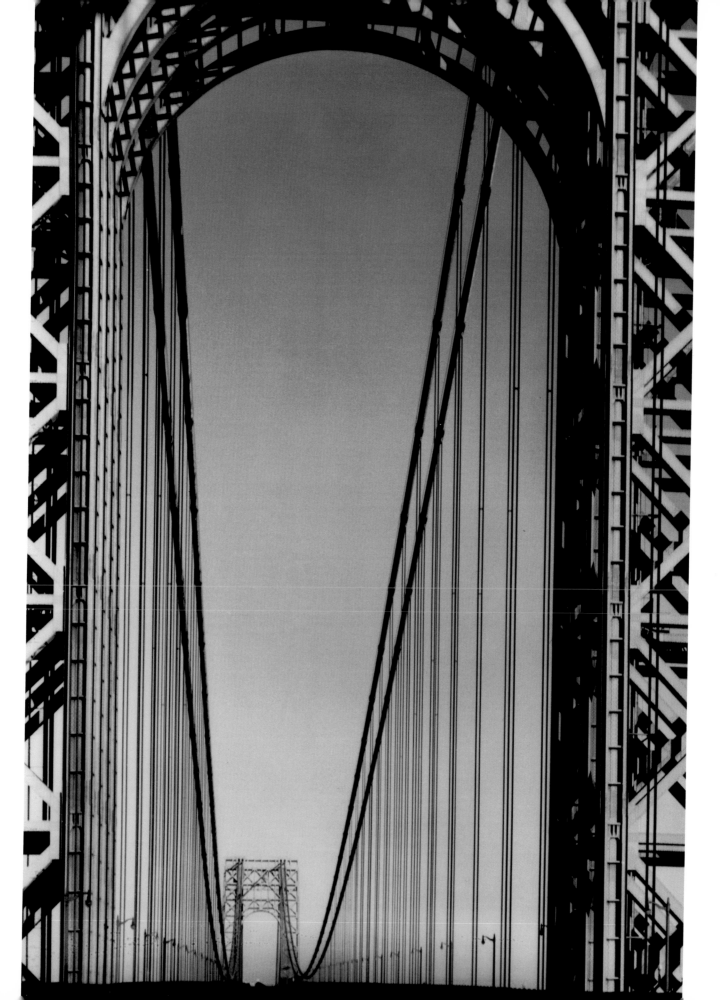

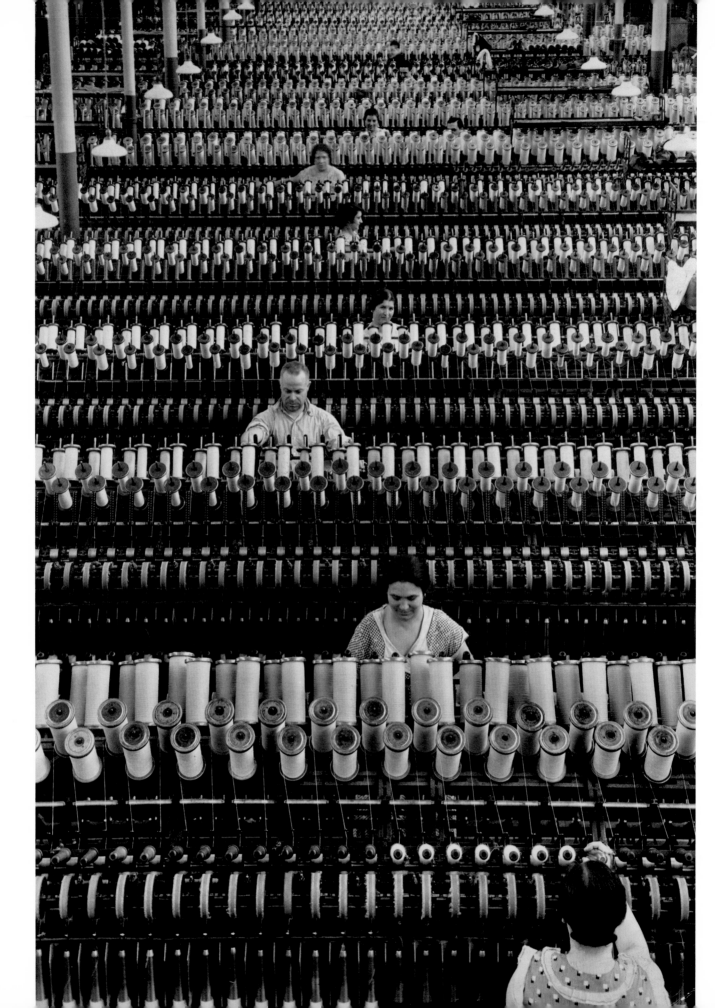

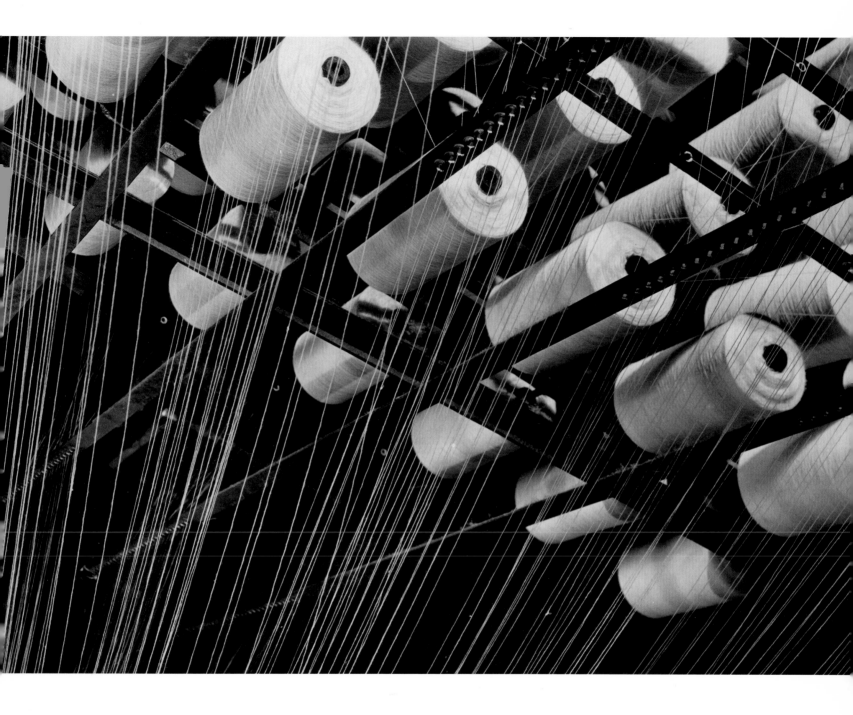

American Woolen

WORKERS AND SPOOLS

1935

American Woolen

SPOOLS

1935

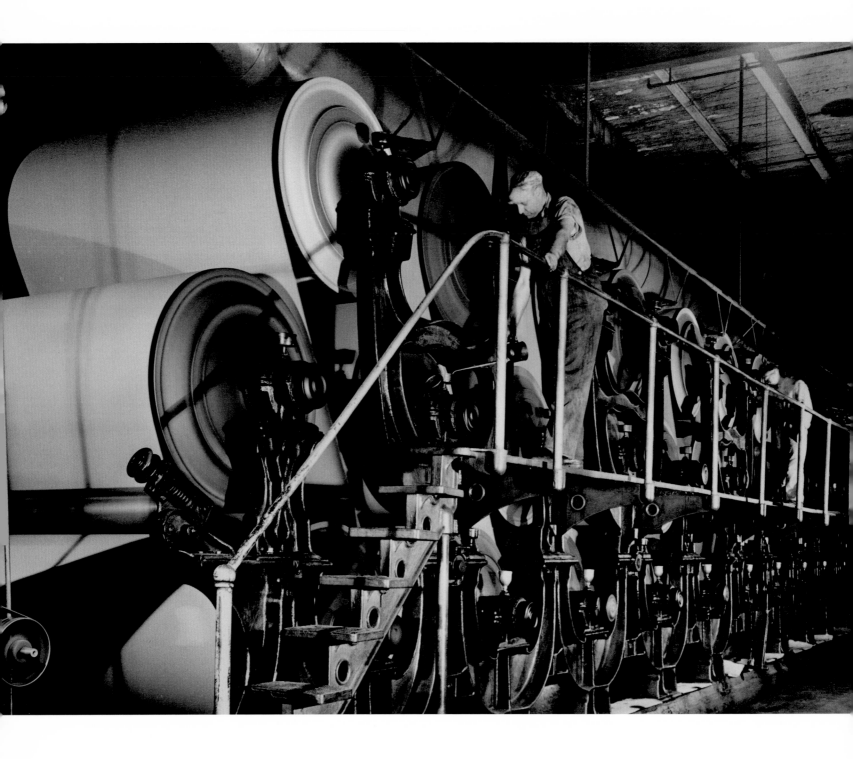

Flintkote

MAKING TARPAPER

1935

American Can

MAN AT PRESS

early 1930s

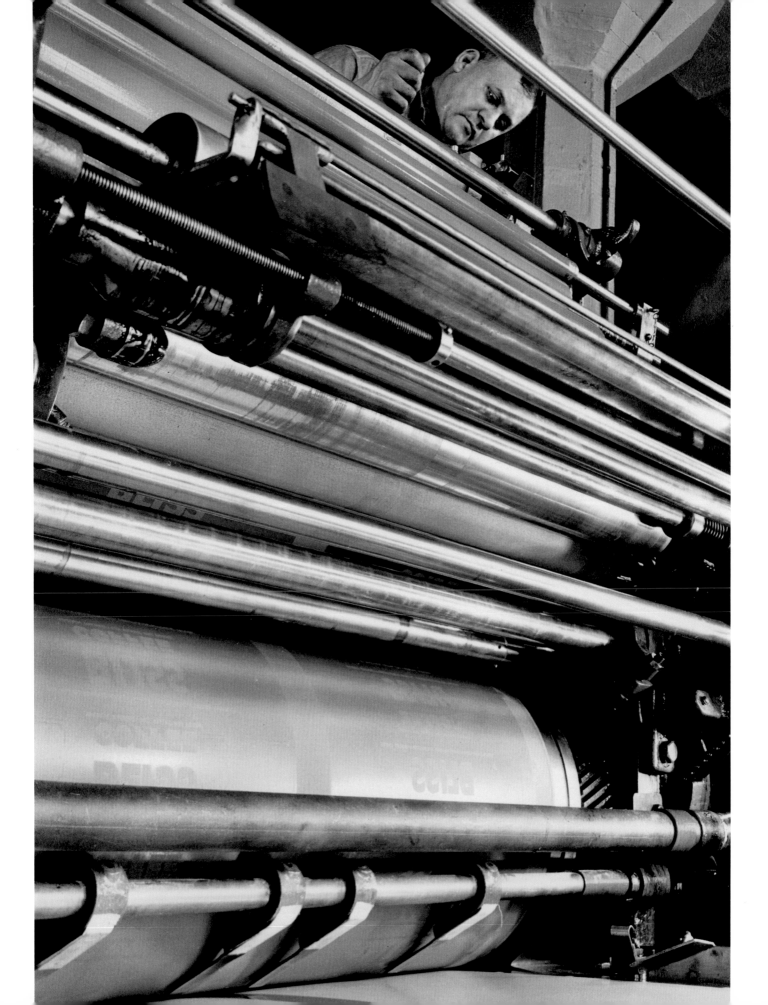

Armour

TAMALES

1934

American Can

Coffee Plantation

YOUNG WOMEN

1936

Campbell Soup

SOUP CANS

1935

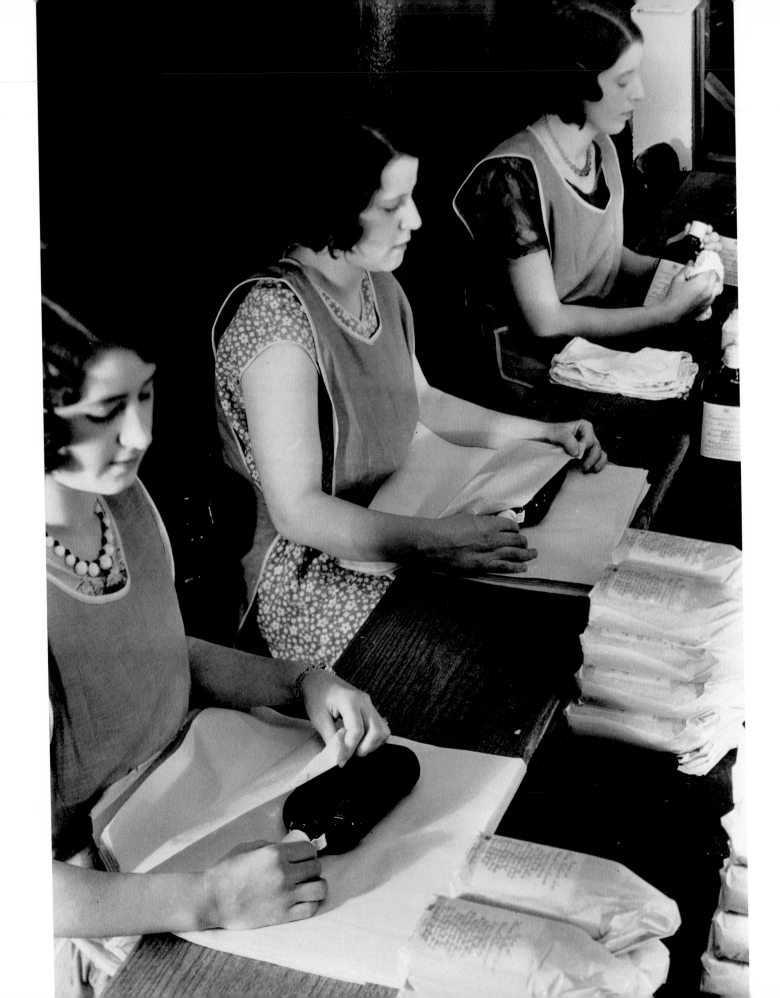

Hiram Walker
WRAPPING BOTTLES
early 1930s

Hiram Walker
BOTTLES
early 1930s

134

Owens-Illinois Glass

PEPSODENT BOTTLES

1932

Owens-Illinois Glass

FIVE-GALLON
WATER BOTTLES

1932

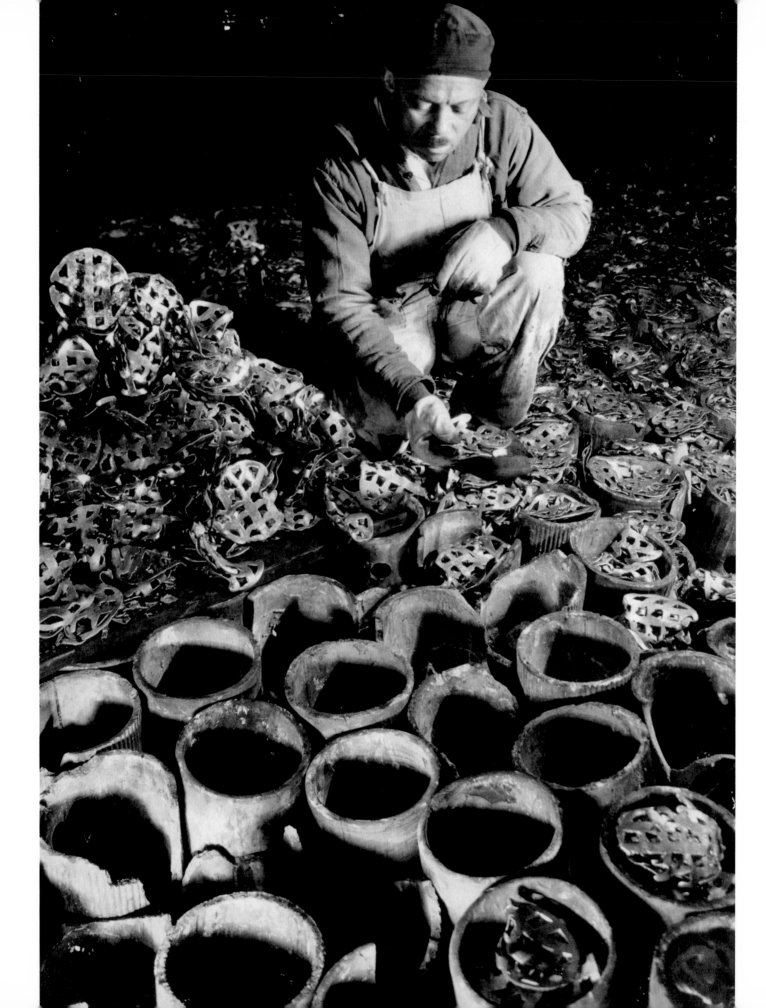

Sherwin Williams

SETTING LEAD

early 1930s

Sherwin Williams

MIXING MACHINE

early 1930s

138

International Silver

PLATING KNIVES

1933

International Silver

STAMPING DISHES

1933

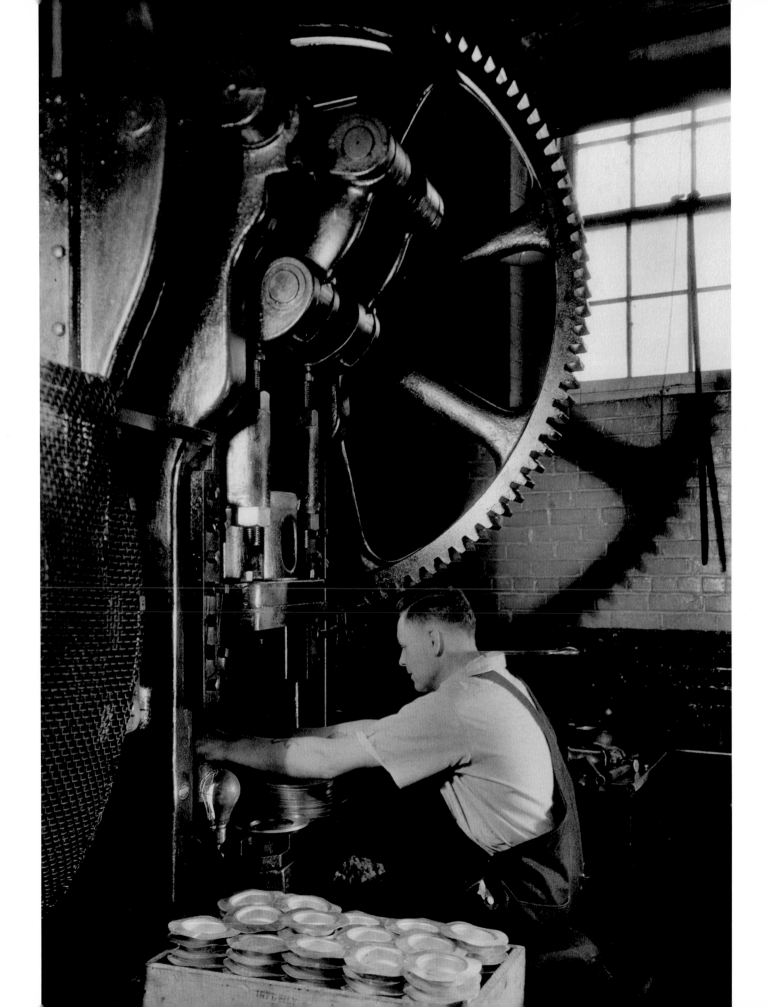

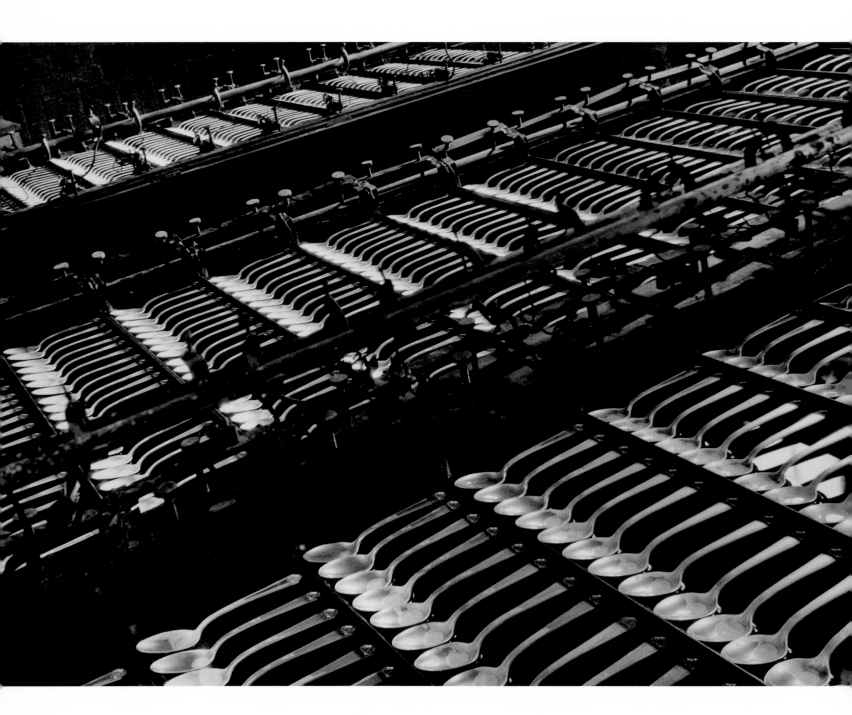

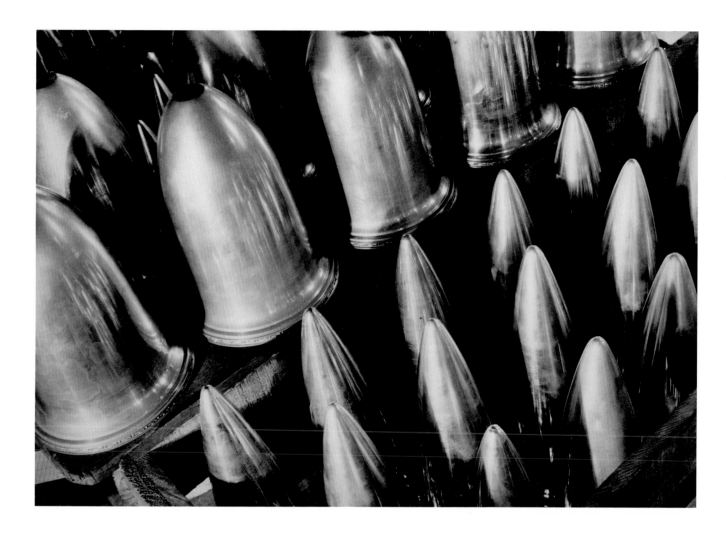

International Silver

Spoons

1933

International Silver

Vase Parts

1933

Steinway Piano

MAKING KEYS

1934

Steinway Piano

DRILLING FRAME

1934

Hearst

New York Times

NEWSPAPER PRINTING ROLLERS

ROUTING

1935

1930

146

Montgomery Ward

MAILING CATALOGS

1934

Montgomery Ward

MAIL ORDER DEPARTMENT

1934

Montgomery Ward

PAILS

1934

United Fruit

BANANAS

1930s

Wall Street

TELEPHONE OPERATORS

1936

American Can

Coffee Plantation

PICKING COFFEE BEANS

1936

General Motors

ASSEMBLY LINE

mid-1930s

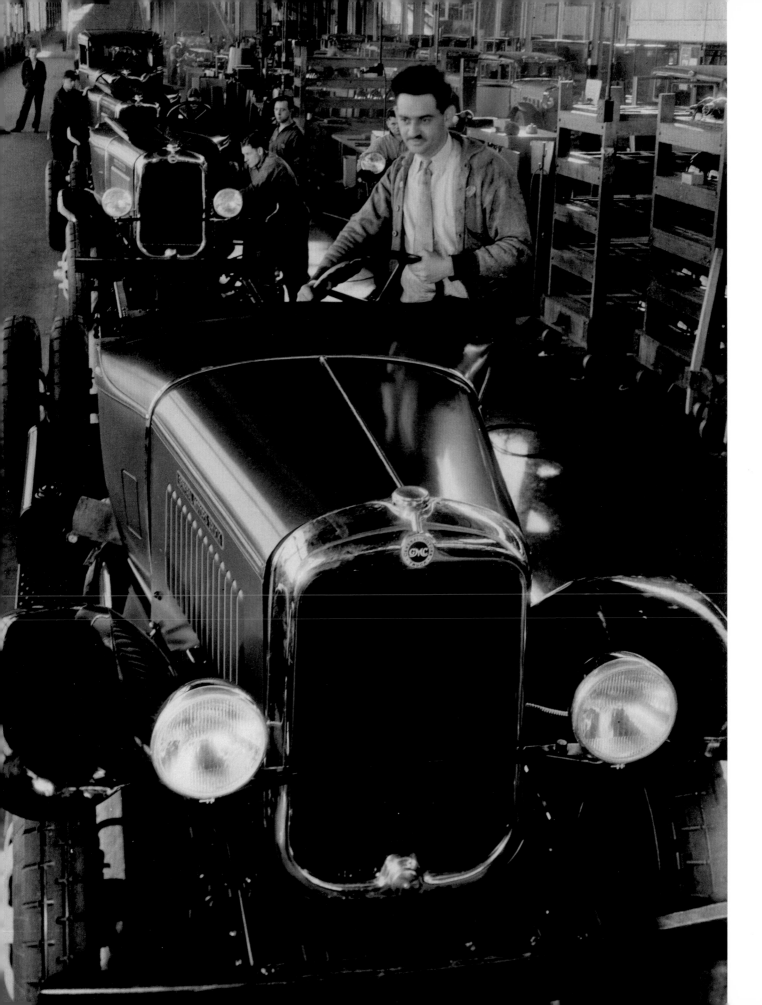

American Catalin

FLASK, CHEMICALS

early 1930s

Pan American Airways

Sikorsky S-42

PROPELLORS (Close-up)

1934

154

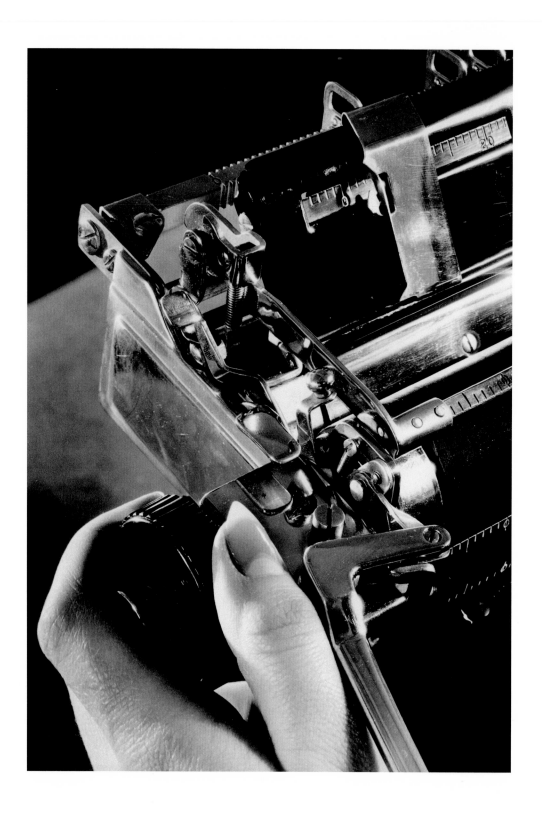

Royal Typewriter

HAND ON CARRIAGE

1934

Platinum Products

LEKTROLITE

1933

Platinum Products

T A B L E S E T T I N G
W I T H L E K T R O L I T E

1933

Martini & Rossi

C O C K T A I L H O U R

1935

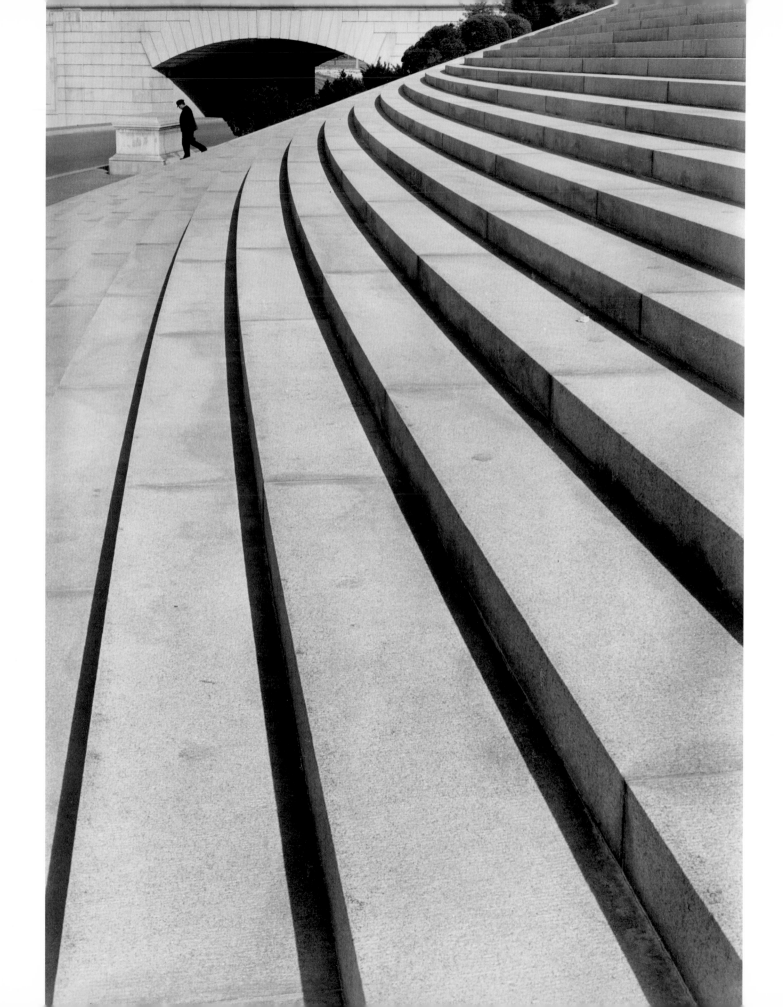

STEPS, WASHINGTON, DC

1935

Bermuda

COVERED WALKWAY

1932

162

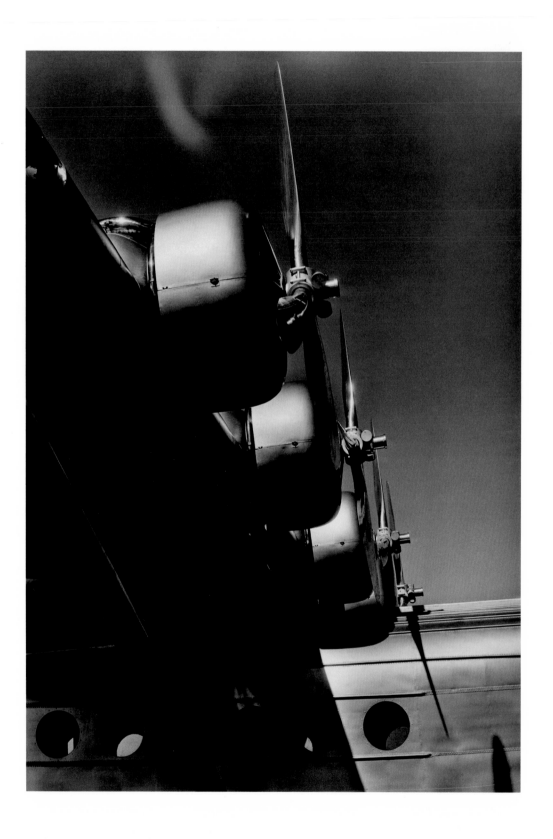

Pan American Airways

Sikorsky S-42

PROPELLORS

1934

Boulder Dam

TRANSFORMERS

1935

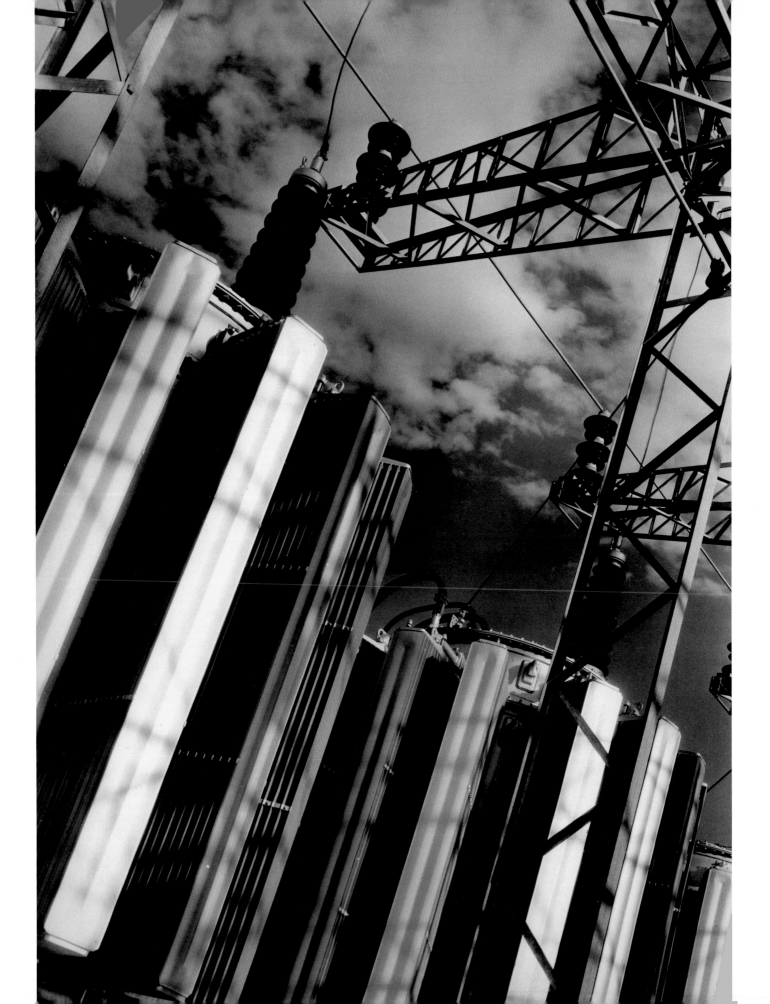

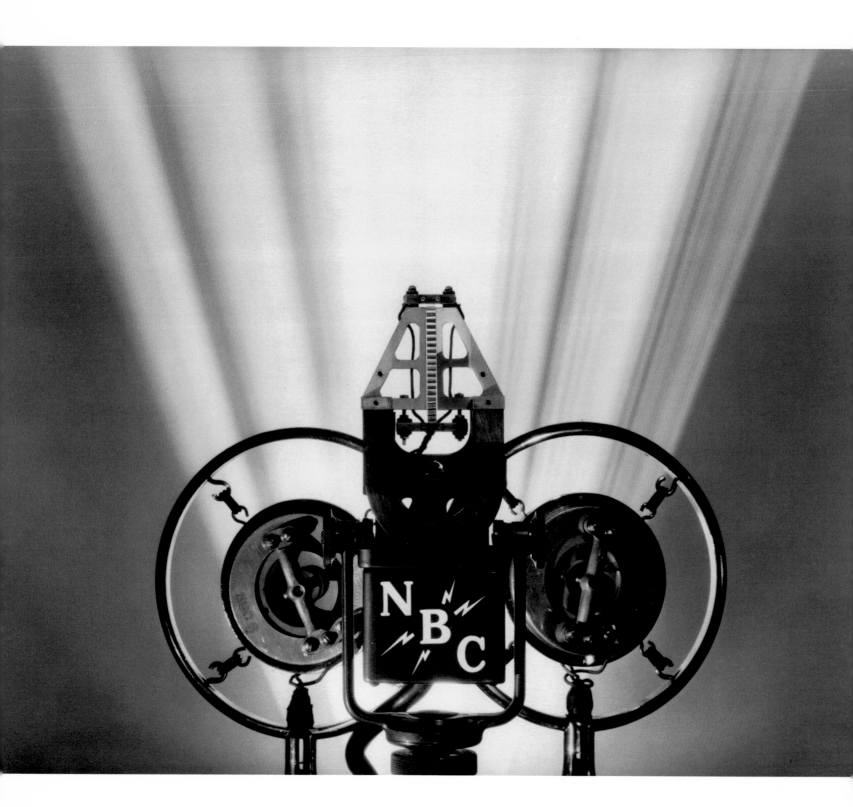

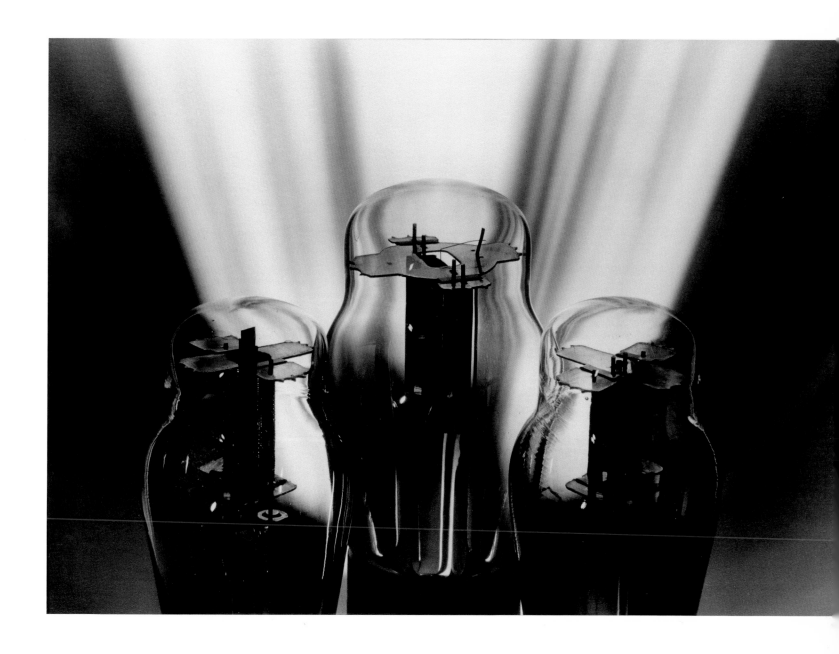

NBC Mural

MICROPHONE

1933

NBC Mural

RECEIVING TUBES

1933

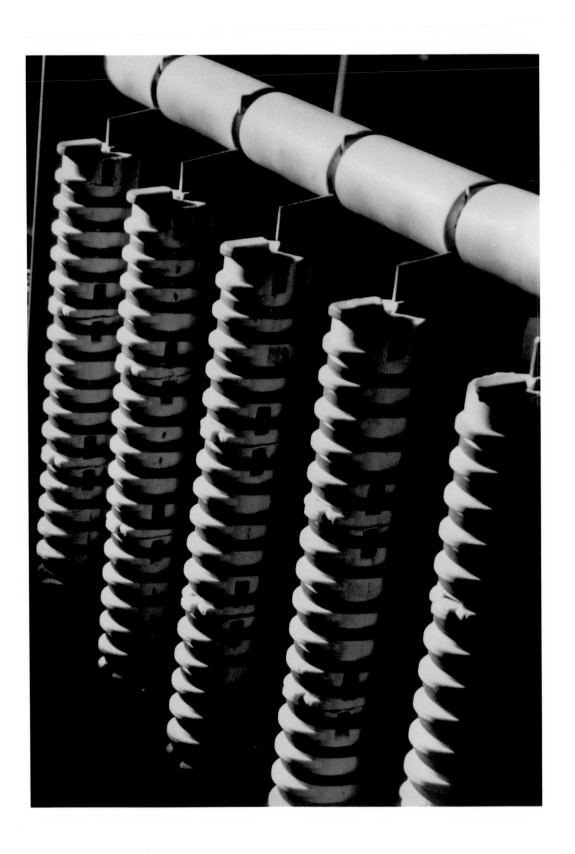

NBC Mural

RADIO PARTS

1933

NBC Mural

BULBOUS TUBES

1933

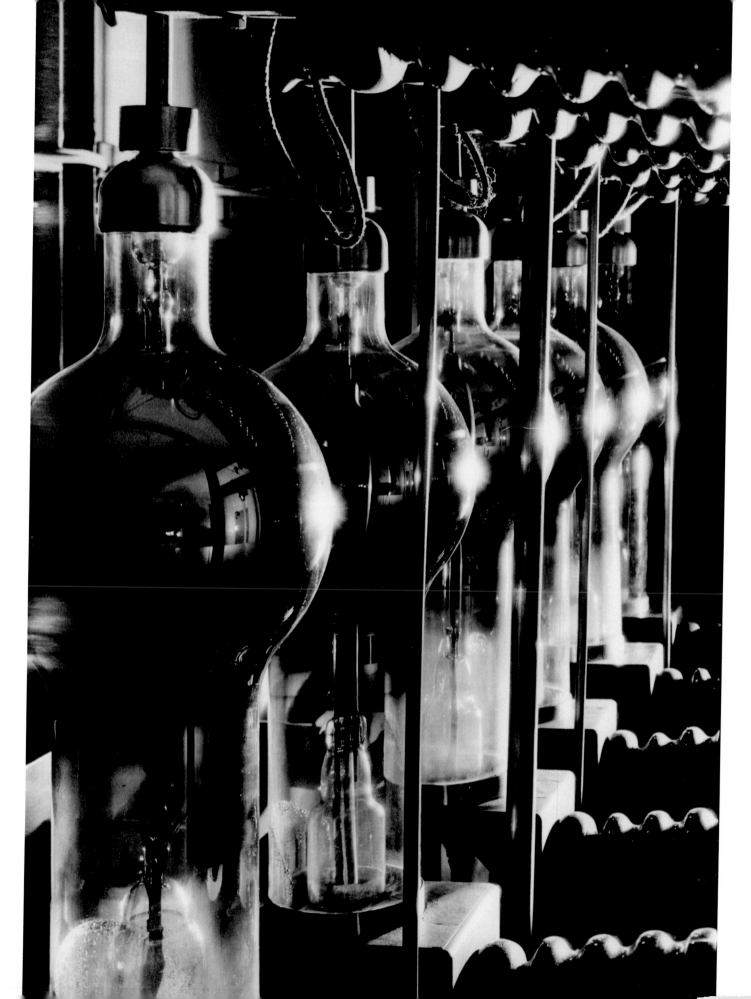

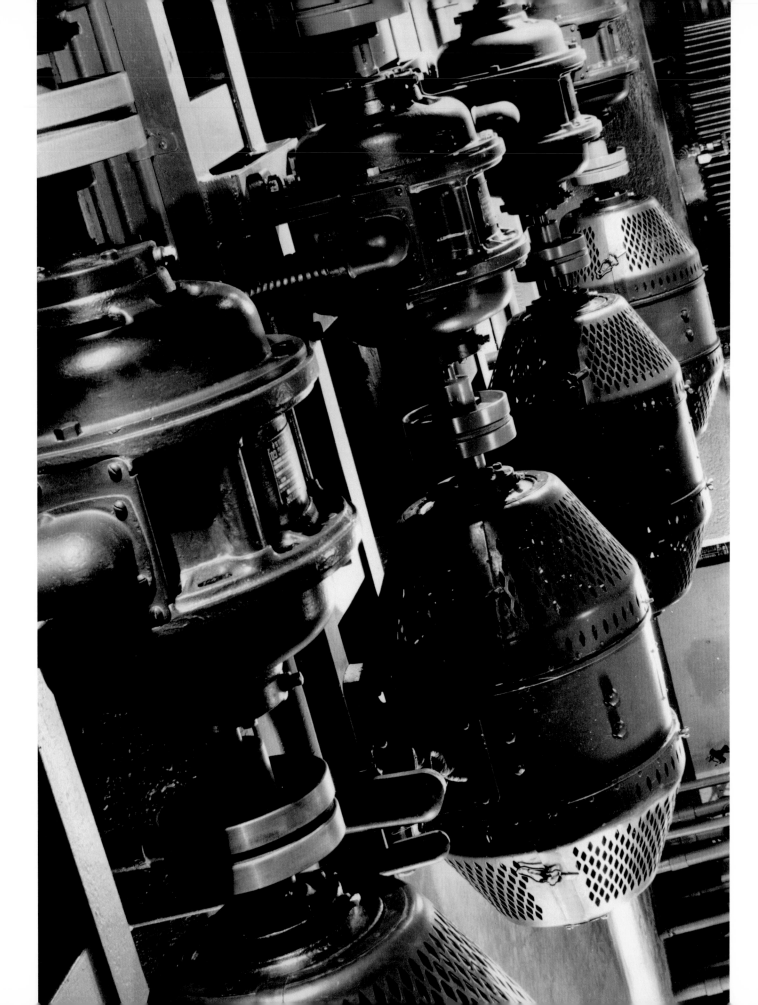

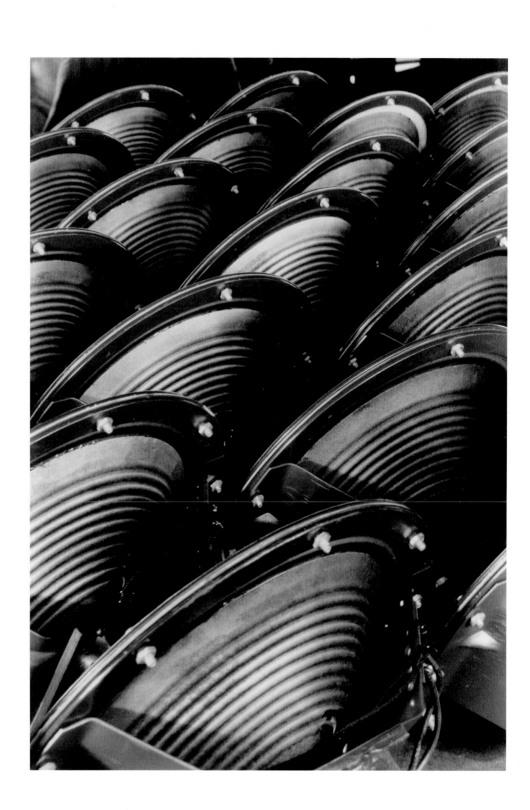

NBC Mural

ELECTRIC GENERATOR

1933

NBC Mural

SPEAKERS

1933

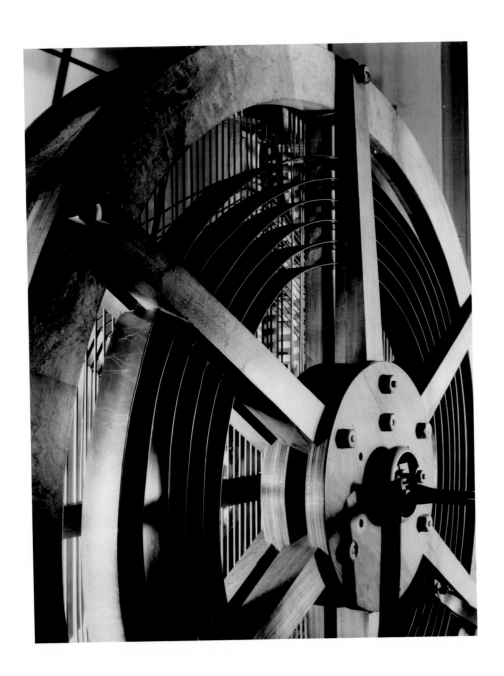

NBC Mural

HELIX

1933

NBC Mural

WAEF BROADCASTING TOWER

1933

A Chronology

In constructing this chronology, the author has relied heavily on Vicki Goldberg, *Margaret Bourke-White, A Biography* (New York: Harper and Row, 1986); Margaret Bourke-White, *Portrait of Myself* (New York: Simon and Schuster, 1963); and Jonathan Silverman, *For the World to See: The Life of Margaret Bourke-White* (New York: The Viking Press, 1983). Other occasional sources are noted in parenthetical references throughout.

Anthony Frederick Sarg (1880–1942)

MARGARET BOURKE-WHITE
IN GOWN FOR ARTISTS' BALL

1934

1870: Joseph White is born in Rochester, New York, into an Orthodox Jewish household, whose family had changed its name from Weiss. By the time he is an adult, he has set aside his Jewish heritage. As an engineer and inventor, he owns several hundred patents, including several for devices to simplify exposure settings on a camera.

1871: The National Woman's Suffrage Association meets in New York City to push for women's right to vote.

1874: Minnie Bourke is born into a poor Irish immigrant family in lower Manhattan. Eager for an education, she enrolls in classes at Pratt Institute when she is college age. She fosters learning, curiosity, and fearlessness in her children and encourages Margaret's interest in insects and reptiles.

1888: Kodak begins production of a lightweight, push-button camera. Users returned the camera and exposed film to Kodak for developing, thus eliminating the need for access to a darkroom. Kodak soon begins marketing the camera to women.

1889: A female reporter for the *New York World* travels around the world in just over seventy-two days.

1897: An advocate of women in photography, Frances Benjamin Johnston writes "What a Woman Can Do with a Camera" for *Ladies Home Journal.*

1898: Minnie Bourke and Joseph White are married 14 June in New York City.

1904: Margaret Bourke-White is born 14 June in New York City. Her family soon moves to Bound Brook, New Jersey.

1916: Publication of Joseph Pennell's *Pictures of the Wonder of Work*, showing the industrial landscape as art.

1917: The first woman is seated in the U.S. House of Representatives, and New York State grants women the right to vote.

1919: Joseph White photographs a pile of ore on a family trip to Niagara, New York.

1920: The 19th Amendment is ratified, giving women the right to vote in national elections.

1921: Bourke-White starts college at Columbia University in New York City.

1922: Joseph White dies 18 January.

1922: Bourke-White enrolls in a photography class taught by Clarence H. White during the spring semester and befriends photographer Ralph Steiner, who gives her technical advice for years to come.

1922: Bourke-White is a photography counselor at a summer camp in Connecticut.

1922: For her second year of college Bourke-White transfers to the University of Michigan to study herpetology and joins the yearbook staff as photographer.

1923: The first issue of *Time* magazine appears in March, marking the launch of Henry Robinson Luce's media empire.

1924: Bourke-White is engaged to Everett "Chappie" Chapman, a senior engineering student at the University of Michigan. They arrange two events to sell her photographs late in May. They marry on 13 June.

1924: Bourke-White visits her mother in Cleveland during the summer and explores the industrial side of the city.

1924: Chappie accepts a teaching job at Purdue University, where Bourke-White enrolls for her fourth year of college.

1924: Late in the year Bourke-White, sensing her marriage is in trouble, terminates a pregnancy.

1925: Chappie accepts a job at Lincoln Electric Company in Cleveland. Bourke-White moves with him and takes night classes at Case Western Reserve, majoring in education.

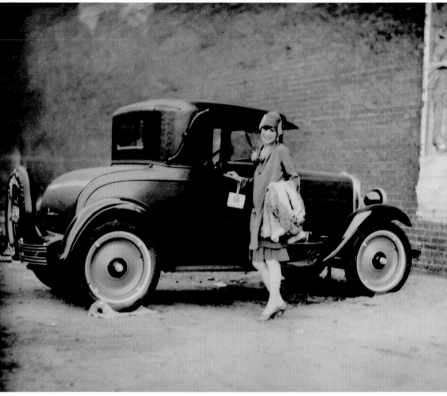

174

Gordon Conner

PORTRAIT OF
MARGARET BOURKE-WHITE

1920s

Anonymous

MARGARET BOURKE-WHITE
WITH FUR COAT AND NEW CAR

ca. 1928

1925: Luce and Briton Hadden, founders of Time Inc., move their company offices to Cleveland in August.

1926: Bourke-White leaves her husband. She does not publicly admit to this marriage until years later, and she shaves two years off her stated age. She begins using the surname "Bourke White," initially without a hyphen.

1926: Attracted by its beautiful waterfalls and good biology department, Bourke-White transfers to Cornell University. She sells her pictorialist-inspired photographs of campus buildings and environs.

1927: Ford Motor Company opens the River Rouge plant in Michigan, the world's largest manufacturing complex. Ford hires Charles Sheeler to photograph the plant. His images are published in periodicals in the United States, Europe, the Soviet Union, and Japan (Karen Lucic, *Charles Sheeler and the Cult of the Machine* [Cambridge: Harvard University Press, 1991], 89–90).

1927: *Machine-Age Exposition* opens in New York in May, focusing on the industrial age with displays of machinery and art.

1927: After graduating from Cornell, Bourke-White moves to Cleveland, where a number of Cornell-trained architects are in practice, to become an architectural photographer.

1927: Time Inc. moves its headquarters back to New York City in the summer.

1927: Bourke-White sells her first commercial photograph, which is reproduced in *The Clevelander*, a magazine of the Cleveland Chamber of Commerce. Subsequently, the Union Trust Company publishes her image of the High Level Bridge on the cover of its monthly magazine and becomes a regular client.

1927: Bourke-White learns to use artificial light and improves her darkroom skills.

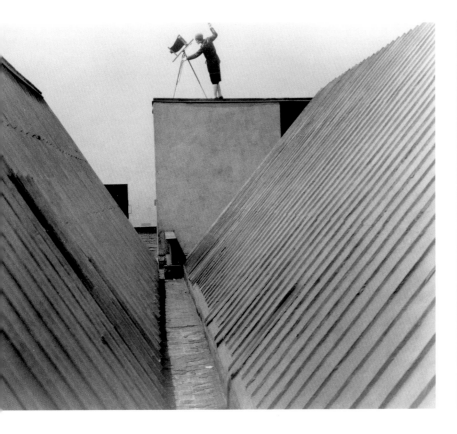

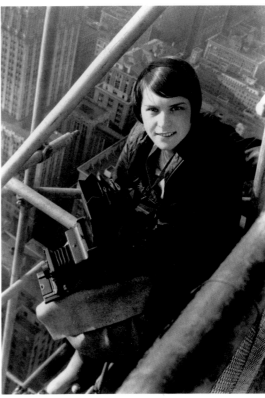

1927: The Van Sweringen brothers, builders of Cleveland's Terminal Tower and developers of the wealthy suburb of Shaker Heights, hire Bourke-White as company photographer.

1927: Bourke-White begins photographing the process of steel making inside the Otis Steel Mill, having persuaded the company president to exempt her from the company's rule barring women from entering the mill.

1928: By February, after months of effort, Bourke-White finally achieves good prints inside the Otis Steel Mill, using magnesium flares for light and a new photographic paper with higher silver content. The president of Otis Steel purchases eight photographs and commissions more.

1928: Bourke-White rents a studio in the newly completed Terminal Tower in March.

1928: *House & Garden* publishes four Bourke-White photographs in an article titled "In a Garden in Cleveland" in April, the first time a national magazine reproduces her work. Also in the spring her industrial photographs appear in newspapers.

1928: Bourke-White's photograph, *Otis Steel: 200 Tons, Ladle,* wins first prize at an exhibition at the Cleveland Museum of Art in May.

1928: Eugene O'Neill's play, *Dynamo,* opens. Bourke-White's photographs of dynamos at Niagara are used as stage sets for the play, and she becomes known as the girl who discovered the dynamo.

1928: In Germany Dr. Erich Salomon publishes the first candid photographs of important events (Gisele Freund, *Photography and Society* [Boston: David R. Godine, Publisher, Inc., 1980], 120).

1929: In January *Nation's Business,* with a circulation of more than 300,000, reproduces Bourke-White's *Otis Steel: Open Hearth.*

1929: Lincoln Electric Company commissions Bourke-White to photograph the inside of its factory.

Ralph Steiner (1899–1986)

MARGARET BOURKE-WHITE
ON ROOF IN CLEVELAND

ca. 1929

MARGARET BOURKE-WHITE
ON CHRYSLER
BUILDING SCAFFOLD

New York

1930

1929: In June and July Bourke-White takes on first assignments for *Fortune*, a new magazine published by Time Inc.

1929: Stock market crashes in October.

1929: Prototype for *Fortune*, first called *Power*, is produced, featuring Bourke-White's work.

1929: The Chrysler Corporation hires Bourke-White to photograph the construction of the Chrysler Building, Walter Chrysler's new skyscraper in New York City.

1930: The first issue of *Fortune* is released in late January.

1930: Bourke-White spends five weeks in the USSR over the summer, photographing industrial projects and installations throughout the country.

1930: Late in the year Bourke-White moves her studio from Terminal Tower in Cleveland to the Chrysler Building in New York City.

1930: Photojournalism advances in Germany with the development of a small 35-mm Leica camera with thirty-six exposures. Stefan Lorant initiates the concept of the photographic essay for the *Münchner Illustrierte Presse*. He refuses to accept any posed photographs for the magazine (Freund 1980, 124, 129).

1931: In February, *Fortune* publishes some of Bourke-White's photographs from the Soviet Union. Later that year Bourke-White publishes a book, *Eyes on Russia*.

1931: In August, Time Inc. moves its headquarters to two floors of the Chrysler Building (Robert E. Herzstein, *Henry R. Luce: A Political Portrait of the Man Who Created the American Century* [New York: Scribner's, 1994], 62–63).

1931: The Soviet government invites Bourke-White back to the USSR to photograph Magnitogorsk. She begins to view workers as an important subject for her camera.

1932: Bourke-White's accounts with the Chrysler Building are in arrears. In April a friend writes to the building treasurer on her behalf, arguing that the rent is too high considering the current economic downturn and asking for a reduction (Herman Seid to Harry C. Davis, 8 April). The treasurer does not yield, and Bourke-White begins paying off the rent in small increments, usually of one hundred dollars a month (Bourke-White to Davis, 14 April). By June she owes thirteen hundred dollars in back rent (Davis to Bourke-White, 6 June).

1932: Amelia Earhart is the first woman to fly solo across the Atlantic Ocean.

1932: Bourke-White travels again to the USSR. She works with moving cameras as well as still cameras—her first and last experiment with motion pictures. She focuses on rural areas instead of industry.

1932: Bourke-White writes and illustrates six articles about her trip to the Soviet Union, published in the *New York Times Magazine*.

1933: Financially this is not a good year for Bourke-White. Advertisers are cutting back, and she is barely able to find enough work to keep her business afloat. By July she owes more than forty-one hundred dollars in back rent (Bourke-White to Harry C. Davis, 21 April and 25 July). Some months she is able to pay two hundred dollars, but other months she can manage only one hundred dollars (Bourke-White to Davis, various dates in 1933 and early 1934). The building treasurer declines her offer of photographic services in lieu of rent (Bourke-White to Davis, 26 April; and his response, 27 April).

1933: *Fortune*'s associate editor Ralph McAllister Ingersoll complains to Bourke-White (4 March) about her photographs for an article on New York's transportation system. Implicitly, the criticism points up the fact that she is using a large-format camera, considered old-fashioned equipment, and not a 35-mm.

1933: Further financial woes arise for Bourke-White when *Fortune* lowers its fees from four hundred to three hundred dollars per job (10 March).

1933: Bourke-White receives no bonus from *Fortune* in July (Ingersoll to Bourke-White, 28 June).

1933: The play *Tobacco Road*, based on Erskine Caldwell's novel (1932) describing rural poverty in the South, opens on Broadway, 4 December.

1934: The Depression worsens, and unemployment rises. Companies cut back on advertising, a major source of Bourke-White's income (Goldberg 1986, 139–140). At the beginning of the year she owes her landlord more than fifty-six hundred dollars (Harry C. Davis to Bourke-White, 15 January). The treasurer realizes she will never catch up on her account and demands that she start paying three hundred dollars a month, still less than her actual rent, or she will be locked out of her studio (Davis to Bourke-White, 8 February and 28 April). By late spring her account is turned over to the landlord's attorney, who demands payment in full (Francis B. Upham Jr. to Bourke-White, 25 May). As this is impossible, she meets with the building treasurer. He wants her to take a cheaper studio in the building, but she argues that even that rent is too high; she is able find twice the space for half the price in other buildings. Owing six thousand dollars in back rent, she proposes paying one thousand dollars to settle the account and threatens to declare bankruptcy if the offer is not accepted ("Notes after Conversation with Mr. Davis," n.d.). On 4 September she turns over the keys and vacates her studio in the Chrysler Building (C. C. Lawrence to Ethel P. Fratkin, 5 September). See Goldberg 1986, 139, for an account of Bourke-White's finances in 1934 and 1935.

1934: Bourke-White moves her studio to the mechanical room of a building at 521 Fifth Avenue, accessible only by taking the elevator to the top floor, then climbing up a steep flight of stairs. The space also has a terrace for her pet alligators. Wanting to make the new studio as elegant as her Chrysler studio, she hires John Vassos to design the interior.

1934: The Midwest experiences the worst drought in American history. *Fortune* commissions Bourke-White and writer James Agee to document the disaster.

1934: *Machine Age* exhibition at the Museum of Modern Art in New York City focuses on the aesthetic of machine purity by displaying machine objects such as ball bearings, springs, and propellors (Richard Guy Wilson, Dianne H. Pilgrim, and Dickran Tashjian, *The Machine Age in America 1918–1941* [New York: Harry N. Abrams, Inc., 1986], 52–53).

1934: Dispute arises in August over the prior publication by the Newspaper Enterprise Association (NEA) of Bourke-White's drought pictures taken for *Fortune*.

1934: Bourke-White receives commission to produce two large photographic murals for the rotunda of Rockefeller Center in New York City. The murals focus on radio production and transmission. Bourke-White receives other mural commissions, including one to decorate the Soviet Consulate in New York City with images she took in the USSR.

1935: Bourke-White's finances do not improve, and she is living hand-to-mouth. She barely escapes eviction from her apartment and experiences ongoing struggles with *Fortune* over fees and candid versus posed photography.

Lotte Eckener (1906–1995)

MARGARET BOURKE-WHITE
IN HER STUDIO IN
THE CHRYSLER BUILDING

ca. 1931

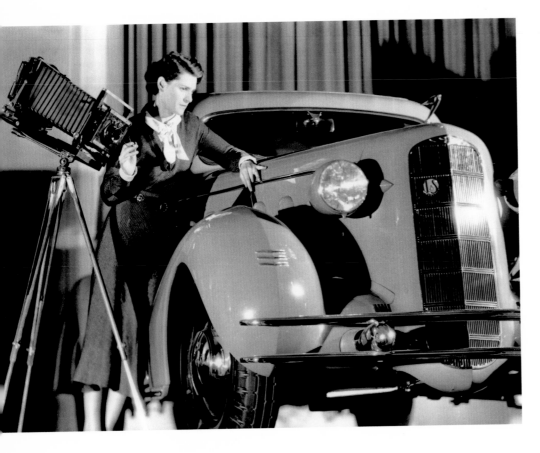

MARGARET BOURKE-WHITE
PHOTOGRAPHING
AUTOMOBILE FOR LASALLE

ca. 1933

1935: Bourke-White signs a contract with Eastern Airlines in late October to document various aspects of air travel.

1936: The movie, *Modern Times*, is released, with Charlie Chaplin as a factory worker driven mad by the machine.

1936: Bourke-White meets Erskine Caldwell in January.

1936: In the spring Bourke-White resorts to sharing her studio with a commercial photographer in exchange for half the rent. Growing tired of commercial work, she turns down assignments and no longer needs as much space.

1936: Bourke-White signs an exclusive contract with NEA and Acme Newspictures, Inc., in March, which guarantees her one hundred dollars a week in exchange for a minimum of forty-eight days of work a year. The contract allows Acme to act as Bourke-White's sole agent in soliciting future commercial assignments with advertisers and magazines in exchange for twenty-five percent of the commission (Fred S. Ferguson to Bourke-White, 11 March).

1936: During the summer Bourke-White and Caldwell travel by car through the American South, working on their collaborative project on sharecroppers.

1936: NEA and Acme Newspictures, Inc., terminate their contract with Bourke-White in August after she repeatedly flouts its exclusivity clause.

1936: Bourke-White signs an exclusive contract with Time Inc. in September, which gives her twelve thousand dollars to work ten months a year for *Life* magazine and allows her two months of free time for noncompeting assignments.

1936: Bourke-White travels to New Deal, Montana, in October for her first photo shoot for *Life*.

1936: The first issue of *Life* is released on 23 November with a cover photograph by Bourke-White. This publication competes with the *Saturday Evening Post* and *Collier's*.

1937: Bourke-White's work appears in an exhibition at the Museum of Modern Art.

1937: *Look* magazine begins publication, in direct competition with *Life*.

1937: By February Bourke-White and Erskine Caldwell are living together at the Mayflower Hotel in New York City.

1937: Bourke-White's and Caldwell's book, *You Have Seen Their Faces*, is published in November. As in *Life*, photographs tell the story.

1938: In the spring, spurred by the success of *You Have Seen Their Faces*, Bourke-White and Caldwell travel to Czechoslovakia and Hungary to gather material for a book on the Sudetenland crisis, *North of the Danube*.

1938: Bourke-White and Caldwell buy a house in Darien, Connecticut, in October.

1939: Bourke-White and Caldwell marry in February.

1939: Ralph McAllister Ingersoll leaves *Life* in April to join *PM*, a photographic newspaper in competition with *Life*.

1939: *Life* assigns Bourke-White to photograph London preparing for war, and she travels to Romania, Turkey, Syria, and Egypt from December into the next year.

1940: Construction of Fort Peck Dam, Montana is completed.

1940: Bourke-White quits *Life* to work for Ingersoll's *PM*. The first issue is published 18 June for a price of five cents as compared with two cents for the *New York Times*.

1940: *PM*'s liberalism leads to anonymous allegations that its staff members are Communist Party members or sympathizers. FBI opens a file on Bourke-White.

1940: In April, with *PM* failing, Bourke-White begins negotiating again with *Life*, which hires her on contract.

1940: Bourke-White and Caldwell begin a joint assignment for *Life* on 1 November, traveling around the U.S. for a report on "the state of America." *Life* does not use the material, but Caldwell and Bourke-White publish another book, *Say, Is This the USA?*

CA. 1940: Bourke-White and Caldwell buy a house in Arizona.

1941: After 3,180 performances, Caldwell's play, *Tobacco Road*, closes on Broadway.

1941: Bourke-White and Caldwell begin a trip through China into the USSR on 20 March.

1941: Bourke-White and Caldwell arrive in Moscow in late April. In June they travel to the Ukraine and Black Sea area. They return to Moscow when Germany attacks the USSR; Bourke-White is the

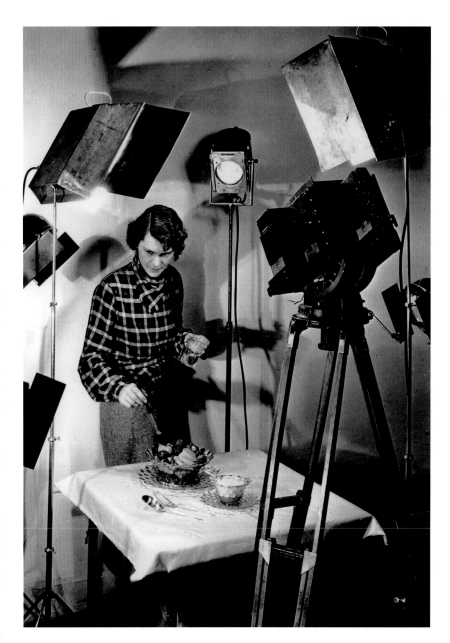

only foreign photographer in Moscow at the time, staying until 23 September. She photographs numerous German bombings of the city.

1942: Bourke-White writes *Shooting the Russian War*.

1942: This spring Bourke-White is the first woman accredited as a war correspondent by the U.S. Air Force. In early August she goes to England to cover the arrival of the first thirteen U.S. Air Force B-17s for the start of bombing raids on Germany.

MARGARET BOURKE-WHITE
TAKING FOOD SHOTS

ca. 1935

PHOTOMURAL INSTALLED
IN SOVIET CONSULATE

1934

1944: Bourke-White returns by convoy to Italy on a second tour in the fall, photographing Allied-occupied Rome and later working with the 88th Division near Bologna. Her three hundred photographs are later stolen en route to the U.S.

1945: From January to March, while in Italy, Bourke-White finishes writing another book, *Forgotten Front.*

1945: Traveling with Gen. George Patton's army through Germany from March to October, Bourke-White photographs prisoners at Buchenwald in April.

1945: Before Germany's surrender to the Allies (7 May), Bourke-White accepts a *Life* assignment to photograph Germany's major industrial centers from the ground and the air as they are captured. She is among the first to photograph the devastation of German cities as well as the horrors of the concentration camps. *Life* does not publish her photographs, which become the basis of a new book, *"Dear Fatherland, Rest Quietly": A Report on the Collapse of Hitler's Thousand Years* that Bourke-White writes in the winter of 1945–1946.

1946: Bourke-White travels in India from March to October on assignment for *Life.*

1946–1947: During the winter, while living in the U.S., she attempts to write a book about India but decides to return there to gain a better understanding of the country.

1947: *Real Life Comics* publishes an issue devoted to Bourke-White's life.

1947–1948: Bourke-White makes a second trip to India from September to January on assignment for *Life* and CBS. Traveling throughout the country with Lee Eitingon, a reporter for *Life*, the two women cover the civil unrest accompanying the partition of India. Bourke-White is the last journalist to see Gandhi alive, interviewing him hours before his assassination.

1948: In February Bourke-White begins writing *Halfway to Freedom* on the partition of India, completing it in March 1949.

1942: Caldwell files for divorce in November.

1942: Bourke-White's convoy is torpedoed en route to North Africa on 22 December. After eight hours in lifeboats, she and the other passengers are rescued by a British destroyer.

1943: Bourke-White is the first woman to accompany an air force crew on a bombing raid, flying on 22 January to German-held El Aouina Airfield near Tunis.

1943: In the late summer and fall Bourke-White is assigned to Army Supply Services in Italy.

1943–1944: Bourke-White photographs areas around Naples and Monte Cassino during the fall and into the new year.

1944: In the spring Bourke-White recounts her experiences on the Italian front in a book, *They Called It "Purple Heart Valley."*

1949–1950: Bourke-White covers South Africa for *Life* from December to April, photographing, among other subjects, black South African miners.

1951: In the spring Bourke-White photographs the Strategic Air Command for *Life*.

1951: Columnist Westbrook Pegler writes several articles (4 September–9 September) accusing Bourke-White of Communist sympathies, criticizing access she was given for the story on the Strategic Air Command, and using Bourke-White's connection with *Life* to attack Henry Luce, owner of Time Inc.

1952: Bourke-White is on assignment in Japan and Korea for *Life*.

1953: Bourke-White photographs Jesuits for *Life*, traveling to Maine, California, and British Honduras. She begins to feel the first symptoms of Parkinson's disease.

1955: *The Family of Man* exhibition opens at the Museum of Modern Art, including photographs by Bourke-White. This photography exhibition travels to more than thirty countries and is seen by approximately nine million people.

1955: Bourke-White begins writing her autobiography, *Portrait of Myself*.

1957: Bourke-White's last story for *Life* is published. Parkinson's disease prevents her from working as a photojournalist.

1959: Bourke-White undergoes brain surgery in January to slow the progression of Parkinson's disease.

1961: A second brain operation in January, to alleviate the symptoms of Parkinson's disease, affects her ability to speak.

1961: *Life* runs a story on Bourke-White's convalescence, photographed by Alfred Eisenstaedt.

1963: *Portrait of Myself* is published and becomes a bestseller.

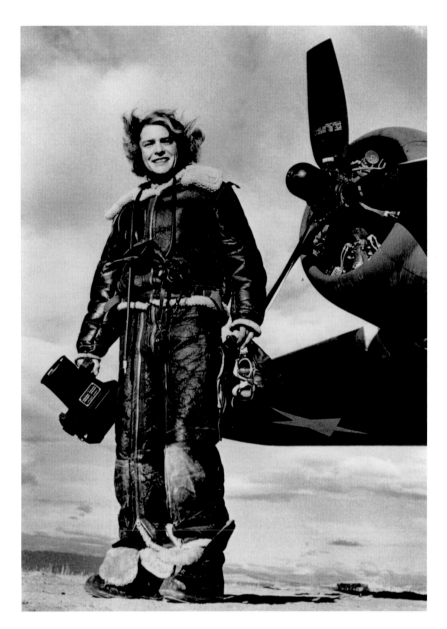

1969: Bourke-White officially retires from *Life*.

1971: Bourke-White dies in Darien, Connecticut, on 27 August.

1971: *Look*, a major competitor to *Life*, ceases publication.

1972: *Life* ceases publication.

1978: *Life* resumes publication, but as a monthly magazine. ■

MARGARET BOURKE-WHITE IN HIGH-ALTITUDE FLYING SUIT

1943

Appendix

1929

8 May. *Time* publisher Henry Robinson Luce to Bourke-White (telegram)
Harold Wengler has shown me your photographs. Would like to see you. Could you come to New York within a week at our expense. Please telegraph when.

14 May. Luce to Bourke-White (telegram)
May we borrow one photo Otis steel mills for experimental gravure work. Please wire collect.

22 May. *Time*'s managing editor, Parker Lloyd-Smith, to Bourke-White
About expenses. I thought the idea that we discussed over cocktails was pretty sound. We should naturally not expect you to make a trip to Butte, Montana, or New Orleans out of your own pocket. On the other hand, I think you might stand your living expenses when you are near home.

10 June. Lloyd-Smith to Bourke-White
This is to inform you officially of what you might conceivably have suspected—that we are glad to accept your proposition of giving us half your time from July 1, the cash consideration being $1,000 a month.

16 June. Bourke-White to Lloyd-Smith
My excitement about beginning on *Fortune* is entirely spoiling me for gardens. . . . Remembering that the first of July happens to fall on Monday, I shall be standing ready with my camera in my hand at the stroke of twelve, if you wish, on the night of the thirteenth. How soon may I begin talking about *Fortune*? I have been very close-mouthed about it, thinking that was only proper. Since the red-seal letter came I have mentioned it in whispers to three vice presidents in three banks, and the Van Sweringen publicity manager and it has been met with the most intense interest. Please let me know when I may talk a little louder. I like your attitude, and you are the sort of people I shall enjoy working for.

26 July. *Fortune* writer Dwight Macdonald to Bourke-White
Parker has just shown me the glassmaking series. It's very fine—even better than I anticipated. You certainly got a great deal out of

your material. . . . Your pictures fit in well with the story, bringing out the craftsman very dramatically. It will be a great combination of pictures and text, I think.

4 September. Lloyd-Smith to Bourke-White

In making up the first pages of Vol. I, No. 1, the other day we were both struck by the difficulty which arises from the similarity in the sizes of your photographs. In order to arrive at a workable variation in size we should have to do a lot of talking and laying out together. But will you try on the Great Lakes to make some pictures in the wide size, as well as some in the vertical size? . . . You will also be glad to know that we have almost filled our advertising quota for 1930.

19 December. *Fortune* associate editor Alan Jackson to Bourke-White

Herewith our plans for the Texas hegira. Mr. Keep will leave New York at 5:10 on the twenty-fifth as I told you by telegram. . . . I understand that you and Mr. Keep have never been introduced. I don't know what I can do about that. . . . At any rate, you will be glad to hear the Mr. Keep is extremely nice, has curly yellow hair, and, the last time I saw him, a small mustache.

22 December. Bourke-White to Jackson

Of course, all the information about the blond curly hair was received with much interest—although I could perhaps live without the mustache if anything has happened to it since you saw it last. I don't see the need of rising to receive me at six-fifteen. It seems a rather unfortunate hour to meet even a blonde mustache. However, when he does seek me out, you can tell him that I shall be wearing either burgundy-red, or purple.

26 December. Bourke-White's secretary to Macdonald

You will be interested to hear that Miss Bourke-White is going on to California to inspect 'movie making' and will be glad to give you a complete report the next time she is in New York.

1933

13 January. *Fortune*'s associate editor Ralph McAllister Ingersoll to Bourke-White

Confirming this morning's chat, we have set down in your schedule the fact that you are undertaking the following illustrations:

 1. Port of New York Authority

We will provide you in a few days with a list of the works under the control of this body. Our story's to be a major effort, perhaps broken into two parts, and much stressed will be the engineering miracles which remain miracles whether New York is taking them for granted or not. Hence, in line with our theme are pictures of their bridges, tunnels, freight handling devices, etc., which *suggest engineering accomplishment.* We shall also use photographs of individuals, but as I explained to you, we will get these elsewhere.

 2. General Motors

 3. International Harvester

Both of these are major efforts too. Pictures should be taken on one trip West—you should probably devote a week to each. We shall have to have our official contact made before you go ahead. We have set a deadline of April 1, of accomplishing this contact, at which time we hope to be able to provide you with proper introductions, etc., and we can more intelligently outline what we want then.

 4. International Silver

Not confident of the photographic possibilities of this subject, it is understood that you're taking the job entirely on speculation. We are, however, making contact with the company [and] will provide you with the proper introduction, together with [a] list of their plants and what process goes on in which. You [will] probably have to confer direct on photographic possibilities. International Silver does over fifty per cent of the industry's volume, makes all kinds of silver from five and ten cent store plate stuff to White House sets. We shall tell all about their activites. The more completely the pictures document the manufacturing end the better.

In addition to these subjects, we are reserving for you pending further investigation, the following:

 1. Aeroplane Manufacture.

 2. American Ice.

 3. Obstetrics. a. A good picture of a Caesarian—if one can be taken which is not too gruesome. b. Incidental shots in and about a delivery room—surgeon's hands, implements, fingers, etc. If it is possible to take pictures, I am confident that an interesting set can be made, building up the atmosphere—with some of the same technique used by the movies—and avoiding principal subject. . . .

On the subject of Cleveland you are to gather together and send us from your files all pictures which might conceivably illustrate the story—pictures in and about the city, Van Sweringen activities, etc.

Finally you [are] already engaged in a portfolio of New York speakeasies. We will set a deadline of February 1 on taking these pictures, as I would like to get them in the April issue. . . . All of these pictures are being taken in accordance with the arrangements recently agreed on and outlined in my letter of December 20. Right?

4 March. Ingersoll to Bourke-White

I am not awfully happy about the Port of New York pictures, but it doesn't make sense for me to criticize until I know your problem—what you couldn't get, etc. For instance, on the Hudson Tunnel, I sort of wanted to get inside the tunnel and the ventilating apparatus. And I haven't a list of bridges and other work at my finger tip to check to see if there are any others we ought to have. For all of which reasons I want to hold the set over. If, however, that movie of yours wants another feeding I would be glad to advance you some funds to be charged off presently. Say the word and I will put through $400 for you. But I warn you, it is not for the Port of New York pictures, on which there may be more work to do.

8 March. *Fortune*'s Mr. Prentice to Ingersoll

Fortune photographers should have some familiarity with the advantages and disadvantages of the gravure process by which *Fortune* is printed. Generally speaking . . . neither big solids nor big highlights can be used effectively in gravure. In *Fortune*, the best effects are always obtained by breaking up all masses, whether light or dark. . . . Our photographers can still mass areas, but they must work with dappled areas instead of wide flat areas. A woman's black coat will not come out looking like much in *Fortune*, for example. A woman in a checked coat will come out looking better in *Fortune* than anywhere else. . . . Wherever possible, *Fortune* photographers should come in to talk with the Production Department about what we can and what we cannot do well by gravure before taking the pictures. . . . After all it is a complete and total waste to make beautiful pictures [if we cannot] transfer the beauty of that picture to paper. . . . Our photographers should . . . try to develop new artistic standards which will enable them to get the utmost out of gravure printing.

9 March. Ingersoll to Bourke-White

This is undoubtedly an old story to you but in the interest of getting all we can out of black and white reproductions I asked Mr. Prentice to give me a memorandum on the problem from the production standpoint. This memorandum is enclosed. What he says makes a great deal of sense. Many's the time both your heart and mine have bled for the unhappy reproduction of pictures of yours which were so splendid in the original. And as Mr. Prentice so caustically points out we don't get any credit for fine originals—people only see what we show them. I think this is worth your while studying—although whether you want to take advantage of Mr. Prentice's offers to talk about it I leave up to you.

10 March. Ingersoll to Bourke-White

This will be a not very welcome note to say that we are revising our prices again and that on future work the base figure will be $300 instead of $400. This does not affect those jobs on which you have already begun taking actual photographs. Nor does this mean that we won't be able to pay you more on occasion. For instance, had you been taking a job that requires as much work as the speakeasy business, on the new scale we would undoubtedly have given a bonus. But we have been running over our budget consistently since the first and we are trimming sails. The policy continues to be to live within our means but to plow back any increase in revenue into material we buy.

15 March. *Fortune*'s arts editor Eleanor Treacy to Bourke-White (with reference to Port of New York Authority pictures)

1. Something on the ventilating towers. When the tunnel was first built I heard a lecture by the Chief Engineer which he illustrated with slides. In these slides the ventilating fans were extremely interesting and ought to make marvelous pictures.

2. In the tunnel itself there are the policemen all along the sides.

3. Just before you come out on the Jersey side there's a curve. Although you can't see the end of the tunnel you can see daylight striking against the tile sides. This ought to make a good picture too.

4. On the Jersey side there is that long approach with the high concrete sides and top. The light striking through the openings in the concrete makes a very good pattern on road.

5. Then, it certainly should be possible to get an interesting picture of the solid mass of cars on the Jersey side, waiting to get in the tunnel on Sunday, for instance.

4 May. Ingersoll to Bourke-White

You and your movies and your advances—I don't know what to say. . . . Not only is there the firm policy in force on the subject of advances but even commission work is legislated against. And I bust both rules for you. Well, I'll do what I can. The advance you got on March 8th ($20. cash and $380. check) is charged off on Speakeasies. I will put through a bonus of $100. on the set. And I'll give you a further advance of $100.—which makes the check for $200. enclosed.

5 June. Bourke-White to Ingersoll

You have not yet asked us for glossies on the *Port of New York Authority* job. . . . The regulations at the Holland Tunnel about stopping traffic made it impossible for me to get some of the viewpoints I wanted. I played around the tunnel for the greater part of three days and the authorities were all very cooperative but the results were not everything that I had hoped for.

28 June. Ingersoll to Bourke-White

We were, again, terribly pleased with the Harvester pictures and we hope we have given them a good break. But our budget didn't balance despite my hopes and there will be no bonus for poor Bourke-White this cold July. We will see if we can show our appreciation on a subsequent set.

1934

25 April. Ingersoll to Bourke-White

Your pictures weren't good enough. At Armour you got too interested in the people and neglected the processes. The Montgomery Ward boiled down to a total of nine subjects. You got no fun out of the diversity of mail order house wares.

28 August. Bourke-White to Ingersoll

I can hardly tell you how sorry I am about this whole NEA business. . . . NEA wanted a story about my adventures in the Middle West and asked if they could have a picture of me and perhaps a picture or two of the drought. . . . I wish to repeat that I had no knowledge whatsoever that they would feature the drought pictures, that they would use as many of them, or that they would use them apart from the interview. I did not authorize their use in this way. . . . Frankly I feel very unhappy about this incident because this is my first contact with a newspaper where there was a misuse of my pictures. This commission made me particularly happy—it seemed such a splendid subject and I was so pleased you turned over the planning of it to me. (She also sent a much shorter letter of apology to Henry Luce on 28 August.)

31 August. Luce to Bourke-White

To tell the truth I, too, was quite pleased with myself for having the idea of asking you to record the most famous drought for all time. And naturally, therefore, I was most unhappy when I found that NEA had taken the edge off this idea.

4 September. Ingersoll to Bourke-White

I want to thank you for your nice note about the pictures. It is all very sad, isn't it? It would have meant a good deal to us to be the first to present 'Bourke-White on the Drought.' The idea was Harry's and had my enthusiastic support as soon as I heard of it. . . . I think both you and *Fortune* share the blame for having carelessly provided the opportunity for NEA to play us tricks. But we are still proud of the pictures. . . . We have at least learned ourselves a lesson, haven't we?

1935

16 January. Ingersoll to Bourke-White

Look here—this latest and most scandalous evidence of somebody's carelessness in your office about releasing pictures you have taken for us for exhibition elsewhere brings to a head a situation which has long been bothering us. Another cocktail is indicated. In the meantime, would you please cancel any permissions you may have given and regard this as blanket instructions that no picture taken for *Fortune* shall be released by you or your agents without written permission from me.

Bourke-White to Ingersoll (undated telegram)

Let's have a cocktail. I'm upset to the point of tears.

21 January. Ingersoll to Bourke-White

I am sorry if my demands appeared formidable today. But set them down to my estimation of you as an artist and the great value we set upon your work. These then are the terms on which we agreed:

1. You are to arrange for the separate filing of all *Fortune* material in your office. This segregation must pass *Fortune*'s inspection, said inspection to take place during the week beginning January 21. To pass this inspection you must convince us that the physical arrangement of this filing is such that it will be *impossible for any of your employees inadvertently to confuse 'Fortune' pictures with any others.*

2. You are to issue, and post in a prominent place, instructions that neither negatives nor prints from these *Fortune* files go out from your office *to any other destination than this office*, from whom you will get receipts.

3. You will refer all requests for the re-use of your work for *Fortune* to this office. You will make clear to all persons interested that the decisions are ours and that you have no part in them.

4. On our side we assure you that we will look with sympathy upon all requests submitted to us and wherever consistent with our policy will grant these requests. The physical procedure for so doing will be the dispatch of the material from your office to ours, we in turn forwarding it, keeping our own correspondence files on the subject and being completely responsible both for authorization and delivery and return of negatives, prints, etc. *There will be no exceptions whatever to this routine.*

5. All *Fortune* material in your office shall be kept in the segregated files referred to and none shall be kept elsewhere, with one exception which is as follows: To facilitate the work of your salesman we agreed that you may prepare a separate portfolio of samples of work done for *Fortune* which your salesman may carry along with whatever other pictures he may be using in his solicitation. This portfolio shall be prominently marked with the name *Fortune*, which will be exhibited to your clients separately from your others, and when not in use contents to be returned to your *Fortune* files.

6. You are hereby informed that *Fortune* will henceforth resell no pictures, either yours or anyone else's.

7. Specific permission is hereby granted to reprint and distribute, as you see fit, copies of your favorite Hudson Bridge picture.

8. You are hereby notified that unless all pictures taken for *Fortune* are adequately identified by you in written captions on the backs thereof, we will, following notification, exact financial penalty, amount of this penalty to be discussed following the first violation.

9. It is, of course, understood that all the above refers exclusively to pictures taken by you for *Fortune* upon assignment by us.

Obviously exempted are pictures taken by you for others, the second rights to which have been bought by us.

If the above differs from your conception on any of these points—or if I have omitted any items you think ought to be included—I suggest that you indicate such changes as you might care to propose and return this letter to me, whereupon I will consider these proposals and let you know my decision. If, however, the above is a correct statement of our understanding will you please write me acknowledging it? And so having mended our fences to the best of our separate abilities let us live as happy neighbors from this day forth.

26 January. Kilburn R. Brown of Bourke-White Studio to Ingersoll
I am very certain that the strict instructions given to everyone in our office will prevent any future errors on our part in sending out *Fortune* pictures.

31 January. Bourke-White to Treacy (clarifying the ownership of images)
We have checked over your list of *Fortune* jobs, and they are correct with a few exceptions. From time to time, as you know, *Fortune* publishes pictures which I have not taken specifically for you but have had in my files as a result of some other commission. To avoid misunderstanding in the years to come, Mr. Ingersoll and I talked over the need of keeping these subjects clear and distinct. The exceptions are:

Champion Paper Company

Chrysler Building

Ford Motor Company

Swimming Pools

Steel Rails

Russia

The pictures accompanying the article on the Champion Paper Company were actually taken in the Oxford plant, and your people got them from Oxford at the time the article was written. The Chrysler Building was executed for the Walter P. Chrysler Company, and the picture was borrowed from the Bourke-White Studio. The swimming pools, as far as I know, were not used at all. They are old prints of mine which I took years ago, and if you have prints in your files, they properly should be returned to us. The picture of steel rails taken at Bethlehem Steel is part of a vacuum oil commission.

As you may remember, Russia was a country I went into entirely on speculation at the time when outside photographers were not being permitted to enter at all, and these pictures later became part of my book, *Eyes on Russia*.

In addition to those you have listed, we have filed away under *Fortune* Magazine the following three classifications: Drought (August 1934), Hiram Walker, Chase National Bank. I believe everything else is in order.

6 February. Bourke-White to Ingersoll

Now that your earnest pupil has learned her lesson, don't you think she might be invited to cocktails?

31 May. Treacy to Bourke-White

For some time past we have been faced with a growing confusion due to the fact that we have had no uniform practice in our financial arrangements with the photographers who do the greatest number of our important jobs. In order to remedy this condition and also in an effort to be entirely fair, we have decided that it would be advisable to reduce these arrangements to a standard practice and hope you will be agreeable to accepting the following terms:

$125 a day for the first 2 days' work

$100 a day for the second 2 days' work

$50 a day for any time thereafter

Fortune to pay transportation and hotel room expenses only.

14 June. Brown to Treacy

You have asked me to write to you outlining our charges for editorial work. We have standardized them at the following rate:

$150 a day for the first 2 days' work

$125 a day for the second 2 days' work

$100 a day for any time thereafter

The client to pay transportation, board, and all
 traveling expenses.

As you know, these charges are greatly under our rates for advertisers, due to the fact that we well understand the value of publicity received from editorial work in such publications as *Fortune*, large circulation general magazines, and newspaper syndicates. We are willing and anxious to cooperate with the publishers. At the charges

we have listed, we really earn no direct cash profit from editorial work. However, were we to reduce these rates, we would be doing business at an actual loss. We believe that doing business at a loss is poor business. . . . We are very appreciative indeed of the business you people have given us in the past, and we enjoy very much appearing in *Fortune* magazine.

19 June. Treacy to Brown

I am sorry to hear from you that you have standardized *your* prices one way just at the time we have standardized our prices another. For your letter would seem to suggest that after all these years we are to be denied the privilege of publishing Miss Bourke-White's work. Please say it isn't so! You will understand, of course, why it is impossible for us to make an exception to this rule. It would hardly be fair to our other contributors. Nor do we feel justified at this time in raising our prices horizontally to meet your figures. Perhaps the fact that we contemplate the awarding of bonuses to regular contributors will justify Miss Bourke-White in continuing a relationship of which we have long been proud. We do hope so!

2 July. Treacy to Bourke-White

Since our talk the other afternoon I have been reviewing Bourke-White–*Fortune* relations in order to find just what encouragement I would be justified in offering for the future. See if you don't think the following should clear up some of your doubts and unhappinesses. From June 1934 through April 1935 there were seven jobs which totaled $4826.20, an average of $688 a job. However, this average is somewhat distorted because of the inclusion of two color jobs, Steinway and American Woolen. Subtracting $900 for this color work makes the average $560. At an assumed average of $400 per job under the new plan, ten jobs a year would equal the 1934-5 earnings minus the color jobs, this without considering a possible bonus. And if you carry out your intention of developing a candid camera technique successfully, the picture would become much more attractive. As I told you, I am simply not going to commit myself to something I may not be able to live up to, and I can't guarantee you ten jobs, but, based on past volume and with the candid camera possibilities added, I can't see that the new arrangement will work out badly for you at all.

9 July. Bourke-White to Treacy

As many as ten or twelve jobs a year would of course make me feel very differently about this whole arrangement. As you probably know, I had supper with Mac a couple of day ago. I had never thought to mention to him before my growing interest in the lives of workmen. It seems to me that while it is very important to get a striking picture of a line of smoke stacks or a row of dynamos, it is becoming more and more important to reflect the life that goes on behind these photographs. This fringes on the candid camera type of photography, and also represents a point of view which I think is becoming increasingly important in regard to photography, and is something I have given much thought to lately.

I happened to mention this to Mac, and immediately he talked to me about doing the automobile worker's family and the others which you are trying to line up if they come through successfully. I am delighted that *Fortune* is going in for things of this kind. There is so much happening behind the scenes these days, and *Fortune*, better than any other magazine, can portray it.

21 October. Treacy to Bourke-White

The next family story has not yet been decided on and so I really have no news to give you except that I will let you know when it is and plan for you to do the work. However, before I do that I think I should pass on to you some criticisms that have been made here of your automotive family set. There was a general feeling that the pictures were too stiff and posed-looking, and I certainly think that you didn't get the spontaneity in your candid shots that there might have been. After all, the only reason for candid photography is the ability to catch people unawares and to get natural expressions and actions which cannot be caught in any other way. I do think if you are interested in going on with candid camera you ought to concentrate on taking lots of pictures without the subjects' knowledge if possible. Never mind if the technical quality of the prints is not as high as you would like to have it for a while. I think it is better to sacrifice that a little in order to get life and action into your pictures. Do try your hand at it on this next family job.

While I am discussing unpleasant things I might as well get this all off my chest at once. Mr. Hodgins, who wrote the Campbell

Soup story and arranged for the pictures taken at the Camden plant has been uttering cries of pain about what you missed in the set you took. Of course I think that gets back to the old problem of trying to plan pictures ahead when you are doing plants but that can't always be done and such a set as Campbell is very apt to shake editorial confidence in your ability to go into a plant and do a thorough job of photographic reporting.

So—I will hope to have word for you very soon about the next family job. It might be helpful if we could go over the automotive pictures before you start out and I will see if we can't arrange to do it.

22 October. Bourke-White to Treacy

Let's get together over a lunch or cocktails—or just over the pictures—and talk about them. I shall be more than happy to get all possible suggestions from you.

1936

4 September. Ingersoll to Bourke-White

I did not put in anything about our buying your equipment because I think we agreed that it would be satisfactory to leave it for negotiation between you and Bill Palmer of Pictures Inc. Since he is equipping the darkroom primarily for you, he must either come to terms with you or else buy new equipment at a higher price so that I don't think any clause in this agreement is necessary—and besides I have no price to fill in.

It is possible I may have overlooked other points we discussed, but if this suits you, it suits us. We could spend the rest of the month trying to word this so that every eventuality is provided for and in the end the document would never be worth more than Bourke-White and *Time*'s good faith.

You will be, of course, under no obligation to continue this relationship if you do not find it satisfactory—you can ask for your money back (in the form of equipment) and go home mad anytime you like. That seems to me your best protection. But we'll take a chance on keeping you happy. As I see it, this agreement is a simple salary-and-leave-of-absence deal such as we make every day with our writers. The business you are giving up is protected (a) by the provision we worked out yesterday afternoon to

set you up in shop again, and (b) by the fact that Pictures Inc., in its operation of your files, will maintain the "going concern" value of your pictures.

So if this is agreeable to you, write me a letter saying so and enclose one of the two copies herewith, initialed by you. If it is not, have at it again.

8 September. Luce to *Time* and *Fortune* subscribers

For six years now we have been seeking new ways to capture for *Time*, for *Fortune* and for the cinema *March of Time* the tremendous unrealized power of pictures.

But the more we have worked with pictures, the more clearly we have seen that a tremendous picture job remains to be done— a picture job no existing magazine, either here or abroad, is even attempting; a picture job no magazine can hope to achieve without first freeing pictures from the conventions and limitations of written journalism.

We have learned that pictures are a new language—difficult, as yet unmastered, but incredibly powerful and strangely universal. We have learned that for many stories the camera is itself the greatest reporter of all time.

We have learned that pictures can be grouped and edited to tell their own story of our world today—vivid, heroic, kaleidoscopic, and quite different from that other story you can read in words.

So now we propose to venture a new and utterly different kind of weekly magazine—*The Show Book of the World*. And I ask your encouragement, your support and your help as a Charter Subscriber to the first fifty-two weekly issues.

In this magazine you will see the faces of the poor and the gestures of the proud; the women that men love, and many children. You will see man's work—his towers, paintings and discoveries. You will see machines, armies, multitudes. You will see strange things—things thousands of miles away—things dangerous to come upon.

You will see and be amazed. You will see and take pleasure in seeing. You will see and perhaps wonder why you had so long been satisfied not to see.

For this magazine we will need more newsworthy pictures than you can find in all present magazine and Sunday supplements combined. We will need the art of the world's best photographers;

we will need the most painstaking editing, with an eye to visual form, to coherence, to drama, and to history. We will need the same brilliance of printing as a costly class monthly—fine paper, fine engravings, big pages and many pages.

In brief, this would be one of the most expensive of all magazines to publish. Yet its appeal seems so universal that we would like to offer it to *Charter Subscribers* at the price of a popular weekly—$3.50 a year, or less than 7¢ a copy on their subscription.

2 October. Bourke-White Studio to Mr. W. E. Palmer of Pictures Inc.

According to the agreement between Miss Bourke-White and *Time, Inc.* the following people from our studio should be on your payroll as of October First:

> Oscar Graubner, 3521-81 Street, Jackson Heights, Long Island
> Bert Kopperl, 414 East 52 Street, New York City
> Margaret N. Smith, 3 Mitchell Place, New York City.

You will find these referred to in paragraphs 5 and 7 of the agreement: *Time Inc.* agrees to employ and place at Miss Bourke-White's disposal a secretary who shall receive the salary of an editorial secretary—not less than $30 a week. *Time Inc.* agrees to employ two darkroom assistants: one developer and print maker at a salary of not less than $60 a week; one mounter and general boy at a salary of not less than $18 a week. Is there any other information that I should give either you or Mr. Longwell on this?

5 November. *Time*'s Daniel Longwell to Bourke-White (telegram)

Fort Peck pictures excellent night life perfect. Hope you are getting some human touches on the other big projects new settlers etc things to contrast with big building. Keep in touch with me by wire whenever you send back pictures so I will know when to expect them.

19 November. Bourke-White to Ingersoll

The more carefully I look through the magazine the more I like it. We're going to have a splendid time helping *Life* grow up. It has more possibilities than anything I can think of. I'm going to start raiding caterpillars soon for some butterfly pictures. It delights me to think that even the herpitologist and entymologist who was folded away in a college diploma can come to *Life* also. ∎

RADIO TALK:
OPPORTUNITIES FOR YOUNG WOMEN IN THE FIELD OF PHOTOGRAPHY

Transcript of Margaret Bourke-White speaking on Women's Radio Review,
NBC Radio, 14 June 1934

There are few professions that give a woman an opportunity to see so many sides of life as that of photographer. Her profession will bring her into contact with all kinds of people and will lead her into all imaginable situations.

She will feel, after she has worked as photographer for a few years, that she has touched the edges of many sides of life.

There is probably no profession that will call on all of a woman's faculties, as that of a photographer will. If she is able to arrange flowers, if she knows how to adjust the fold of a dress, if she can read the characteristic expression of a person's face, if she can chat comfortably and be at ease, or if on the other hand she has a feeling for architecture, for industry or a sense for news, any or all of these qualities will be brought into her business.

My own work, being that of industrial photographer, which is rather specialized, has led me into the most eccentric situations.

At one time I was photographing the Chrysler Building 1,000 feet above the sidewalk, standing on scaffolding with three men hanging on to the legs of my tripod to keep my camera steady in the gale. All this in mid-December when the metal parts of my camera were so cold that I could hardly bear to touch them with my hands. A month later I had left my perch high above the earth and had gone 1,000 feet below the earth's surface to photograph the mines.

Every day I got into the mine elevator dressed in miner's clothes and boots and wearing a light on my hat like the men, and found that it took much more than photography to do my work. It took a good deal of acrobatics. Sometimes I would have to crawl on my hands and knees through passages so low that if there were an inch or two of water on the floor I became completely soaked.

I had to take my photographs with my camera propped on a rock and I leaning on my elbows while I focused on the ground glass. It was sometimes very funny because the men would begin pitying me. I, of course, was having the time of my life but the men would say, "Poor little girl . . . how hard you have to work for your living. . . . How are you getting along? Do you own your camera yet?" I would answer, "All but the last payment."

At one time I was spending day after day in the steel mills, sitting in a traveling crane and being shuttled directly above the ladles of white hot metal. Sometimes there would be only room for me and my camera, and the men—unable to see me because of the fumes—would watch anxiously from the floor for fear I had fainted. I never fainted, of course, but sometimes it was so hot that the varnish on my camera would rise up in blisters and once I got a coat of tan as though I had been to Florida.

After the steel mills I went to Canada to record the story of papermaking. I lived in the lumber camps with the lumberjacks and took pictures at forty degrees below zero. Sometimes I would have to travel through the forest on snowshoes to get to my locations, and often it was so cold that my shutter froze.

Always I found that being able to chat with miners or gossip with lumberjacks or joke with electricians was just as important as being able to converse with the presidents of these companies if I were taking their portraits. Which does not mean that this latter quality is one to be ignored, because a photographer must first of all have poise; all her dealings are with people. First she has to "sell" those people, which means that she must build up a feeling of confidence in her ability, and secondly, she has to work with them when she is photographing them, and her skill in doing this helps to determine her results.

To come back to that part of photography which is selling: A woman can, I believe, in the last analysis, make good as easy as a man, but the opening steps of the game are harder. Compared with the man photographer, she has certain advantages and certain disadvantages. Her disadvantage is the age-old superstition that a man is more worthy of confidence than a woman. Another disadvantage is the opinion that men have—and unfortunately not always unjustified—that women are apt to take a fling at something

enthusiastically and then turn off to something else. This is something that the serious photographer must live down, and she lives it down very quickly if she produces a good deal of work.

Her great advantage is one that I think more than outweighs the disadvantages: people are much more willing to help her, if she shows any signs of getting along at all. It is much easier for her to take portraits because where men show impatience with a man photographer, either real or feigned, a woman can usually take as much time as she needs to, to work carefully and thoroughly. It is much easier for her to keep her subjects entertained while she is photographing them.

There are many types of photography that a woman can enter, such as work with architects and landscape gardeners, photography of children, straight portrait work, commercial advertising, fashion work.

There are several schools of photography where a girl can get preliminary training. Additional study of art and design would be very valuable.

I would strongly advise girls getting a job with an established photographer as apprentice or assistant to get practical experience, but in days like this when jobs are scarce that might be difficult, and if she has exceptional ability and initiative she might be able to start on her own.

I have found that my industrial work has run in many interesting channels. One of the most interesting of these was a commission from the National Broadcasting Company only a few months ago. One of the NBC executives who was having the rotunda in Radio City decorated, marched in one day and said, "Why do we have a painted mural with a lot of nymphs running around the rotunda that have nothing to do with radio? Why don't we have a photo mural that really tells the story of radio?"

You can imagine how delighted I was when I was called in to do the work. The mural is completed now and if you go up the broad staircase from the RCA lobby to the National Broadcasting Company's rotunda, you will see it. The photographs are ten feet high and the mural is 160 feet in circumference—the largest permanent thing of its kind that has ever been done.

I went into all kinds of places to get the photographs. Backstage at NBC, where I photographed the very switches and cables which are controlling the sound of my voice at this instant. I photographed the Camden factory where the radio set at which you are sitting at this minute was probably made. I made trips to the sending station at Bellmore, Long Island, to photograph the high-power transmission tubes, which are now in the act of converting the low frequency electric waves from my voice into the high frequency electrical waves which are being transmitted through the ether.

The central panel of the south wall in the mural shows a symbolic group of three microphones. The central one is the new ribbon velocity microphone. I photographed it with the outside shell taken off. The magnesium ribbon is so sensitive to atmospheric vibrations that it is vibrating with every word that I am speaking at this instant.

The opposite wall is composed with a central panel of three receiving tubes. These tubes on the wall are about eight feet high, but in your own radio set they are only two inches high. It is these tubes which are transmitting my voice into your room at this very minute.

Taking the pictures at the Bellmore Station was fun. You cannot get near those sending tubes without being electrocuted. So I found I had to do most of my work between midnight and six o'clock in the morning. I would go out at midnight and work hour after hour behind the double glass walls. Every so often the electricians would hand me cups of coffee and I would go on working. Toward morning they would have to come in to warm up the tubes. I would always beg them for a little more time and would go right on taking pictures and they would say, "Move over or you'll be electrocuted." I would squeeze in "just one more and just one more" and they would push me closer to the door so that I wouldn't be electrocuted. Finally it would be within minutes of the time when broadcasting was to begin and I would be putting the finishing touches on my last picture, and they would pick up my camera and shout, "You will have to get out of here or you'll be killed." And they pushed me bodily out of the door. ■

RADIO INTERVIEW:
ADVENTUROUS CAREERS FOR WOMEN

Margaret Bourke-White interview on WNEW arranged by *Mademoiselle* in collaboration with Henriette Harrison, radio director of the YMCA, 5:30 P.M., 8 May [1935?]

ANNOUNCER:

Today a new series of radio interviews begin at this hour over WNEW. "Adventurous Careers for Women"—that's the name of this novel series, which will bring to you each week at this same hour a different young woman who has made an outstanding success in some exciting profession. We are willing to wager that women are going to love these interviews—for they will be given the chance to win a weekly prize of $10 in cash besides ten other prizes. We also suspect, however, that the men are going to want to come down here and cut our throats before the series is finished.

For most men believe that all the really adventurous careers belong to the masculine sex. And that women, the timid dears, prefer nice, safe, sane, secure jobs that stick close to the ground with absolutely no risk attached to the pay envelope.

But *Mademoiselle* and Henriette Harrison say they know better, and they are both out to prove it. But perhaps first of all you would like to know who "they" are. Well, *Mademoiselle* is the new magazine for young women whose editors are so interested in careers of all kinds that they have devoted a regular department to giving readers the lowdown on every kind of money making profession for women. As their contribution to this program the editors offer a weekly prize of $10, and ten additional prizes of ten yearly subscriptions to *Mademoiselle* for the best letters from women describing what they would like best as a career. We'll give you the details later in the program. Perhaps the interviews will give you some ideas on the subject. And that brings us to Mrs. Harrison, radio director of the YMCA, and the demon radio interviewer of the Western Hemisphere. In her time Mrs. Harrison has interviewed over the air about all of the most glamorous women in New York City and she guarantees to bring you a particularly glamorous group to listen in on over these programs. What celebrity have you bagged for this broadcast, Mrs. Harrison?

MRS. HARRISON: To tell you the truth, I feel quite proud of today's capture. For I've brought down with my little celebrity gun—Margaret Bourke-White, the famous industrial photographer, who was recently included in the list of the twenty most able business women of the country. And when I say "brought" down I meant it literally. For Miss Bourke-White, who has crawled through miles of Russian coal mines on her stomach to get a picture, teetered so close to molten steel that the varnish on her camera was blistered off—has been living in the clouds for the past month. Isn't that so, my dear?

BOURKE-WHITE: Well, no. Not exactly. It's true that I've been out West shooting pictures from the airplane. But mostly the atmosphere was so clear that there weren't any clouds. But that's an exaggeration. I remember one cloud in particular—a dear little, soft, fluffy pink cloud. In fact it was the heroine of one of our trips. It was sunrise and we were flying about two miles high over the San Bernadino Mountains. And between us and one dazzling snow covered peak was this lovely little cloud bathed in the early morning sunlight. I shouted to Jack through the speaking tube to bank and to dip and to stand the plane on its tail so that I could get pictures of the cloud from all possible angles. It was positively the most overworked little cloud West of the Mississippi.

MRS. HARRISON: (laughs) hee hee. You better look out, Miss Bourke-White, or the celestial N.R.A. will be after you. I'm sure they don't permit clouds to begin work before sunrise. For goodness sakes, when did you start to work?

BOURKE-WHITE: Oh, about 2:30 every morning. I would call up the airport from my hotel or wherever I was staying and the pilots would read me the weather reports. If these sounded good we would start out at once, for we usually traveled about 200 miles to 400 miles to location, and it was important to get there by sunrise. You see the morning light is by far the best for picture-taking in the air.

MRS. HARRISON: What a life! I wonder how many girls who complain about getting to work at 9:30 would like to start their jobs at 2:30 A.M.

BOURKE-WHITE: But after all, think of the view, once I was ready to shoot. The Grand Canyon. Boulder Dam, besides the gorgeous Indian country around the Painted Desert.

MRS. HARRISON: I understand that you took all your airplane pictures with the doors of the plane off and the pilots helping you hold your camera steady. Weren't you simply terrified?

BOURKE-WHITE: But I wasn't in any danger. I never run any risks—even if I do get into tight places that sound dangerous. I don't dare—the insurance companies raise too many objections. Any way, this was a strictly business trip for an airplane company and naturally they didn't let me take any chances even when I might have wanted to. I traveled in a tri-motor plane. And of course I lived with a parachute strapped to my body. Have you ever seen one, Mrs. Harrison?

MRS. HARRISON: I don't think so.

BOURKE-WHITE: But maybe you did see a parachute but didn't know it at the time. That's what happened to me. When I first met my pilot he was wearing a white scarf around his neck. It was made of the loveliest strongest white silk I had ever seen and I admired it. "Oh, that's my parachute," said he casually. "It brought me safely to earth only about a month ago." He then went on to explain that only parachute jumpers have the right to wear this lovely stuff as a scarf. Right then and there I determined to take lessons and win a pilot's license.

MRS. HARRISON: Let the news about those white silk parachute scarves get about and there'll be no keeping women down to earth.

BOURKE-WHITE: I'm not sure about that. A parachute looks lovely and light. But actually they are awfully heavy things. There are two bundles of the stuff—one you sit on and one is fastened over your back and around your chest with big straps. It takes quite a lot of self-control to carry out the technique of the thing. You have to count ten according to rules before you pull its string and then it opens immediately.

MRS. HARRISON: It's all simply fascinating, Miss Bourke-White. But tell me, what did you wear besides the parachute? A regulation aviator's outfit? They always looked so clumsy for women to me.

BOURKE-WHITE: I considered my airplane costume the triumph of the trip. For it was one of those great strokes of economy that make a woman feel she is just the cleverest thing with budgets in the world. You see, I had in my closet a handsome ski suit—one of those extravagances that you buy in a mad moment and wear about twice and then pack away as a dead loss. Well, this ski suit was navy blue and I wore it with an airplane helmet, which is awfully becoming. It turned out to be the ideal aviation outfit for a photographer. I wore doeskin boots with it and a blue calico necktie. And when I photographed the {mountains} on the ground, we got into the "dusters"—of course, I added a mask with adhesive tape. It's the regulation mask for wear in the West these days.

MRS. HARRISON: Oh, you got caught in the dust storms. Do please tell us all about them. Are they as terrible as they sound?

BOURKE-WHITE: They are simply unbelievable. Even when there isn't a real "duster" which is what they are called out there in progress, there is dust everywhere. You eat dust—it gets through the icebox and into the butter. It creeps into the baby's milk. People shut their windows and doors and stop up the cracks with clothes and when they go out they put wet towels around their noses. The dust banks up around chicken coops and barns—people never get through digging. We passed whole families on trucks going to other states to look for jobs. The wheat had actually been blown out of the ground in some areas.

MRS. HARRISON: Good heavens! It sounds terrifying. I'm sure there won't be many girls writing letters saying they want to pursue dust storm photography as a career after that description. By the way, how did you get your pictures of the dust storm? I saw some in the papers.

BOURKE-WHITE: The chief problem was the light. It gets dark as late twilight during a duster. And the light turns a dark yellow. And then there's the dust—so much of it and so knife-like when it hits that the lenses of my camera were cut to pieces. I had to change them every time I took a picture.

MRS. HARRISON: Tell us, Miss Bourke-White, what you consider the most exciting camera adventure you ever had. I've seen your book

Eyes on Russia and I've heard that when you were working on the pictures for it, you had the most thrilling times. Romances, too. Is it true that you had five Russian proposals once in an evening?

BOURKE-WHITE: (laughs) Where did you read that?

MRS. HARRISON: I saw it in proof sheets, to tell you the truth. Proofs of the story about you for the June issue of *Mademoiselle*.

BOURKE-WHITE: Well, I guess it's true about the proposals. But you see, it was so unusual for them to see an American girl, and they consider us quite exotic.

MRS. HARRISON: Did you find Soviet men gallant?

BOURKE-WHITE: Indeed I did. One trip I made on horseback through the robber country of the Caucasus. I had an escort of eight Soviet [comrades]. Sometimes after a day of riding through the wilderness, we would build a fire, and crawl into caves to sleep and sometimes we would spend the night sleeping on the floor of a cave. They paid no more attention to me than if I had been a picket fence!

MRS. HARRISON: What about the women? They all work pretty hard, don't they? Is it true that they do men's work as well as the men do.

BOURKE-WHITE: Oh, yes. They love to do men's work, in fact. Sometimes girls would do volunteer work on a dam or steelmill to speed up work and we all know that the city of Moscow was reliant on these women to help dig dirt for the new subway.

MRS. HARRISON: All this makes me feel positively lazy! I wonder if there will be any letters from girls who would like a Soviet career. And now tell me this, Miss Bourke-White. You have seen so much. And done so much. What is YOUR ambition?

BOURKE-WHITE: You'll laugh when you hear. I want to do a children's book some time with pictures and text of reptiles—but such lovely ones that the children will no longer be afraid of them. You see I once studied biology at Columbia and I studied herpetology. I got so fascinated by snakes and other reptiles at that time that I grew to love them.

MRS. HARRISON: That accounts for those alligators and turtles that you keep in glass fish ponds in your studio. My, how I wish I could take your audience up to that penthouse of yours on the 40th floor of the Lefcourt Building. I never saw such a view. But I hear your last studio was on the 61st floor of the Chrysler Building.

BOURKE-WHITE: Yes, I'm gradually coming down to earth, you see, in spite of my airplane flights.

MRS. HARRISON: Now tell us, Miss Bourke-White—are you ever scared of an assignment.

BOURKE-WHITE: Well, not exactly scared. But I'll have to admit that I was pretty nervous and jittery about a picture I took of President Roosevelt not long ago. It was all on account of a dream. It was one of those rush-by-plane pictures for a news agency. And I had my appointment for the next morning. That night I dreamed that I broke my camera, dropping the bulbs like a clumsy fool every time I set up my equipment. When I went for my appointment to the White House the next morning, I was in a panic. But everything went smooth as cream. The president was charming and posed with no mishap to my machinery. But here's the joke. On the White House lawn as I was setting up for an exterior, my arm hit the camera. The tripod collapsed and the camera broke into a thousand shattered pieces!

MRS. HARRISON: But you have no other fears?

BOURKE-WHITE (reluctantly): We—ll, ye-s. Just one. I'm afraid to have my picture taken. You know I'm one of those girls who says, "I don't care whether it looks like me as long as I look beautiful." ∎

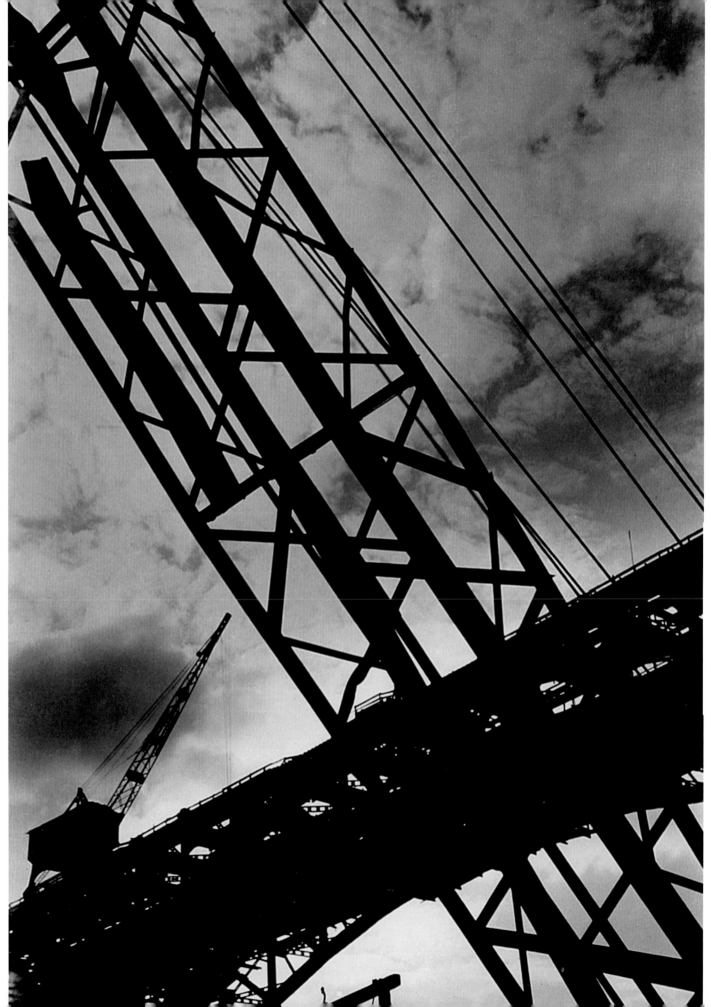

List of Illustrations

Unless otherwise noted, all photographs are by Margaret Bourke-White and are courtesy of the Margaret Bourke-White Collection, Syracuse University Library, Department of Special Collections. With a few exceptions, all photographs are gelatin silver prints. All images are copyright Estate Margaret Bourke-White, unless otherwise noted.

199

Bibliography

UNPUBLISHED LETTERS AND DOCUMENTS

Margaret Bourke-White Collection, George Arents Library, Syracuse University, Syracuse, New York.

BOOKS, CATALOGUES, AND JOURNAL ARTICLES

Agee, James, and Walker Evans. *Let Us Now Praise Famous Men*. Boston: Houghton Mifflin, 1988.

Bourke-White, Margaret. *Eyes on Russia.* New York: Simon and Schuster, 1931.

Bourke-White, Margaret. *Portrait of Myself.* New York: Simon and Schuster, 1963.

Brown, Theodore. Introduction to *Margaret Bourke-White: The Cleveland Years, 1927–1930,* essay by Suzanne Ringer Jones and Marjorie Talalay. Cleveland: The New Gallery of Contemporary Art, 1976.

Caldwell, Erskine, and Margaret Bourke-White. *You Have Seen Their Faces.* New York: Modern Age Books, 1937.

Callahan, Sean. *Margaret Bourke-White, Photographer.* Boston: Little, Brown and Company, 1998.

Daniel, Pete, and Raymond Smock. *A Talent for Detail: The Photographs of Miss Frances Benjamin Johnston, 1889–1910.* New York: Harmony Books, 1974.

Davis, Keith F. *An American Century of Photography: From Dry-Plate to Digital.* 2d ed., rev. and enl. Kansas City: Hallmark Cards Inc. in association with New York: Harry N. Abrams, Inc., 1999.

Elson, Robert T. *Time, Inc.: The Intimate History of a Publishing Enterprise, 1923–1941.* New York: Atheneum, 1968.

Freund, Gisele. *Photography and Society.* Boston: David R. Godine, Publisher, Inc., 1980. Translation from the French, *Photographie et Societe* (1974).

Goldberg, Vicki, *Bourke-White: A Retrospective.* Exh. cat. Hartford, CT: United Technologies Corporation, 1988.

Goldberg, Vicki. *Margaret Bourke-White, A Biography.* New York: Harper and Row, 1986.

Gover, C. Jane. *The Positive Image: Women Photographers in Turn of the Century America.* Albany: State University of New York Press, 1988.

Greenough, Sarah, *Paul Strand: An American Vision.* Exh. cat. Washington, DC: National Gallery of Art, 1990.

Harvith, Susan, and John Harvith, *Karl Struss: Man with a Camera.* Exh. cat. Bloomfield, MI: Cranbrook Academy of Art Museum, 1976.

Haskell, Barbara, *Edward Steichen.* Exh. cat. New York: Whitney Museum of American Art, 2000.

Heron, Liz, and Val Williams, eds. *Illuminations: Women Writing on Photography from the 1850s to the Present.* Durham, NC: Duke University Press, 1996.

Herzstein, Robert E. *Henry R. Luce: A Political Portrait of the Man Who Created the American Century.* New York: Scribner's, 1994.

Heyman, Therese Thau, Sandra S. Phillips, and John Szarkowski. *Dorothea Lange: American Photographs.* San Francisco: Chronicle Books, 1994.

Hine, Lewis W. *The Empire State Building.* Munich: Prestel Verlag, 1998.

Homer, William Innes. *Alfred Stieglitz and the Photo-Secession.* Boston: Little, Brown and Company, 1983.

Kiefer, Geraldine Wojno, *Steel and Real Estate: Margaret Bourke-White and Corporate Culture in Cleveland, 1927–1929.* Exh. cat. Wooster, OH: The College of Wooster Art Museum, 2000.

Lucic, Karen. *Charles Sheeler and the Cult of the Machine.* Cambridge: Harvard University Press, 1991.

Margaret Bourke-White: The Humanitarian Vision. Exh. cat. Syracuse, NY: Joe and Emily Lowe Art Gallery, Syracuse University, 1983.

McCandless, Barbara, Bonnie Yochelson, and Richard Koszarski. *New York to Hollywood: The Photography of Karl Struss.* Albuquerque: University of New Mexico Press, 1995.

Millstein, Barbara Head, and Sarah M. Lowe. *Consuelo Kanaga: An American Photographer.* New York: The Brooklyn Museum; Seattle: University of Washington Press, 1992.

Paul Strand: Sixty Years of Photographs. Introduction by Calvin Tomkins. New York: Aperture Foundation, Inc., 1976.

Peterson, Christian. *After the Photo-Secession: American Pictorial Photography, 1910–1955.* New York: W. W. Norton & Company, 1997.

Rathbone, Belinda. *Walker Evans: A Biography.* Boston and New York: Houghton Mifflin, 1995.

Rosenblum, Naomi. *A History of Women Photographers.* New York: Abbeville Press, 1994.

Rubin, Susan Goldman. *Margaret Bourke-White: Her Pictures Were Her Life.* New York: Harry N. Abrams, Inc., 1999.

Silverman, Jonathan. *For the World to See: The Life of Margaret Bourke-White.* New York: Viking Press, 1983.

Stebbins, Theodore E., Jr., and Norman Keyes, Jr. *Charles Sheeler: The Photographs.* Boston: Little, Brown and Company, 1987.

Steinorth, Karl, ed. *Alvin Langdon Coburn: Photographs 1900–1924,* essay by Nancy Newhall; texts by Anthony Bannon, Karl Steinorth, Reinhold Misselbeck, Marianne Fulton. New York: Edition Stemmle, 1998.

Sullivan, Constance, ed. *Women Photographers,* essay by Eugenia Parry Janis. New York: Harry N. Abrams, Inc., 1990.

Swanberg, W. A. *Luce and His Empire.* New York: Scribner's, 1972.

Tebbel, John, and Mary Ellen Zuckerman. *The Magazine in America.* New York and Oxford: Oxford University Press, 1991.

Tsujimoto, Karen. *Images of America: Precisionist Painting and Modern Photography.* Seattle: University of Washington Press, 1982.

Tucker, Anne, ed. *The Woman's Eye.* New York: Alfred A. Knopf, 1973.

Wilson, Richard Guy, Dianne H. Pilgrim, and Dickran Tashjian. *The Machine Age in America 1918–1941.* New York: Harry N. Abrams, Inc., 1986.

Yochelson, Bonnie, and Kathleen A. Erwin. *Pictorialism into Modernism: The Clarence H. White School of Photography.* Edited by Marianne Fulton. New York: Rizzoli, 1996.

ARTICLES BY MARGARET BOURKE-WHITE

(in chronological order)

The New York Times Magazine, series on the Soviet Union: (14 February 1932), 4–5; (6 March 1932), 4–5; (13 March 1932), 8–9; (27 March 1932), 8, 9, and 23; (22 May 1932), 8–9; (11 September 1932), 7 and 16.

"The Market Place," *American Photography* 28, no. 9 (September 1934), 585–589.

"Dust Challenges America," *The Nation* 140, no. 3646 (22 May 1935), 597–598.

"Photographing This World," *The Nation* 142, no. 3685, (1936), 217–218.

PHOTOGRAPHS BY MARGARET BOURKE-WHITE PUBLISHED 1926–1936

(chronologically within each journal or newspaper)

Architectural Forum 56, no. 1 (January 1932), 28–32: "Office and Studio of Margaret Bourke-White."

Architectural Record 66, no. 6 (December 1929), 504–508: "Portfolio of Five Industrial Photographs."

Architectural Record 76, no. 2 (August 1934), 129–138: "Photomurals in N.B.C. Studios."

Architectural Record 78, no. 2 (August 1935), 74: "George Washington Bridge."

Arts and Decoration 45, no. 3 (1936), 12: "Night View of an American City."

The Cleveland District Golfer (February 1928): cover.

The Cleveland Plain Dealer (29 April 1928) and (12 May 1929).

The Clevelander (January and February 1928, January, March, and April 1929).

The Cornell Alumni News 29, no. 13 (23 December 1926), 161; no. 15 (13 January 1927), 183; no. 16 (20 January 1927), 195; no. 19 (10 February 1927), 229; no. 32 (19 May 1927), 395; no. 34 (2 June 1927), 423; no. 37 (August 1927), 496;

The Cornell Alumni News 30, no. 1 (20 September 1927), 3.

Fortune 1, no. 1 (February 1930), 54–61, 68–71, 77–81, 95–96: "Hogs," "Sand into Glass," "Trade Routes Across the Great Lakes," and "When Wall Street Buys Orchids"; no. 2 (March 1930), 52–57 and 102–111; and 68–71: "The Unseen Half of South Bend" and "Aluminum Company of America"; no. 3 (April 1930), 46–48 and 122; and 88–91: "Petroleum" and "Bottled Time"; no. 4 (May 1930), 56–64, 65–72: "Times vs. Times" and "Paper and Power"; no. 5 (June 1930), 92–100: "Cloak and Suit."

Fortune 2, no. 1 (July 1930), 32–37, 77–82: "Skyscrapers" and "Columbia and United"; no. 2 (August 1930), 67–71 and 110–116: "Temple of the Dollars"; no. 3 (September 1930), 68–73 and 110–112: "Parke, Davis & Co.–E. R. Squibb & Sons"; no. 4 (October 1930), 55–63 and 105–108: "Nitrogen"; no. 6 (December 1930), 89–94 and 126: "Germany in the Workshop: An Industrial Portfolio."

Fortune 3, no. 2 (February 1931), 60–68; 72–83 and 126–130; and 97–99: "Soviet Panorama," "Hard Coal," and "The Grand Central Terminal"; no. 3 (March 1931), 70–76: "A Day at the National City Bank"; no. 4 (April 1931), 73–78, 121–128: "The U.S. Organ"; no. 5 (May 1931), 84: "Steel I"; no. 6 (June 1931), 42–48, 106–118: "Niagara Hudson."

Fortune 4, no. 1 (July 1931), 52: "Steel II"; no. 3 (September 1931), 41 and 66–72: "Steel III" and "Limestone—A Portfolio."

Fortune 5, no. 4 (April 1932), 70–73, 136 and 84–86: "Billions of Bottles" and "William Wrigley, Jr., American,"

Fortune 6, no. 1 (July 1932), 43–46: "Copper in the Mills"; no. 4 (October 1932), 38–39 and 62–63: "The Forgotten Animal" and "Competition not Cartelization"; no. 5 (November 1932): "Fifteen U.S. Corporations, A.D. 1932."

Fortune 7, no. 1 (January 1933), 49–57: "Germany's Reichswehr"; no. 4 (April 1933), 70–75: "International Silver Co"; no. 6 (June 1933), 53–58: "Speakeasies of New York."

Fortune 8, no. 3 (September 1933), 22–31: "Port of New York Authority"; no. 6 (December 1933), 42–47 and 152–153: "The Steel Rail."

Fortune 9, no. 3 (March 1934), 82–89: "Management by Morgan"; no. 6 (June 1934), 58–68: "So Big."

Fortune 10, no. 3 (September 1934), 46–52: "The Aluminum Co. of America"; no. 4 (October 1934), 76–83: "The Drought"; no. 6 (December 1934), 99–105: "Here Are the Steinways and How They Grew."

Fortune 11, no. 1 (January 1935), 69–74: "The Stores and the Catalogue"; no. 6 (June 1935), 65–75: "A $28,600,000 Loss."

Fortune 12, no. 5 (November 1935), 69–76: "Campbell's Soup"; no. 6 (December 1935), 115–126: "Success Story."

House and Garden (February, April, and July 1928, and May 1929).

Life 1, no. 1 (23 November 1936), cover, and 9–17: "Dam at Fort Peck, Montana" and "Franklin Roosevelt's Wild West."

Nation's Business (January, May, and August 1929).

The New York Times Magazine (22 May 1932), 1–2: illustrating A. O. McCormick, "The Future of the Ford Idea."

The New York Times Magazine, (11 September 1932), 3: illustrating A. Maurois, "The New Era That Is Before Mankind."

Rotarian 43, no. 4 (October 1933), 14–16: "Russia."

Theatre Guild (March 1929).

Town and Country Club News (April, May, June, and July 1928), covers.

Trade Winds (Union Trust Co., Cleveland, monthly) ca. 1928–ca. 1931 passim.

Vanity Fair 38, no. 1 (March 1932), 46–47 and 78: illustrating J. Huxley, "A Scientist Views the Russian World."

Vanity Fair 39, no. 1 (September 1932), 34–35 and 66: illustrating P. Scheffer, "Dictators—The Soviet Answer."

Vanity Fair 42, no. 3 (May 1932), 26–27: "Trapping the Magical Waves of Sound."

World's Work 58, no. 9 (September 1929), 43: "Blast Furnaces."

World's Work 61, no. 2 (February 1932), 30–32: "Muzhiks and Machines."

Notes

[1] By the mid-1930s Bourke-White had established a successful career at a time when few woman held positions of power in government or business (Vicki Goldberg, *Margaret Bourke-White, A Biography* [New York: Harper and Row, 1986], 115–116, 139). She had few role models, but her accomplishments received more notice because she was a woman.

[2] Karen Lucic, *Charles Sheeler and the Cult of the Machine* (Cambridge: Harvard University Press, 1991), 12, 20–21.

[3] Richard Guy Wilson, Dianne H. Pilgrim, and Dickran Tashjian, *The Machine Age in America 1918–1941* (New York: Harry N. Abrams, Inc., 1986), 26, 94.

[4] John Tebbel and Mary Ellen Zuckerman, *The Magazine in America* (New York and Oxford: Oxford University Press, 1991), 170.

[5] Goldberg 1986, 114.

[6] Margaret Bourke-White, *Portrait of Myself* (New York: Simon and Schuster, 1963), 77.

[7] Geraldine Wojno Kiefer, *Steel and Real Estate: Margaret Bourke-White and Corporate Culture in Cleveland 1927–1929* [exh. cat., The College of Wooster Art Museum] (Wooster, OH, 2000), 8.

[8] Goldberg 1986, 8, 16; and Bourke-White 1963, 20.

[9] Joseph White owned several hundred patents. His two greatest inventions were the first printing press for Braille and a small truck-mounted press used to print maps on the front lines in World War I (Bourke-White 1963, 20–21).

[10] Goldberg 1986, 13–14, 74.

[11] Bonnie Yochelson and Kathleen A. Erwin, *Pictorialism into Modernism: The Clarence H. White School of Photography*, ed. Marianne Fulton (New York: Rizzoli, 1996), 28, 32; and Arthur Wesley Dow, *Composition*, 13th ed., rev. and enl. (Garden City, NY: Doubleday, 1920; reprint, Berkeley: University of California Press, 1997), 103, 109–110, 136.

[12] Dow ed. 1997, 67–69, 79–86. Opposition occurred where two lines met to create an angle. Transition used a third line or element, often curved, to soften two opposing lines. Subordination depended on a central object with subordinate parts (like a tree with branches) or a large foreground object connected to similar objects in the background (like a mountain peak and a receding range behind it). Repetition portrayed the same object in multiple representations and relied on refined spacing to create harmony. Symmetry was the most common way of establishing order, with two lines or shapes of equal size and/or proportion shown in juxtaposition.

[13] Pete Daniel and Raymond Smock, *A Talent for Detail: The Photographs of Miss Frances Benjamin Johnston, 1889–1910* (New York: Harmony Books, 1974), 43, 51, 87, 95, 115–117.

[14] Yochelson and Erwin 1996, 28, 32, 34, 40, 56, 68–76. White was hired by Dow, chairman of the fine arts department, and recommended by Alfred Stieglitz, who had declined the position.

[15] While still teaching at Columbia University, White opened the Clarence H. White School of Photography in New York City in 1914, offering numerous courses for the commercial photographer. White and Stieglitz eventually had a falling out over their different approaches toward photography (Yochelson and Erwin 1996, 12, 70, 98).

[16] Bourke-White 1963, 29–30.

[17] Goldberg 1986, 25.

[18] Yochelson and Erwin 1996, 28, 38.

[19] Bourke-White 1963, 30.

[20] Goldberg 1986, 34, 49, 53.

[21] Goldberg 1986, 57–59.

[22] Bourke-White 1963, 31–32; Goldberg 1986, 27. During the summer of 1924 Bourke-White had visited her mother in Cleveland and explored the city, planning to come back later to take photographs (Goldberg 1986, 56).

[23] Bourke-White 1963, 36–38; Goldberg 1986, 68–69; and Theodore Brown, Suzanne Ringer Jones, and Marjorie Talalay, *Margaret Bourke-White: The Cleveland Years, 1927–1930* (Cleveland: The New Gallery of Contemporary Art, 1976). Bemis taught her to use artificial lighting and offered various kinds of support.

[24] Bourke-White 1963, 32, 44–45; Goldberg 1986, 69–70, 87.

[25] Naomi Rosenblum, *A History of Women Photographers* (New York: Abbeville Press, 1994), 39–40; around 1910 they could expect to get up to ten dollars for an advertising photograph and from fifty to one hundred dollars for a celebrity portrait, 42–46, 56-60, 63–70, 77–81, 152.

[26] Rosenblum 1994, 60, 64.

[27] Bourke-White 1963, 32–35, 38; Goldberg 1986, 70; Brown, Jones, and Talalay 1976. In the early days she would charge five dollars for each photograph.

[28] Bourke-White 1963, 38. The credit to "White" suggests that this publication predated the creation of her professional name.

[29] Bourke-White 1963, 33–35, 40, 49–50.

[30] Goldberg 1986, 67–68, 82. The exhibition showcased the beauty of the machine by displaying the work of fine artists alongside actual machine-made items and photographs of industrial architecture.

[31]Bourke-White 1963, 38–40. Goldberg 1986, 74; Kiefer 2000, 8.

[32]Bourke-White 1963, 38–40. Yochelson and Erwin 1996, 32–33.

[33]Bourke-White 1963, 33–34, 40, 49–50; Goldberg 1986, 83.

[34]Bourke-White 1963, 50–60; Goldberg 1986, 84, 86–87.

[35]Wilson, Pilgrim, and Tashjian 1986, 23.

[36]Lucic 1991, 47.

[37]Lucic 1991, 47–59, 66–74, 89, 95, 97. The River Rouge plant opened in 1927, with twenty-three buildings, twenty-seven miles of conveyors, fifty-three thousand machines, and seventy-five thousand workers. Bourke-White claimed she knew only of Joseph Pennell, an English artist who created etchings that show the industrial landscape as art. Her father may have had a copy of Pennell's book, *Joseph Pennell's Pictures of the Wonder of Work*, (William Heinemann, London, and J. B. Lippincott, Philadelphia, 1916) which she might have seen (Goldberg 1986, 75, 82).

[38]Goldberg 1986, 87.

[39]Goldberg 1986, 87.

[40]Roy Stryker to Bourke-White, 26 October and 16 November 1928. Stryker later directed the fine arts division of the Farm Security Administration, where he hired photographers Walker Evans and Dorothea Lange.

[41]Goldberg 1986, 105; Bourke-White 1963, 88. Because women made up a majority of the buying public, women photographers found opportunities in the male-dominated world of advertising, where their feminine point of view was thought to give them an advantage in reaching a wider female audience. Graduates of the Clarence H. White School of Photography, such as Margaret Watkins and Wynn Richards, helped lay the groundwork for Bourke-White's work in commercial photography (Rosenblum 1994, 64, 158–160).

[42]Barbara Haskell, *Edward Steichen* [exh. cat., Whitney Museum of American Art] (New York, 2000), 29–34. This in turn raised the fees for other commercial photographers. J. Stirling Getchell was a cutting-edge advertising giant who recognized the potential of photography as a substitute for dreary black-and-white illustrations. He was one of the people who hired such photographic stars as Steichen and Bourke-White for advertising work. The first to use photographs of cars in advertisements, he eventually founded his own magazine, *Picture: The Photographic Digest* (1938). (Tebbel and Zuckerman 1991, 228.)

[43]Bourke-White 1963, 81–82; Goldberg 1986, 140–143. Advertising was lucrative in part because color photography, which was technically challenging and still very expensive, was not yet a mass-market phenomenon. Bourke-White tried to master this aspect of her trade, charging upwards of one thousand dollars a shot for color photographs, but in the end her black-and-white images were more successful than her work in color.

[44]*Lincoln Electric: Sparks*, 1929, and *International Harvester: Welding Parts*, 1933, (figs. 38, 39), anticipated a series that Bourke-White shot in the early 1940s in Moscow, with German bombs falling in a way that recalled sparks in a machine shop. In the later series, however, the silhouette of the city in the distance tells us immediately that the objects photographed are larger than sparks.

[45]Robert T. Elson, *Time Inc.: The Intimate History of a Publishing Enterprise, 1923–1941* (New York: Atheneum, 1968), 12. Baker was mayor 1912–1916 and was Woodrow Wilson's secretary of war 1916–1921.

[46]Robert E. Herzstein, *Henry R. Luce: A Political Portrait of the Man Who Created the American Century* (New York: Scribner's, 1994), 53; W. A. Swanberg, *Luce and His Empire* (New York: Scribner's, 1972), 60–63, 66–67.

[47]Brown, Jones, and Talalay 1976. Telegrams, Luce to Bourke-White, 8 May and 14 May 1929. Another place Luce may have seen her work was in *Nation's Business*, which reproduced *Open Hearth* in January 1929. He would have certainly been reading that magazine if he was going to start his own business publication. *Nation's Business*, a text-driven magazine that used stock images to illustrate more than one industry, had a circulation of more than three hundred thousand in 1929.

[48]Bourke-White 1963, 62–64. Parker Lloyd Smith to Bourke-White, 22 May 1929.

[49]Goldberg 1986, 101–108. Another reason they went ahead with publication was that they had filled their advertising quota for 1930 (letter from *Time*'s managing editor, Parker Lloyd-Smith, to Bourke-White, 4 September 1929).

[50]Herzstein 1994, 56–61.

[51]Memorandum attached to letter of 25 April 1935 from Paul West (*Fortune*'s business manager) to Ethel P. Fratkin of Bourke-White's studio staff. For details see Appendix in the present catalogue.

[52]Brown, Jones, and Talalay 1976. Goldberg 1986, 139.

[53]Bourke-White 1963, 70.

[54]Bourke-White 1963, 65–71.

[55]Goldberg 1986, 107–108.

[56]Bourke-White 1963, 74.

[57]Bourke-White 1963, 66. She was accompanied by Archibald MacLeish, who wrote the text. On her trips for *Fortune* magazine she usually traveled with a writer assigned to the project. For an assignment in South Bend, Indiana, Luce personally served as chaperone and lugged her heavy cameras from factory to factory. At one steel mill he even rescued the cameras when a ladle broke and began to splash molten metal around (Bourke-White 1963, 68–70).

[58]Bourke-White 1963, 76–77. Designed by William Van Alen, the Chrysler Building embodied the industrial age, with its brick frieze on the thirty-first floor implying motion, its stainless steel peak evoking the shiny surface of a machine, its triangular windows lighting up the skyline at night, and its needle-thin spire. It served as a potent form of advertising for the Chrysler Corporation. The building was reportedly the tallest in the city, at 1,046 feet, but critics contended that the spire was merely ornamental. Bourke–White's assignment was to prove that the top element was an integral part of the structure. With the completion of the Empire State Building, the issue was laid to rest (Wilson, Pilgrim, and Tashjian 1986, 162–163).

[59]Harry C. Davis (treasurer of the Chrysler Building) to Bourke-White, 28 April 1934. She wanted to live in the studio as well, but this was forbidden under the New York City building code. When she learned that only the janitor was allowed to live in an office building, she applied for this position at the Chrysler Building— a job she did not get (Bourke-White 1963, 78). The Chrysler Building became the headquarters for Luce's magazines in August 1931 (Herzstein 1994, 62–63).

[60]Introduction, *Archives of American Art Journal* 29, nos. 3–4 (1989), 68; Bourke-White 1963, 80, 84; Goldberg 1986, 130; "Office and Studio of Margaret Bourke-White," *Architectural Forum* 56, no. 1 (January 1932), 28–32. Ironically, Vassos—an artist, illustrator, and industrial designer who specialized in the art deco and art moderne styles—and his wife, Ruth, had just finished a book about humans being controlled by the machine (Wilson, Pilgrim, and Tashjian 1986, 303).

[61]She entertained on the large terrace. And on the small terrace she kept two alligators that a friend in Florida had given her: "The alligators, plus a few small turtles, reminded me pleasantly of the herpetology days of my childhood. At feeding time, I tossed the alligators big slabs of raw beef, which they playfully tore from each other. They grew very fast and ate a great deal, even bolting down several of my turtles, shell and all. I thought they would find this meal quite indigestible, but they calmly slept it off. It astonished me to find the law of the jungle operating in a penthouse at the top of a skyscraper" (Bourke-White 1963, 80).

[62]Goldberg 1986, 110, 139–142.

[63]Goldberg 1986, 125.

[64]Goldberg 1986, 125, 127.

[65]Bourke-White 1963, 90.

[66]Goldberg 1986, 127.

[67]Bourke-White 1963, 95; Goldberg 1986, 128.

[68]The dancers modeled the lockstep actions expected of the whole of Soviet society (Bourke-White 1963, 95).

[69]Bourke-White 1963, 95.

[70]Goldberg 1986, 130–131, 136–138.

[71]Goldberg 1986, 131.

[72]This image may have been taken with a hand-held camera, and if so, it is all the more worthy of attention, because that means she really chose to make the man seem tiny.

[73]Bourke-White 1963, 96. See Goldberg 1986, 134–135, for a critique of the film.

[74]Swanberg 1972, 101–103.

[75]Goldberg 1986, 97–98. In a sense, this was typical of the day. Before the creation of *Fortune*, a single issue of *Time* covered as many as twelve tycoons (Swanberg 1972, 68).

[76]"I had never seen people caught helpless like this in total tragedy. . . . I was deeply moved by the suffering I saw and touched particularly by the bewilderment of the farmers. I think this was the beginning of my awareness of people in a human, sympathetic sense as subjects for the camera and photographed against a wider canvas than I had perceived before" (Bourke-White 1963, 110). In the 1930s many U.S. photographers turned from modernist design-focused compositions toward more documentary images of people and their plight (Rosenblum 1994, 173–174).

[77]Communism gained popularity among many of Bourke-White's friends (Goldberg 1986, 152–155).

[78]See Chronology and Appendix for details.

[79]Goldberg 1986, 109; letters from *Fortune* magazine to Bourke-White, 10 March 1933, and 31 May, 19 June, and 2 July 1935; Bourke-White's responses, 14 June and 9 July 1935. See Appendix for excerpts.

[80]Goldberg 1986, 155–156.

[81]Bourke-White 1963, 107–110.

[82]James Agee and Walker Evans, *Let Us Now Praise Famous Men*, reprint, with intro. by John Hersey (Boston: Houghton Mifflin, 1988), xiv.

[83]Luce to Bourke-White, 31 August 1934: "To tell the truth I, too, was quite pleased with myself for having the idea of asking you to record the most famous drought of all time. And naturally, therefore, I was most unhappy when I found that NEA had taken the edge off this idea."

[84]Bourke-White to Ingersoll, 25 August 1934.

[85]Ingersoll to Bourke-White, 4 September 1934; and 16 and 21 January 1935.

[86]Bourke-White to Ingersoll, 6 February 1935. See also Goldberg 1986, 91–96, 117–118, 121–123. In Bourke-White's day, being a woman in a man's world was tough, but Bourke-White recognized that it could be an asset. Risks taken to get a shot did not make a story, if the photographer was a man. She did not use sexual favors to secure photographic assignments, but she understood and enjoyed the power that she knew her sex appeal gave her over men. She was a thoroughly liberated woman who enjoyed playing against type. She wore tailored slacks in the 1930s, when it not was common for women to be seen in pants. When she showed her portfolio to a potential client, she would often sit on the edge of his desk and lean over him to direct his attention to details of her work. And she would cry on cue, if she thought it would help her get her way. She had affairs with many men, sometimes juggling several at once in different cities. She liked men who were witty and intelligent—and she preferred men who were married and thus did not threaten her independence.

[87]Bourke-White won commissions for several important murals, including two for buildings at the 1933–1934 World's Fair in Chicago—one for the Aluminum Corporation of America and the other for Ford Motor Companies (letter from Bourke-White to General Motors, 17 July 1934).

[88]Vicki Goldberg, *Bourke-White: A Retrospective* [exh. cat., United Technologies Corporation, 1988], 12–13. Another photographer, Drix Duryea, was hired to print Bourke-White's photographs. Apparently jealous, he attacked her both professionally and personally, complaining that she was behind schedule and insinuating that she was older than she said she was and had to be using drugs to keep her frantic pace. During installation he replaced four of her photographs with his own, signed the mural four times, and wanted credit for designing it. Bourke-White was outraged, and after a series of emotional meetings, the mural was restored to her original design (Goldberg 1986, 143–144). On 28 February 1934 in a telegram to John Vassos, Bourke-White wrote: "Dear John We mual [sic] all celebrate, for won on all points with mural. The villain has to take his pictures down new [sic] week and put up mine." *The Architectural Record* (August 1934) ran an article with a photograph of the mural and included ourke-White's name in oversized letters on almost every page. Although heavy-handed, this was understandable in light of the controversy.

[89]Goldberg 1986, 144.

[90]Goldberg 1986, 140.

[91]Goldberg 1986, 144–145.

[92]Letter from Bourke-White to Paul H. Brattain, 17 February 1936; contract between North American Aviation, Inc., and Bourke-White Studio, 31 October 1935.

[93]Bourke-White 1963, 106.

[94]Paul H. Brattain to Bourke-White, 10 February 1936.

[95]Eleanor Treacy to Bourke-White, 2 July 1935; and Bourke-White's response, 9 July 1935.

[96]Eleanor Treacy to Bourke-White, 21 October 1935.

[97]The brochure was intended both to teach schoolchildren about coffee-growing in Brazil and to entice their parents into buying vacuum-packed canned coffee (Bourke-White 1963, 116).

[98]Bourke-White 1963, 113; Goldberg 1986, 161–163.

[99]Bourke-White 1963, 126; Goldberg 1986, 168–171; Erskine Caldwell and Margaret Bourke-White, *You Have Seen Their Faces* (New York: Modern Age Books, Inc., 1937), 51–53.

[100]Belinda Rathbone, *Walker Evans: A Biography* (Boston and New York: Houghton Mifflin, 1995), 118–120. Evans later had a career as an editor at Time Inc.

[101]In *Let Us Now Praise Famous Men* (Agee, Evans, 1988, 142), Agee describes one of the dwellings, the Gudger house as "more poor and plain than bone, more naked and noble than sternest Doric, more rich and more variant than watered silk, is the fabric and the stature of a house."

[102]Agee and Evans ed. 1988, xxviii.

[103]Agee and Evans ed. 1988, 450–454.

[104]Fred S. Ferguson to Bourke-White, 11 March 1936.

[105]Goldberg 1986, 150–151; Fred S. Ferguson to Margaret Smith, 1 May 1936; Ferguson to Bourke-White, 30 June, 13 August, and 20 August 1936; and Bourke-White's response, 17 August 1936.

[106]The other three—Alfred Eisenstaedt, Tom McAvoy, and Peter Stackpole—preferred 35-mm cameras (Goldberg 1986, 175–176). Bourke-White preferred the large-format cameras because they produced larger negatives with sharper detail in the final prints. In the early 1930s she used a 5 x 7 Corona View camera with tripod, a 3¼ x 4¼ Graflex, and a 3¼ x 4¼ Icas Reflex; she later replaced these with a 4 x 5 Soho and a 3¼ x 4¼ Linhof. Beginning in the mid-1930s she occasionally used a 35-mm Leica, then a 35-mm Contax, and a Rolleiflex, which were smaller cameras and facilitated candid photography because they did not need a tripod (Bourke-White 1963, 117; Goldberg 1986, 147–149, 172-181).

[107]Bourke-White 1963, 141–142.

[108]Goldberg 1986, 176–181.

[109]Bourke-White 1963, 142–147.

Index

NOTE: B-W refers to Margaret Bourke-White. Bold page numbers refers to photos.

INDUSTRIAL TRIPTYCH, Texaco, 1930s

Designed by Susi Oberhelman

Composed in Bodoni Antiqua designed by Giambattista Bodoni in 1798,
Formata designed by Bernd Möllenstädt in 1984, with
Walbaum (designed by Justus Erich Walbaum in 1803) as display.

Duotone and tritone separations, by Martin Senn, Philmont, Virginia.

Digital photography, except for the images credited to Randy Batista, by Martin Senn.

Randy Batista: pages 7, 53 (bottom), 208;
August Bendell: page 29;
Barbara Puorro Galasso: pages 2, 11, 17, 34;
Stefan Kirkeby: pages 73, 153;
Adam Reich: pages 89, 92, 93.

Printed in China